OOH – LA – LA!
THE LADIES OF PARIS

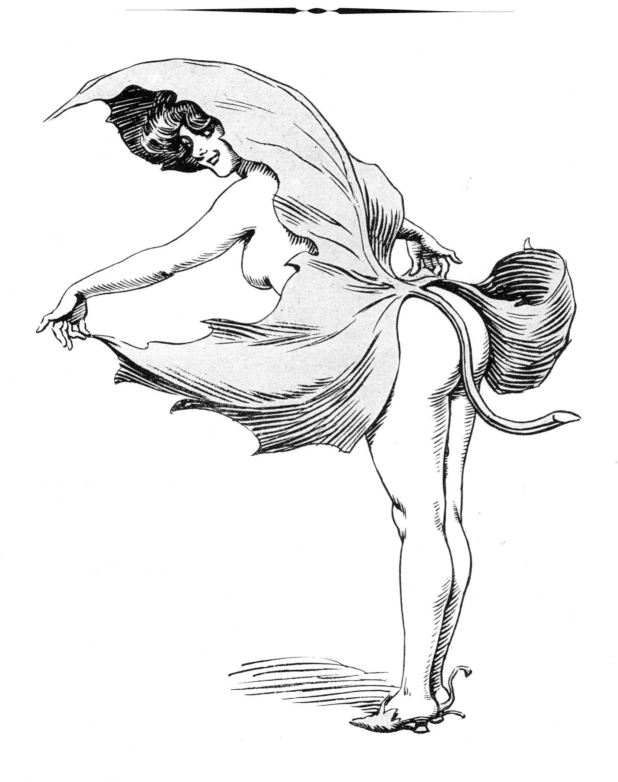

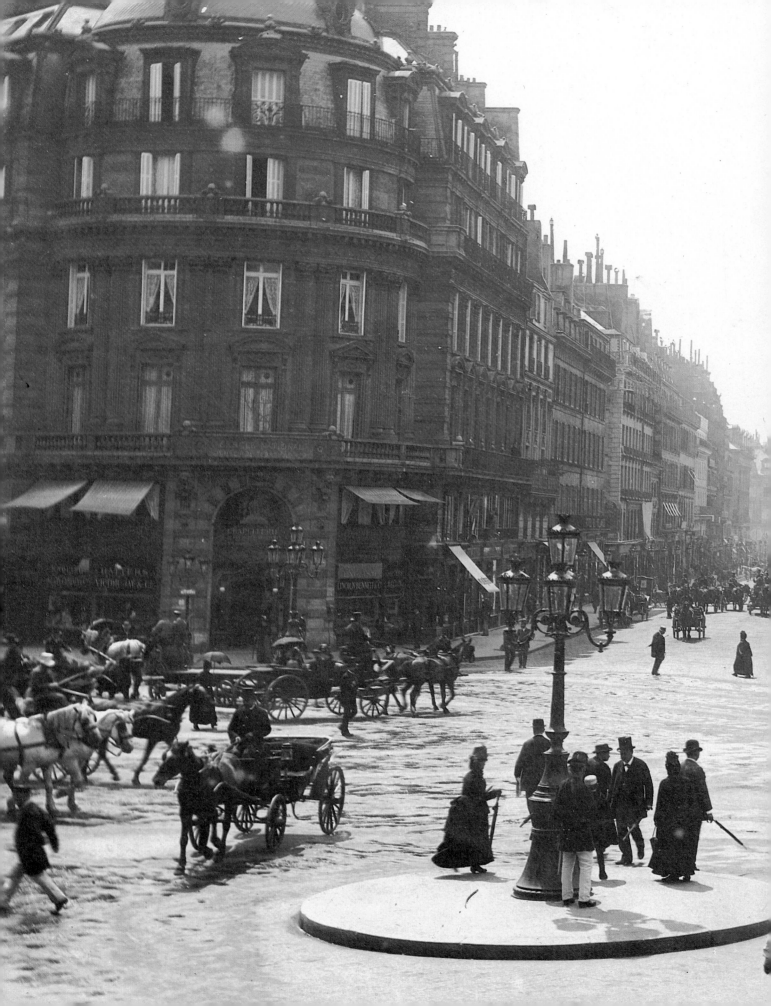

ACKNOWLEDGMENT

The following artists deserve special mention among
the gallery of outstanding talent contained in this book.

MESSIEURS:

AVELOT	FABIANO	METIVET
BAC	GALANIS	MEUNIER
BALLURIAU	GERBAULT	PRÉJELAN
BRUNELLESCHI	GOSÉ	RADIGUET
BURRET	GUILLAUME	ROUBILLE
CARDONA	GUYDO	STEINLEN
CARLEGLE	HARTHY	TOURAINE
DE BEAUVAIS	HEROUARD	VALDES
DE SEMANT	JAQUES	VALLÉE
DIANE	KUPKA	and
DIARDOT	LEONNEC	WELY
ESQUIUS	LISSET	

To the rest, my gratitude for your anonymous
but valuable contributions throughout. You may be
sure, gentlemen, that your efforts will be appreciated.

Ronnie Barker

PUBLISHER'S NOTE:

Great difficulty has been experienced in tracing
copyright of some of the pictures in this book.
We regret if we have unwittingly failed to
give credit to any individual, and
undertake to do so in future
editions of the work upon
notification by the
owners of the said
copyright.
British Library Cataloguing
in Publication Data
Barker, Ronnie
 Ooh la la!: the ladies of Paris
 1. Women in art – Pictorial works
 I. Title
 743'.924'0904 N7632

ISBN 0 340 32346 9 (limp)
ISBN 0 340 32347 7 (cased)

Photoset by Rowland Phototypesetting Limited,
Bury St Edmunds, Suffolk.
Printed in Great Britain for Hodder and
Stoughton Limited, Mill Road, Dunton
Green, Sevenoaks, Kent, by
Jolly and Barber Limited, Rugby.

Book Designed by Bob Hook

Ooh-La-La!
The Ladies Of Paris

By Ronnie Barker

HODDER AND STOUGHTON
London Sydney Auckland Toronto

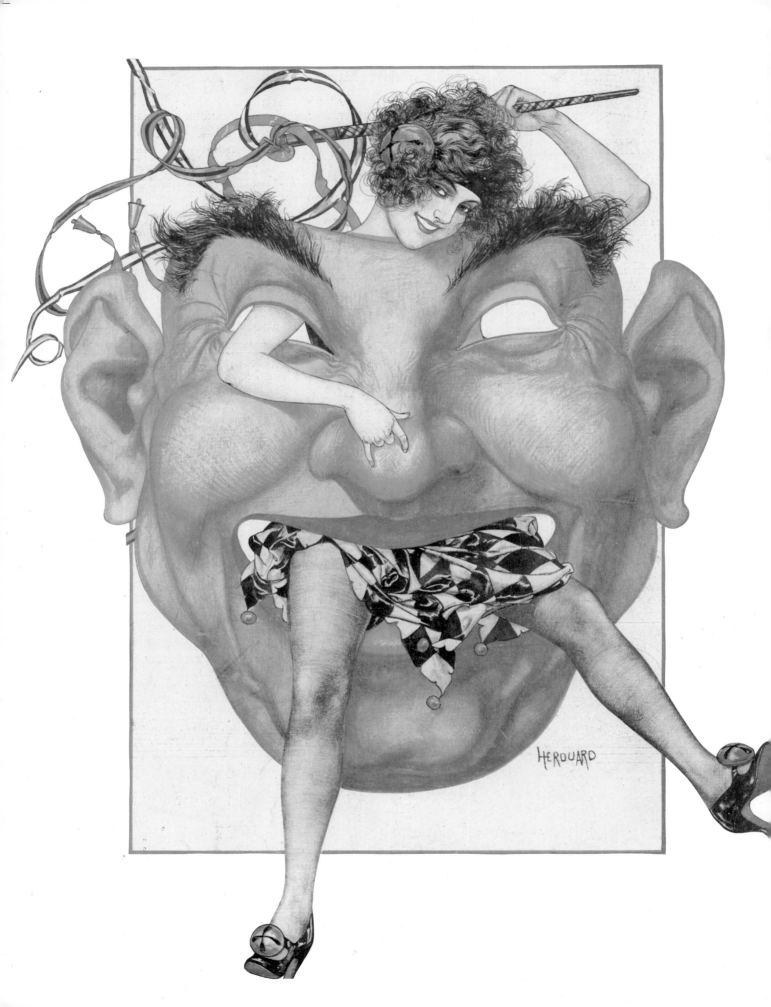

HEROUARD

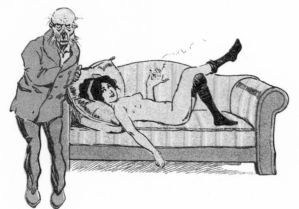

Contents

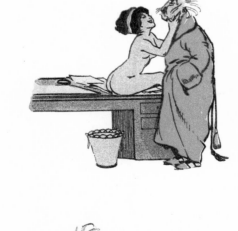

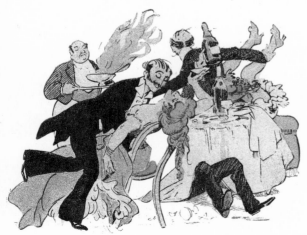

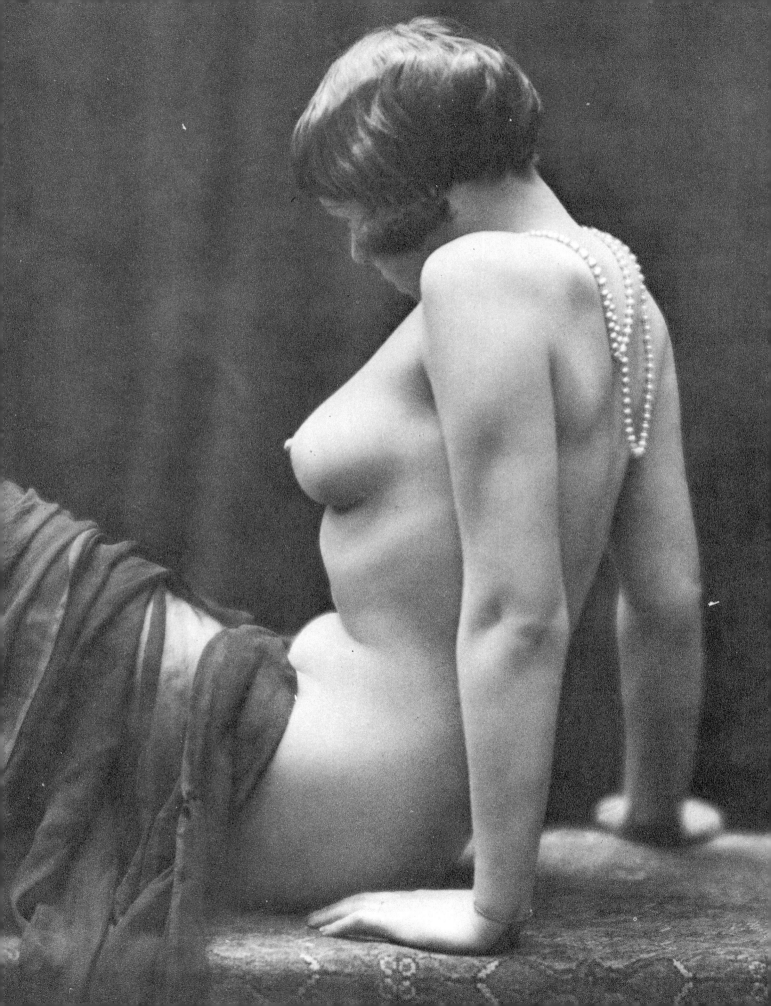

OOH – LA – LA! THE LADIES OF PARIS
FOREWORD

Firstly, you will all have noticed that the girl (opposite) accompanying this foreword is facing backward. But though backward, it is obvious that she is well forward. She comes, as do all the others in this book, from Paris. Five years ago I had never been to Paris. Now I go often; I go to search for the girls that fill the pages of this latest picture book. The ladies of Paris herein contained, I hasten to add, are not in any way representative of the *real* Paris girl – she is sharp, business-like with her hair cut at the back like a wedge of cheese. These girls – charming, naughty, comical and full of joie de vivre – are all made from the dreams of the Parisian artists who toiled at their easels and sketch-pads to provide illustrations for *La Vie Parisienne*, *Le Rire*, and other Parisian magazines in the Eighties, Nineties, and that glorious turn-of-the-century period. The golden Fin-de-Siècle (the very phrase reeks of romance, French perfume, and garlic) produced these delightful drawings and photographs – I merely pass them on to you to marvel over as I have done.

I'm so glad you're not going to miss them.

The words in this book are, in my opinion, of very little consequence. They are the paint on the lily, the gilt on the gingerbread. It is the pictures that matter.

You can read the book in an hour. But you can look at it for the rest of your life. I hope you will.

Ronnie Barker '83

Place Blanche

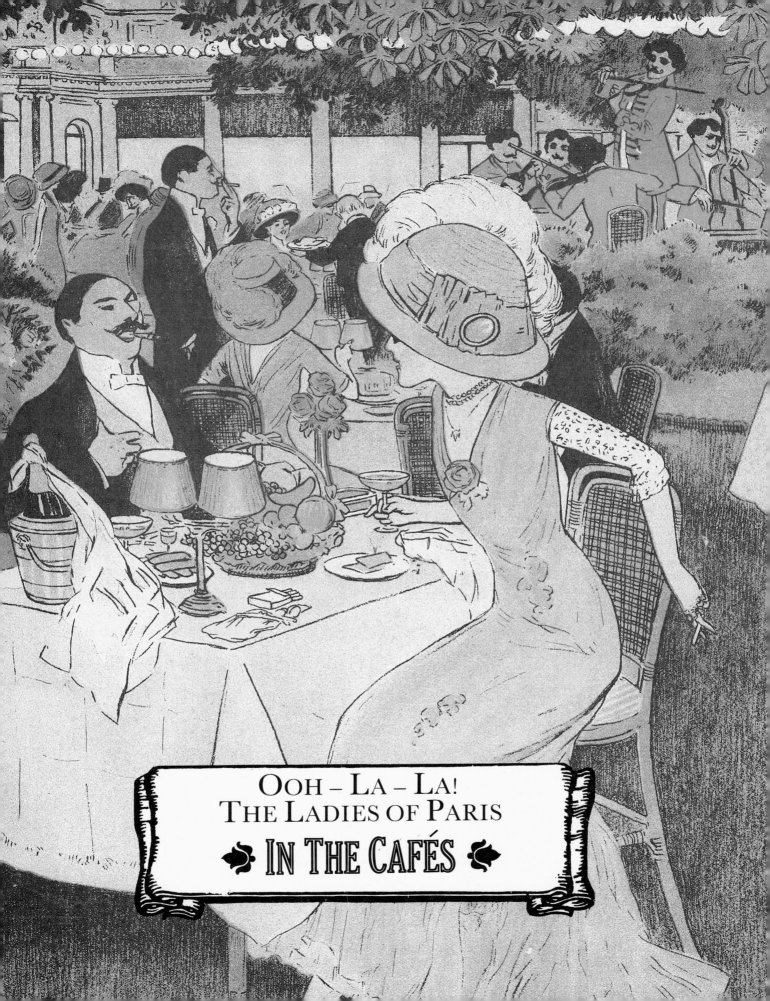

OOH – LA – LA!
THE LADIES OF PARIS
❧ IN THE CAFÉS ❧

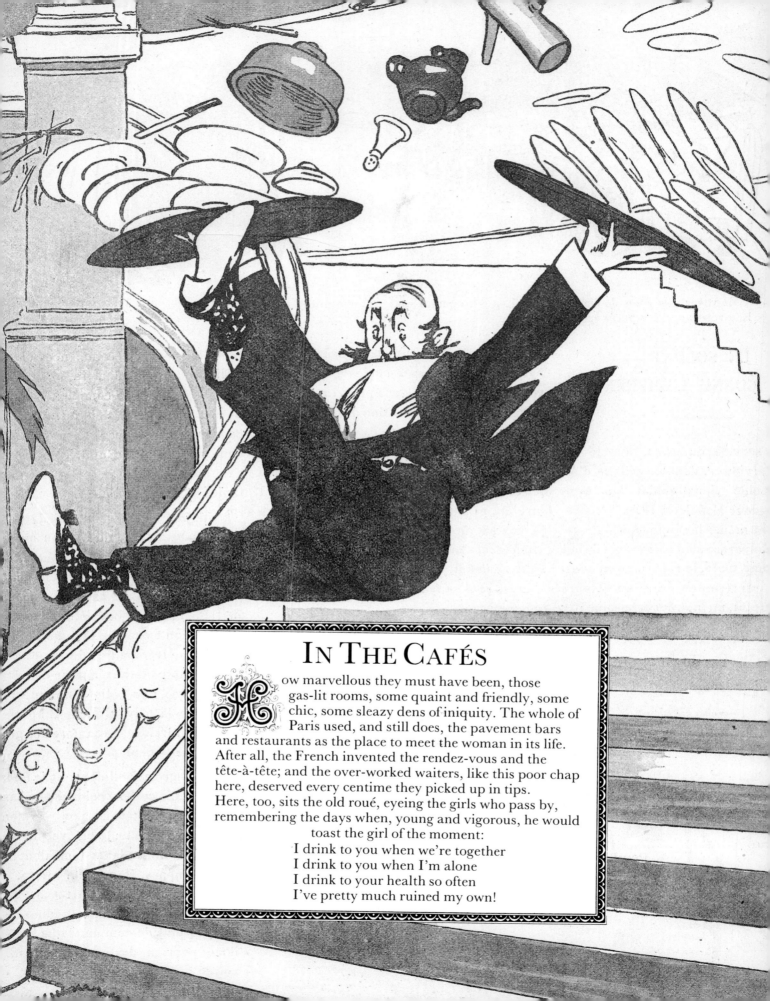

In The Cafés

How marvellous they must have been, those gas-lit rooms, some quaint and friendly, some chic, some sleazy dens of iniquity. The whole of Paris used, and still does, the pavement bars and restaurants as the place to meet the woman in its life. After all, the French invented the rendez-vous and the tête-à-tête; and the over-worked waiters, like this poor chap here, deserved every centime they picked up in tips.

Here, too, sits the old roué, eyeing the girls who pass by, remembering the days when, young and vigorous, he would toast the girl of the moment:

I drink to you when we're together
I drink to you when I'm alone
I drink to your health so often
I've pretty much ruined my own!

The young one: "What do you think of the cigar? A customer gave it to me."
The old one: "It's fine by me – I was gassed in the War, you know."

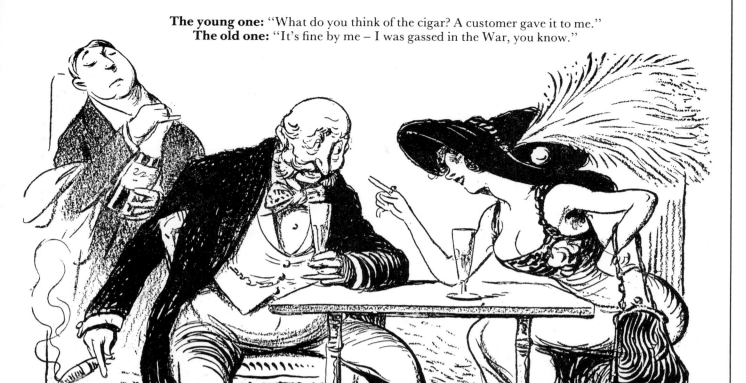

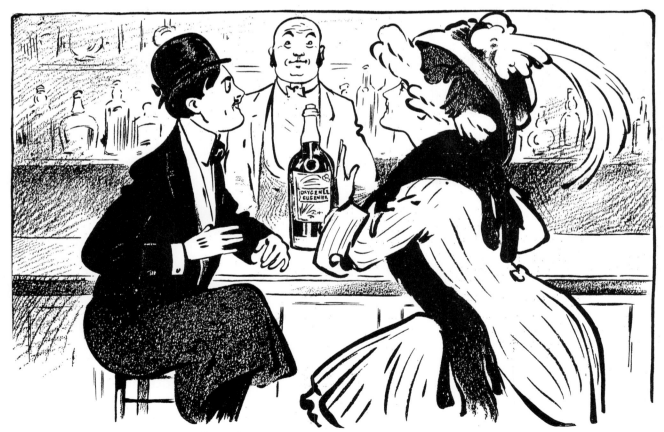

He: "One cocktail is all right. Two is too many."
She: "And three?"
He: "Ah! Three is not enough."

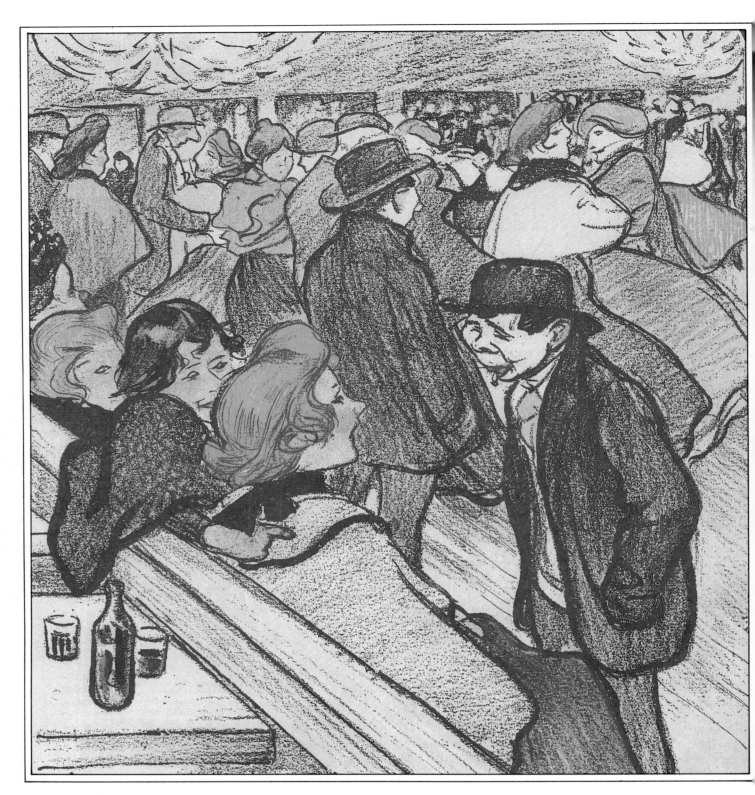

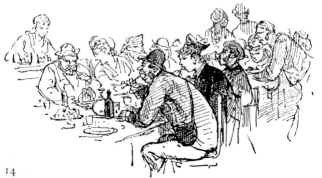

IN THE CAFÉS

He: "Would you like to dance with me?"
She: "No, monsieur, I would not!"
He: "Ah. May I say you have very good taste."

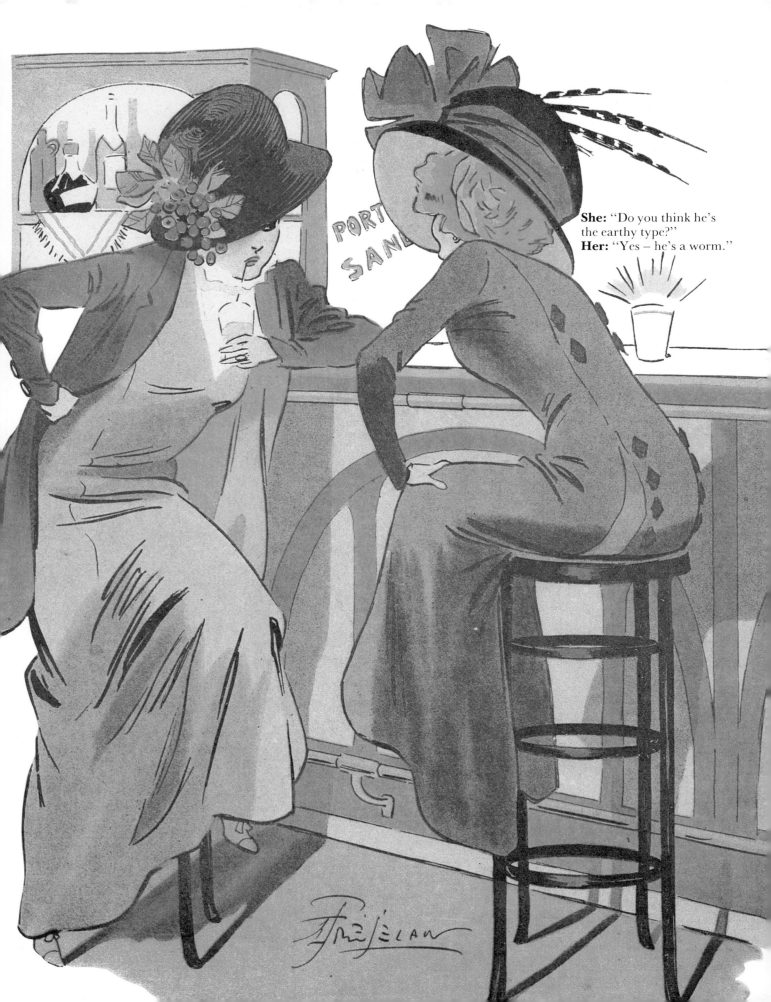

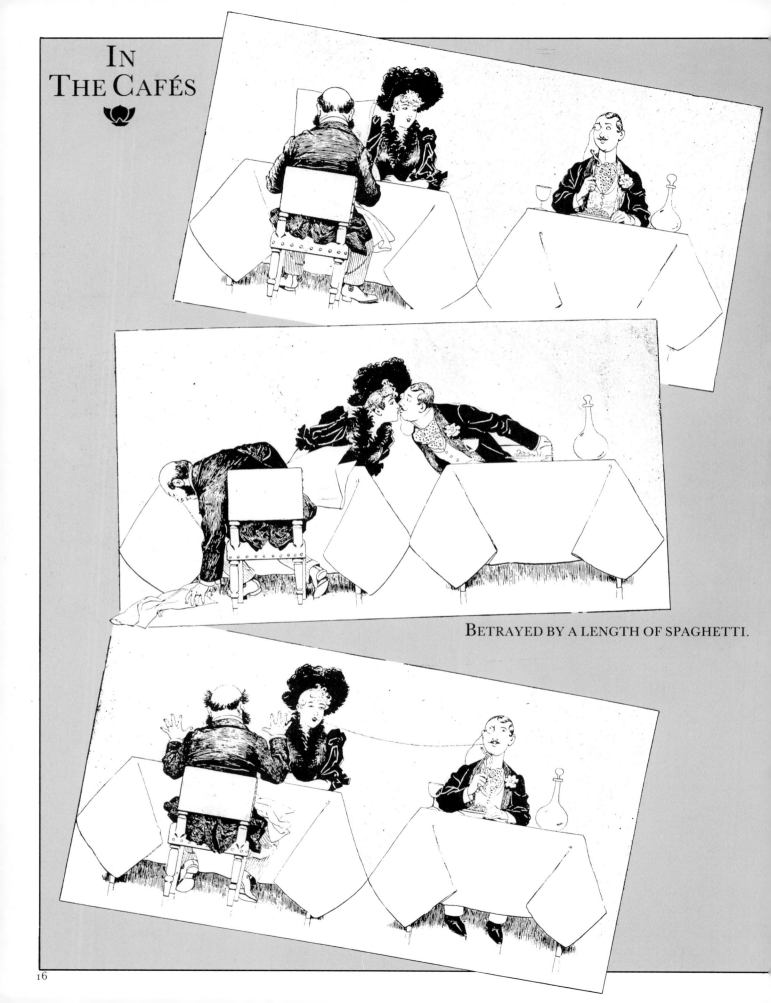

BETRAYED BY A LENGTH OF SPAGHETTI.

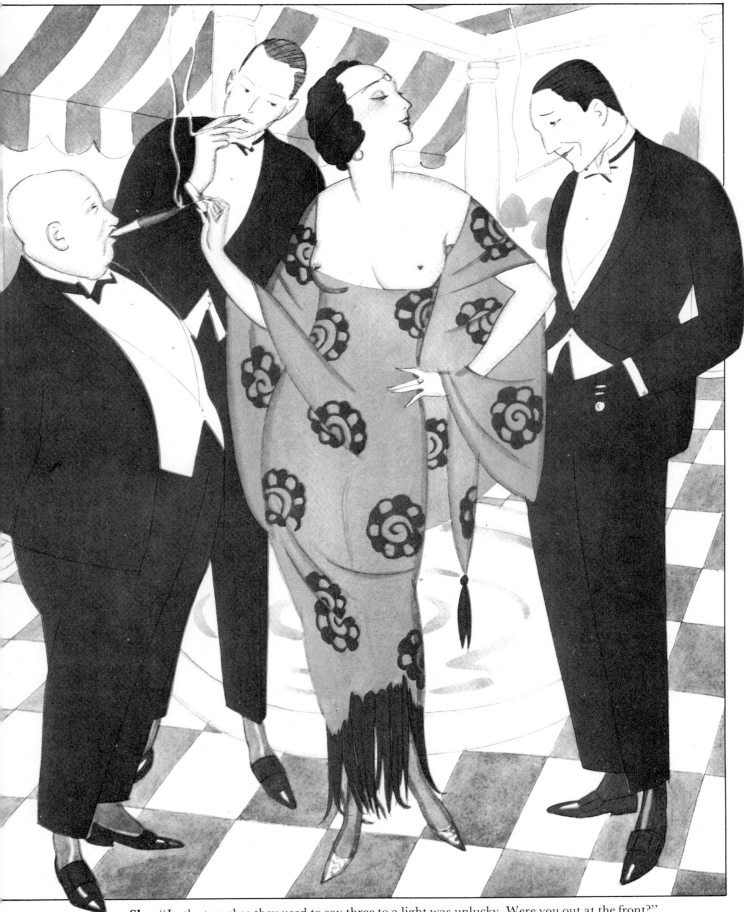

She: "In the trenches they used to say three to a light was unlucky. Were you out at the front?"
He: "Not as much as you, madame."

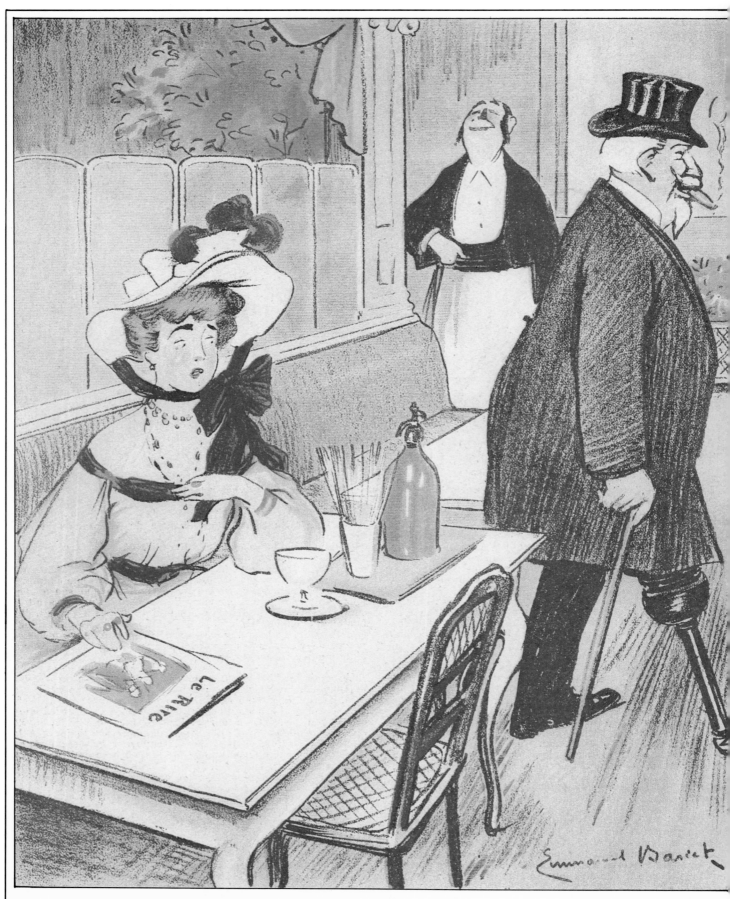

I thought it was the table-leg! I wonder if he sensed it?
I've spent the last half hour here, rubbing my knees against it!

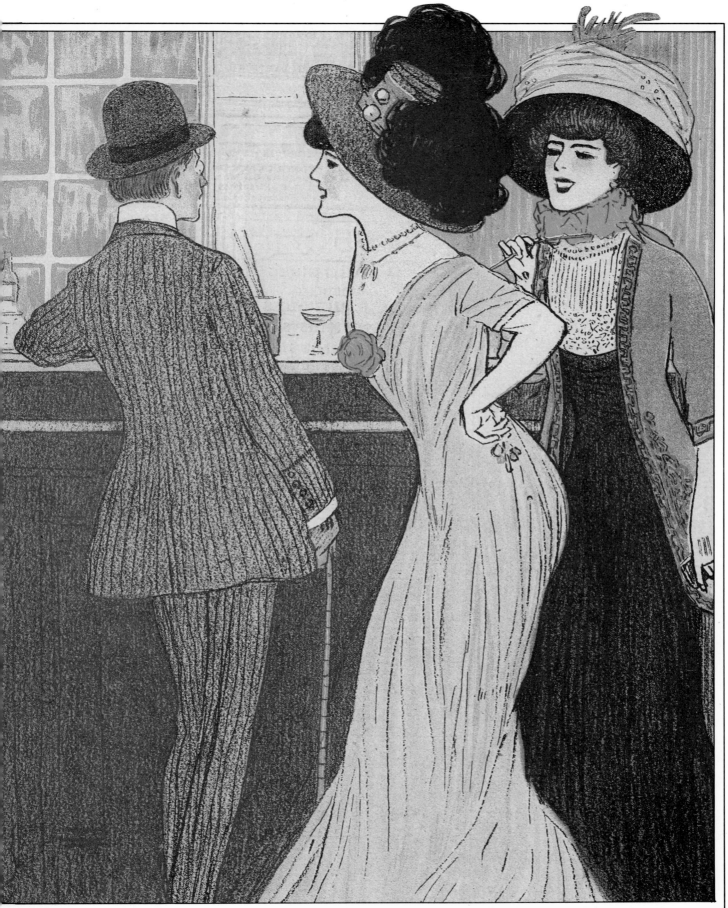

Delphine: "Drinking makes you handsome!"
Alphonse: "I haven't been drinking."
Delphine: "No, but I have."

IN THE CAFÉS

She: "Bored?"
He: "No – it's just that the front of your dress is yawning, and it's very catching."

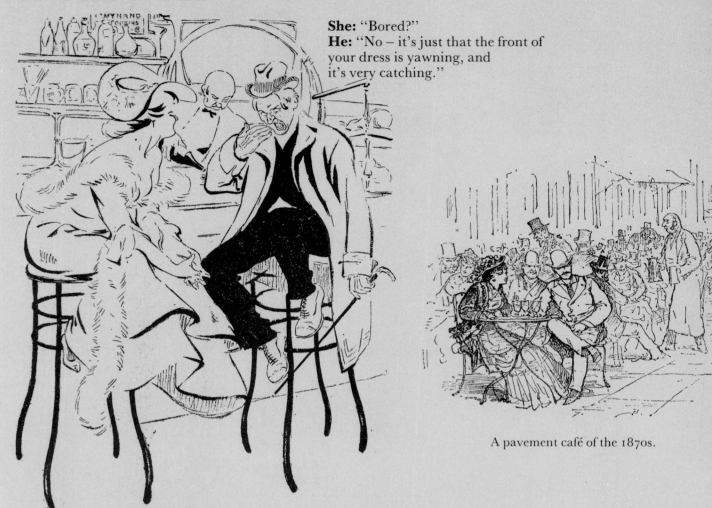

A pavement café of the 1870s.

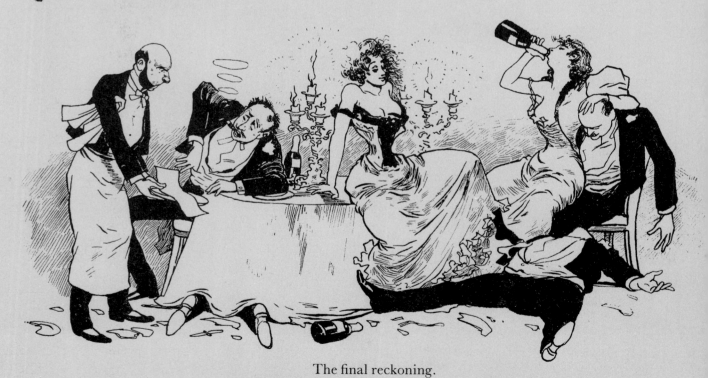

The final reckoning.

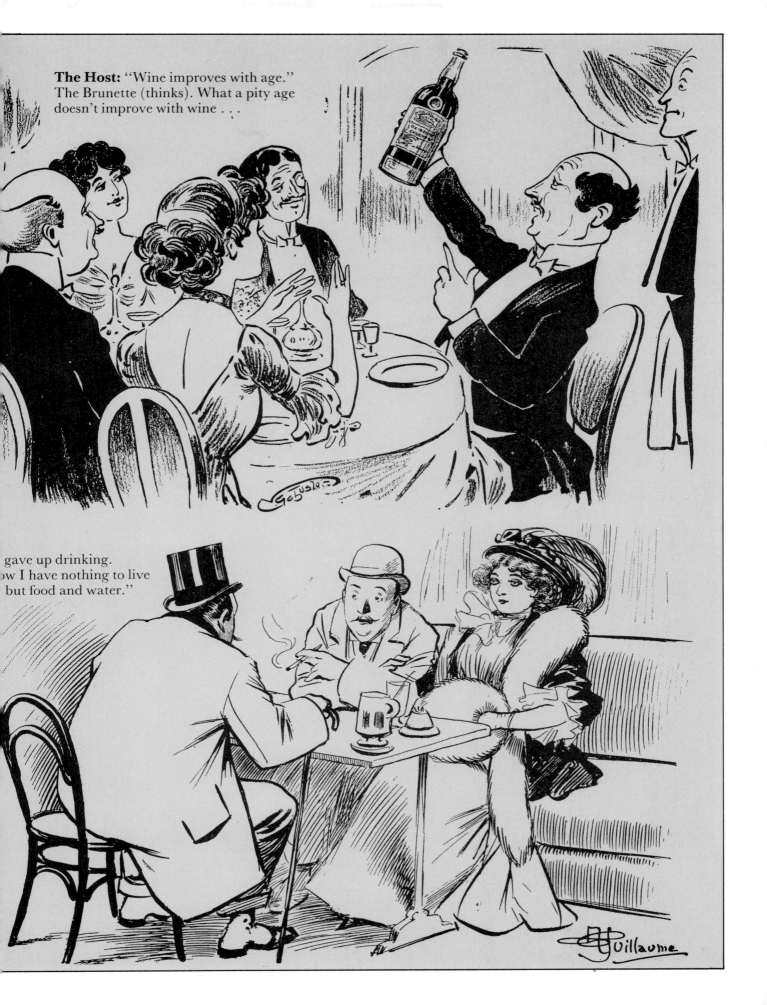

The Host: "Wine improves with age."
The Brunette (thinks). What a pity age
doesn't improve with wine . . .

gave up drinking.
ow I have nothing to live
but food and water."

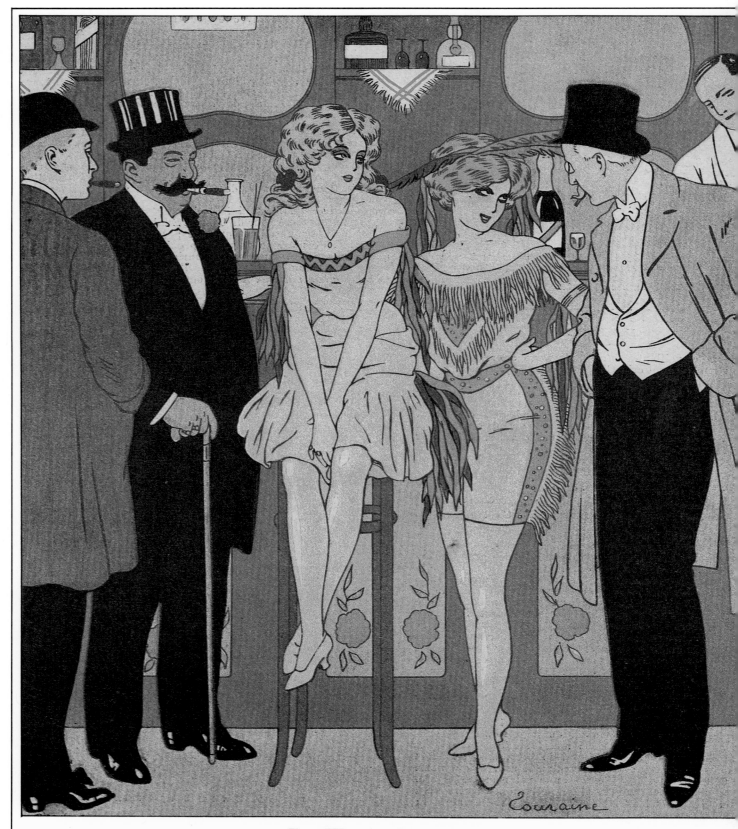

IN THE CAFÉS

The Monocle: "What do you do, my dears?"
The Redhead: "We are in the cabaret, monsieur."
The Monocle: "Musicians, eh? I read somewhere that Orpheus was such a good musician that when he played the trees and stones moved."
The Redhead: "That's nothing. When my sister here was learning to play the piano, the whole family next door moved."

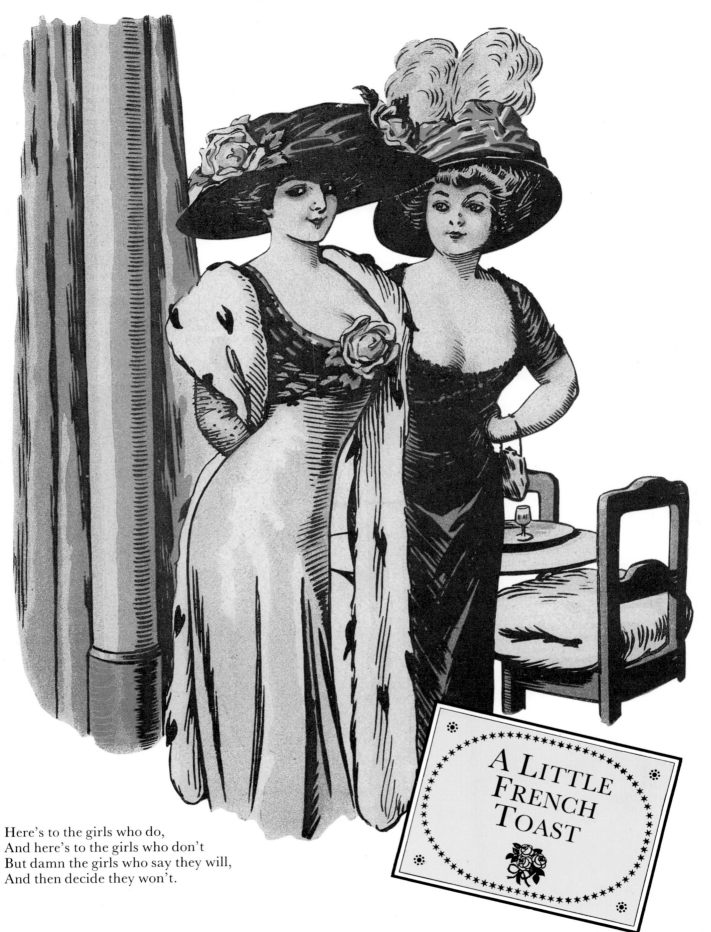

Here's to the girls who do,
And here's to the girls who don't
But damn the girls who say they will,
And then decide they won't.

A LITTLE
FRENCH
TOAST

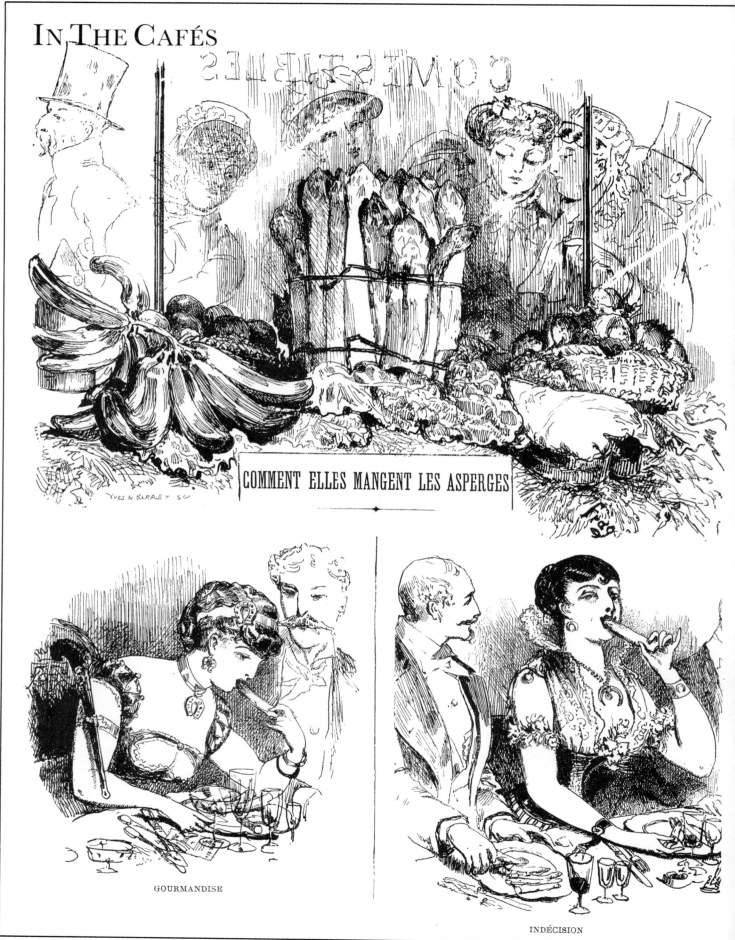

COMMENT ELLES MANGENT LES ASPERGES

GOURMANDISE

INDÉCISION

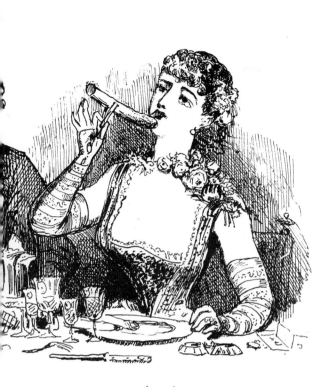

DES MANIÈRES !

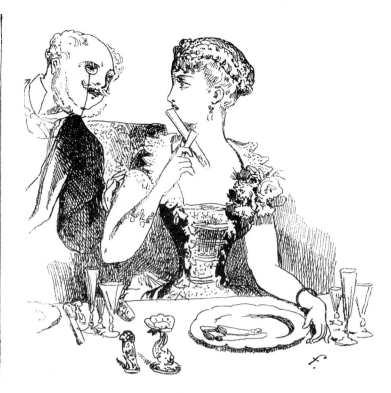

IGNORANCE

INGÉNUITÉ

SANS FAÇON

In 1879, this particular set of drawings, entitled "How they eat their asparagus", caused considerable comment when they appeared in *La Vie Parisienne*. Yet, some forty years later, no one turned a hair at the saucy "Plats-du-Jour" featured on the next page . . .

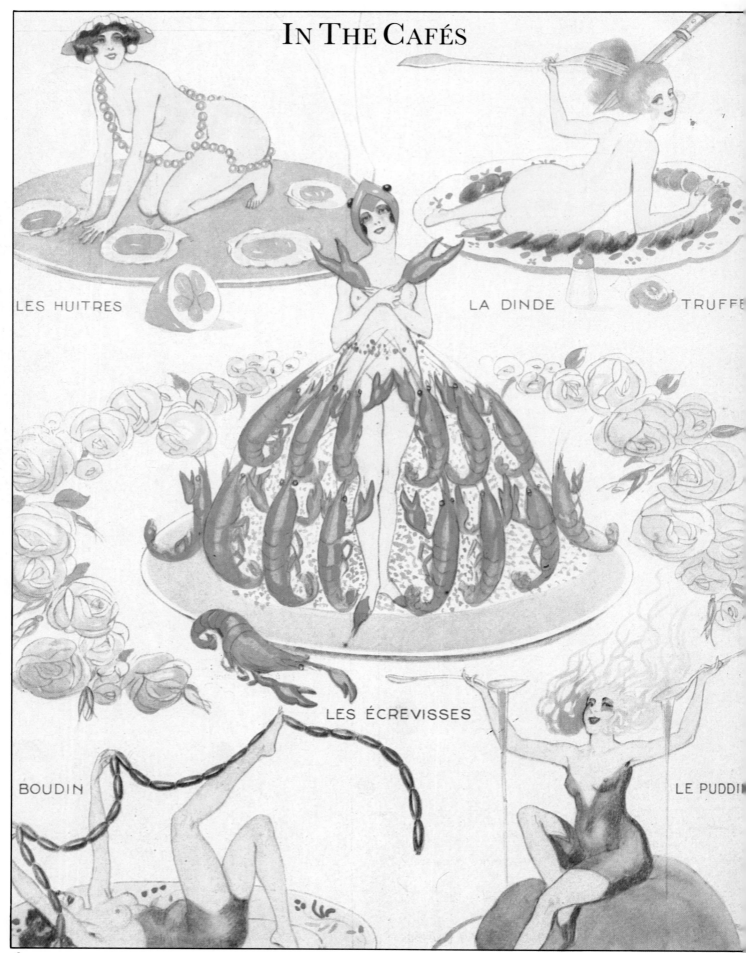

LES HUITRES

LA DINDE

TRUFFE

LES ÉCREVISSES

BOUDIN

LE PUDDI

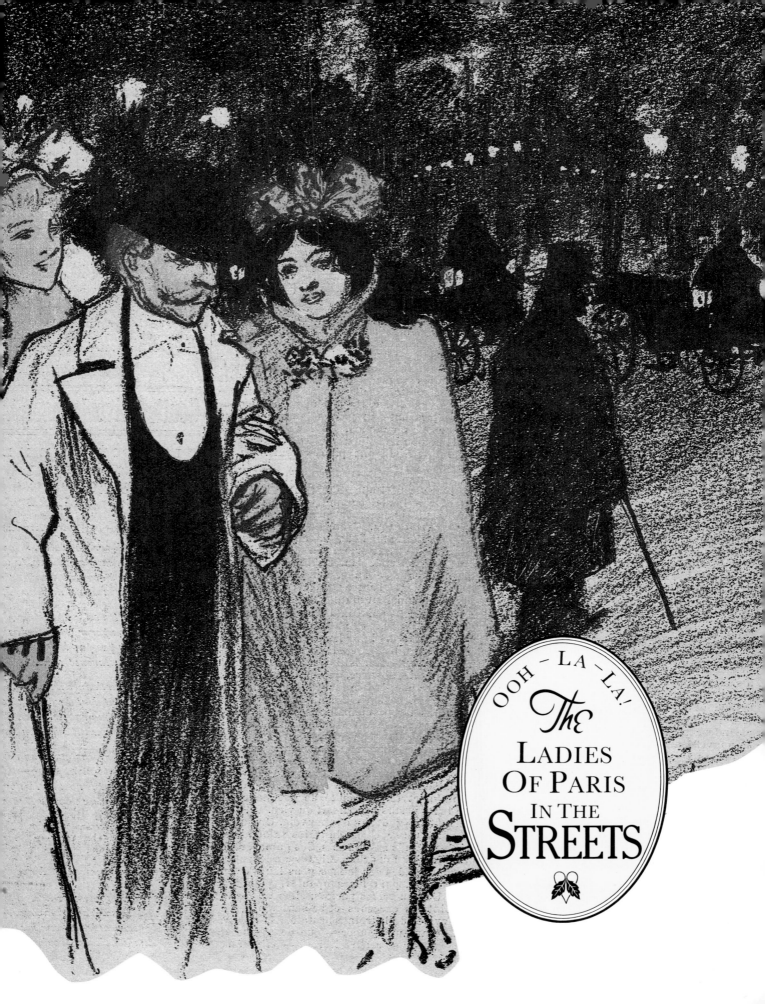

OOH - LA - LA!
The
LADIES
OF PARIS
IN THE
STREETS

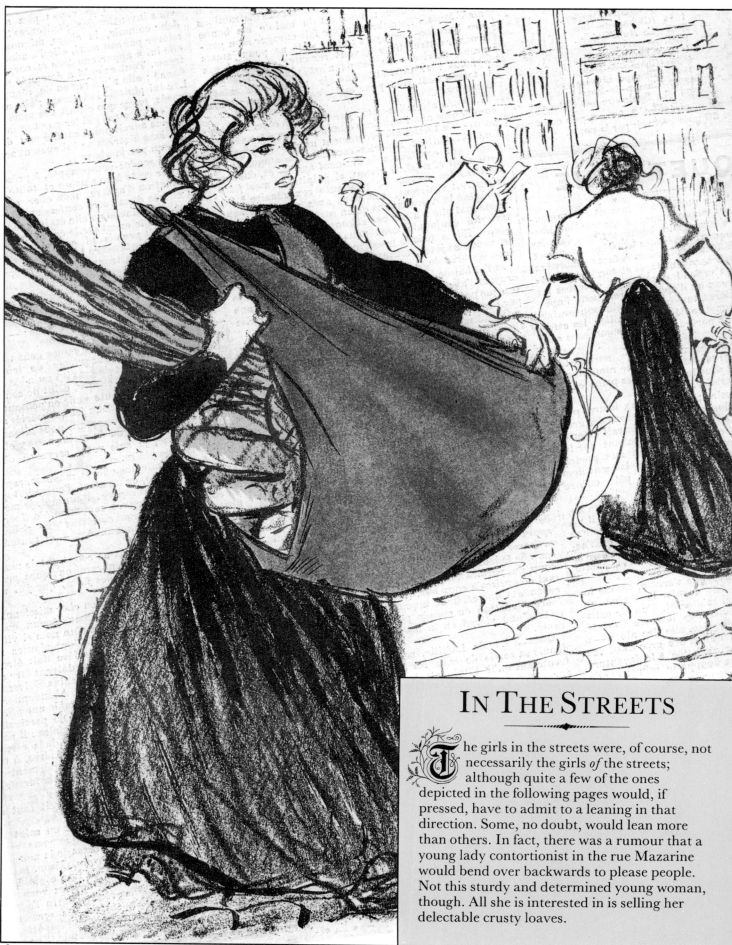

IN THE STREETS

The girls in the streets were, of course, not necessarily the girls *of* the streets; although quite a few of the ones depicted in the following pages would, if pressed, have to admit to a leaning in that direction. Some, no doubt, would lean more than others. In fact, there was a rumour that a young lady contortionist in the rue Mazarine would bend over backwards to please people. Not this sturdy and determined young woman, though. All she is interested in is selling her delectable crusty loaves.

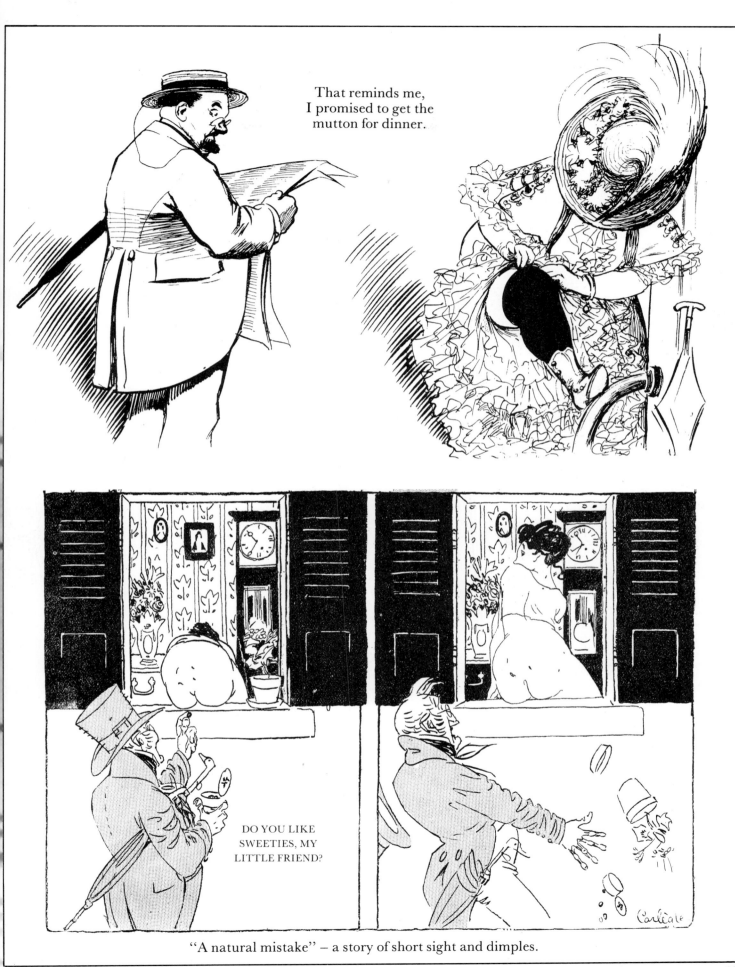

"A natural mistake" – a story of short sight and dimples.

In The Streets

"Tell me, my good man, am I right for the zoo?"
"You look just about right to me, monsieur."

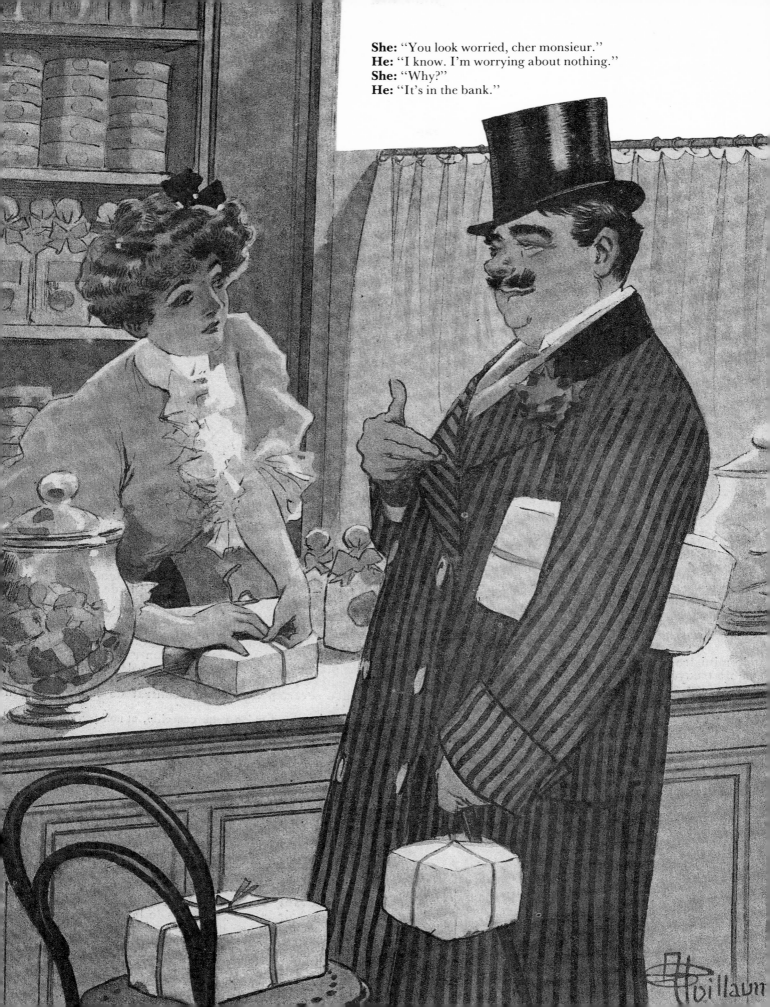

She: "You look worried, cher monsieur."
He: "I know. I'm worrying about nothing."
She: "Why?"
He: "It's in the bank."

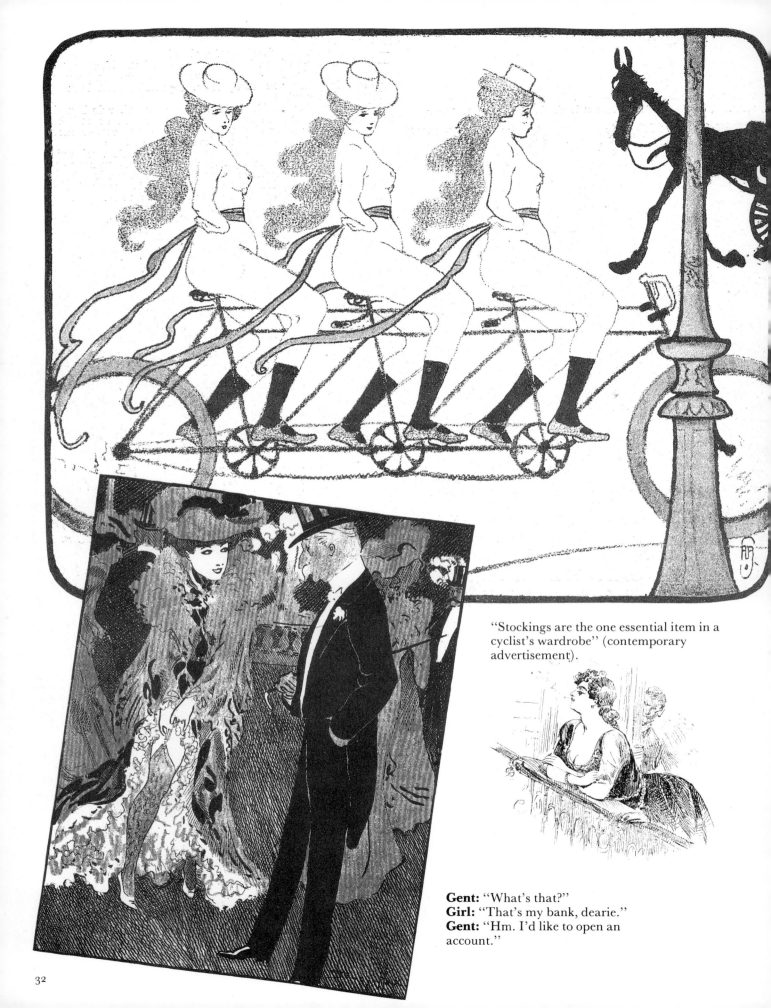

"Stockings are the one essential item in a cyclist's wardrobe" (contemporary advertisement).

Gent: "What's that?"
Girl: "That's my bank, dearie."
Gent: "Hm. I'd like to open an account."

Black Hat: "I dreamed I was walking down the Boulevard des Capucines with nothing on but a pair of shoes."
Yellow Hat: "Weren't you embarrassed?"
Black Hat: "I certainly was. One was black and the other brown!"

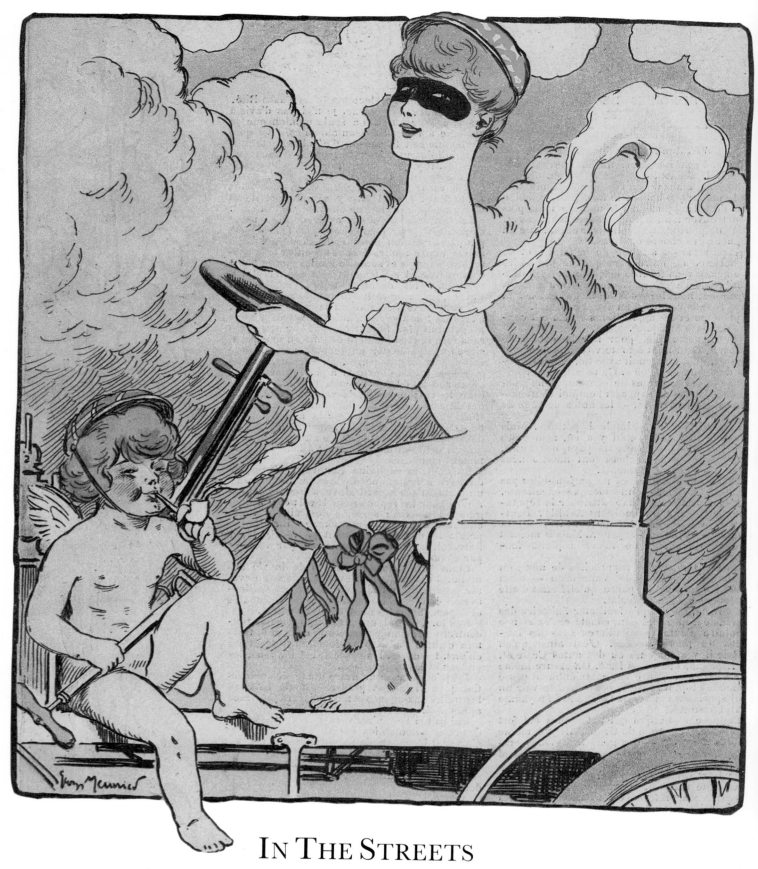

In The Streets

In the streets means, of course, on the roads as well, and the growing popularity of the motor-car led to artist's fantasies such as this, and (opposite page) a sort of dress-yourself doll, together with outfits of various styles, and for various climes.

IN THE STREETS

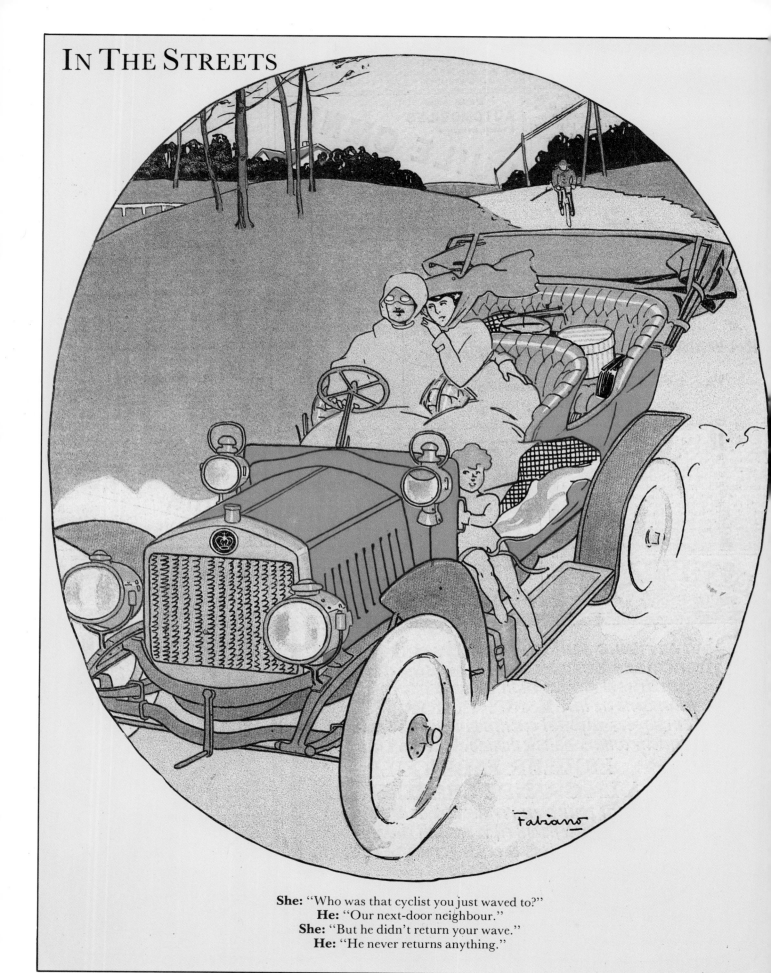

She: "Who was that cyclist you just waved to?"
He: "Our next-door neighbour."
She: "But he didn't return your wave."
He: "He never returns anything."

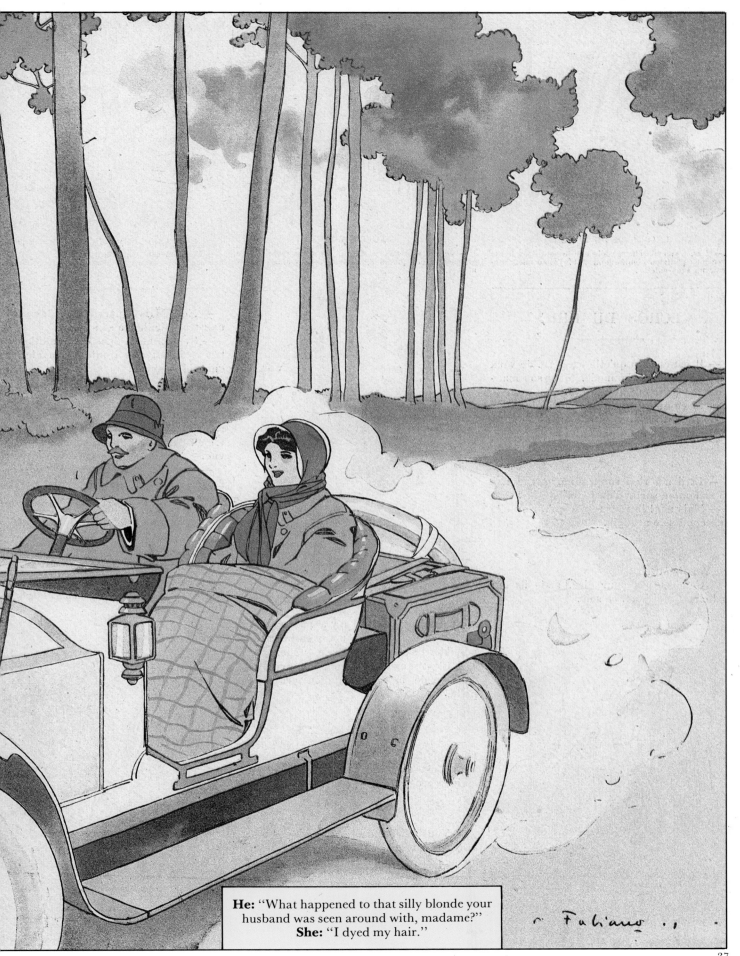

He: "What happened to that silly blonde your husband was seen around with, madame?"
She: "I dyed my hair."

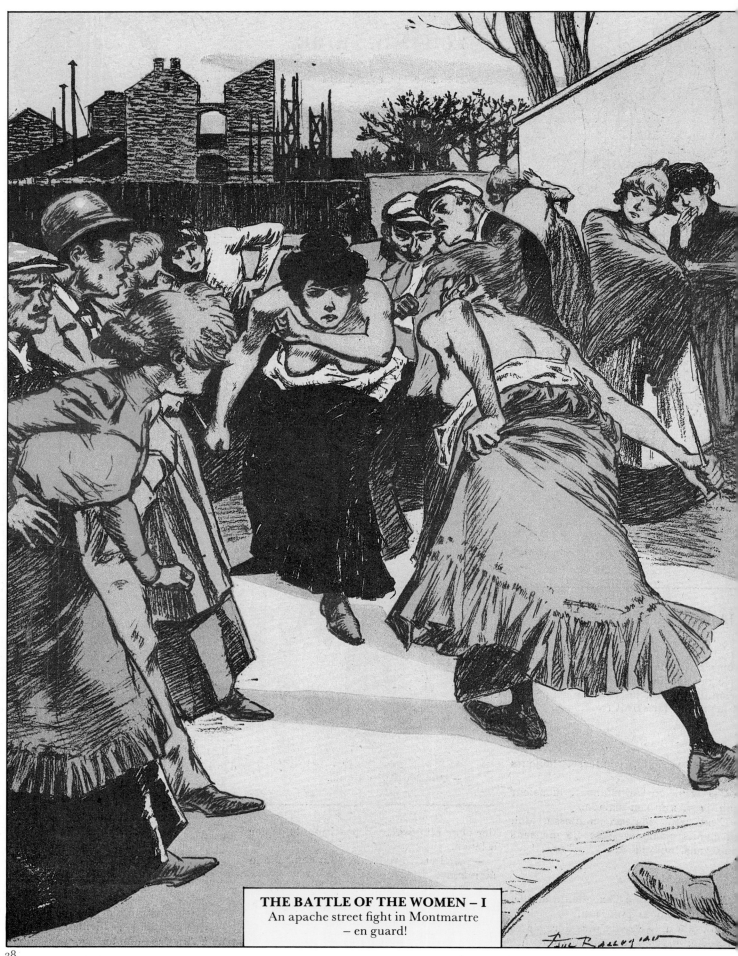

THE BATTLE OF THE WOMEN – I
An apache street fight in Montmartre
– en guard!

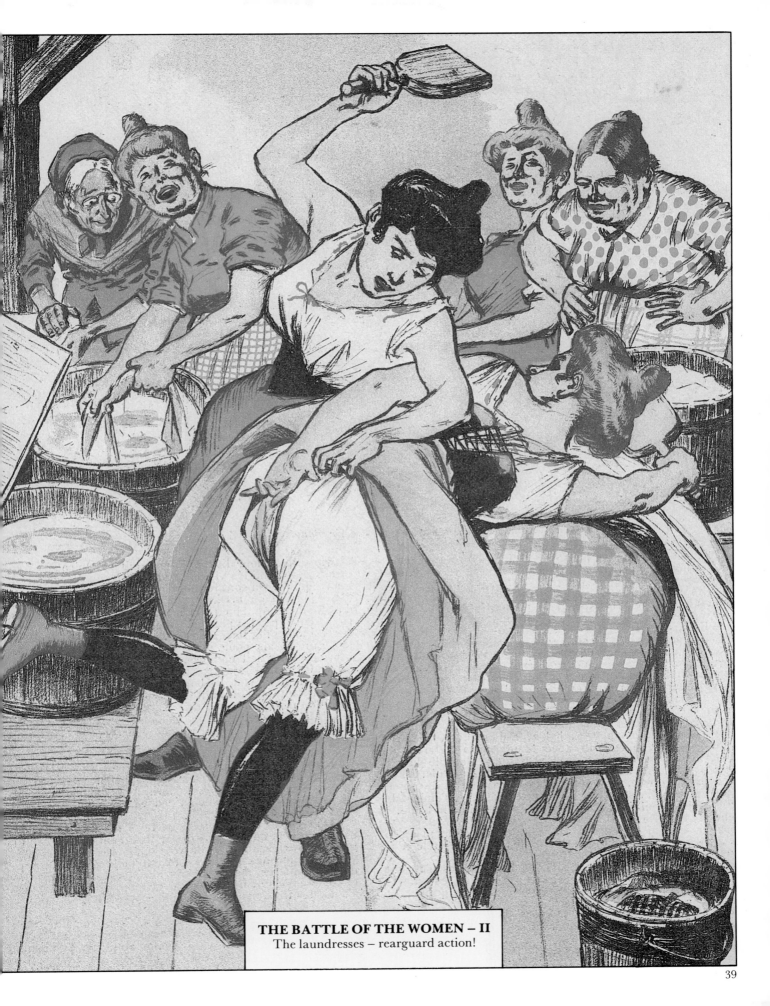

THE BATTLE OF THE WOMEN – II
The laundresses – rearguard action!

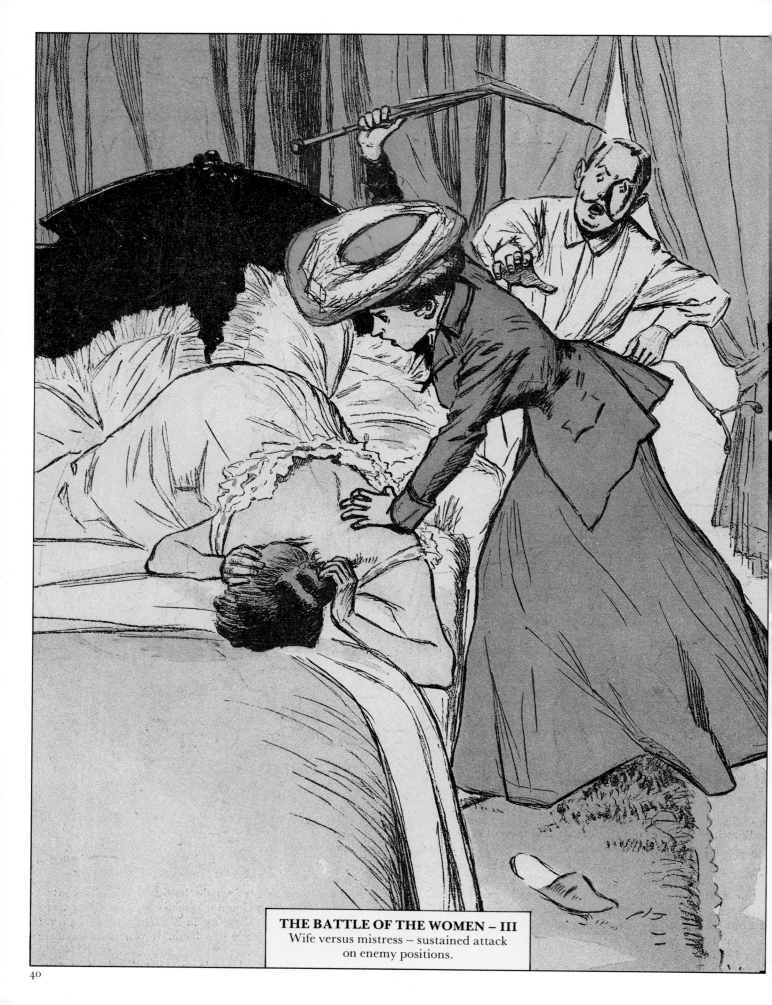

THE BATTLE OF THE WOMEN – III
Wife versus mistress – sustained attack
on enemy positions.

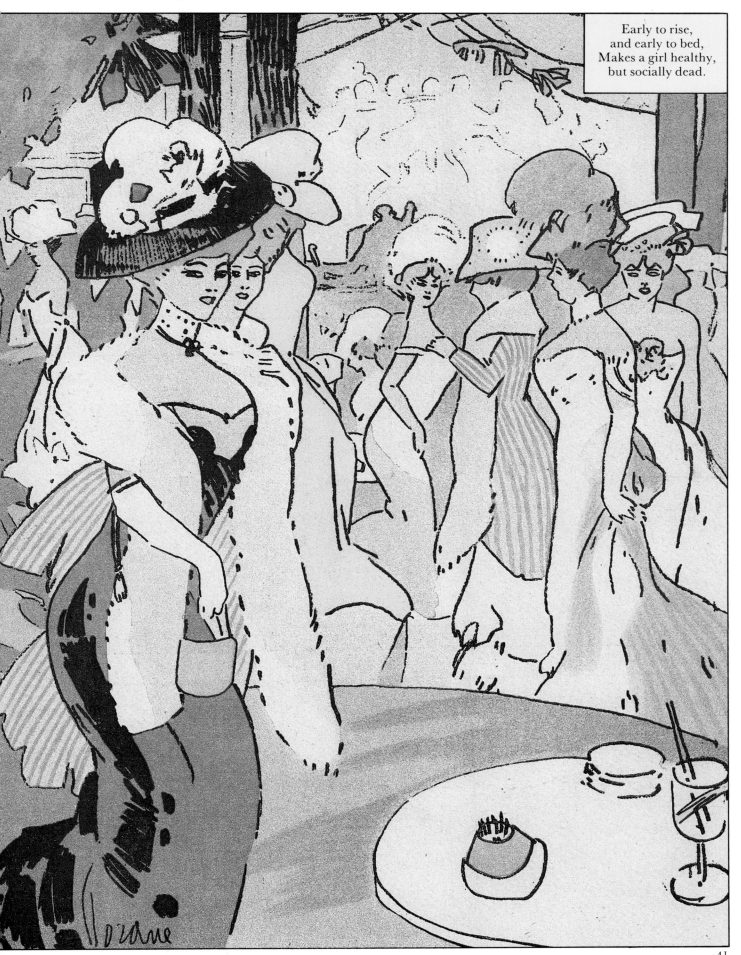

Early to rise,
and early to bed,
Makes a girl healthy,
but socially dead.

IN THE STREETS

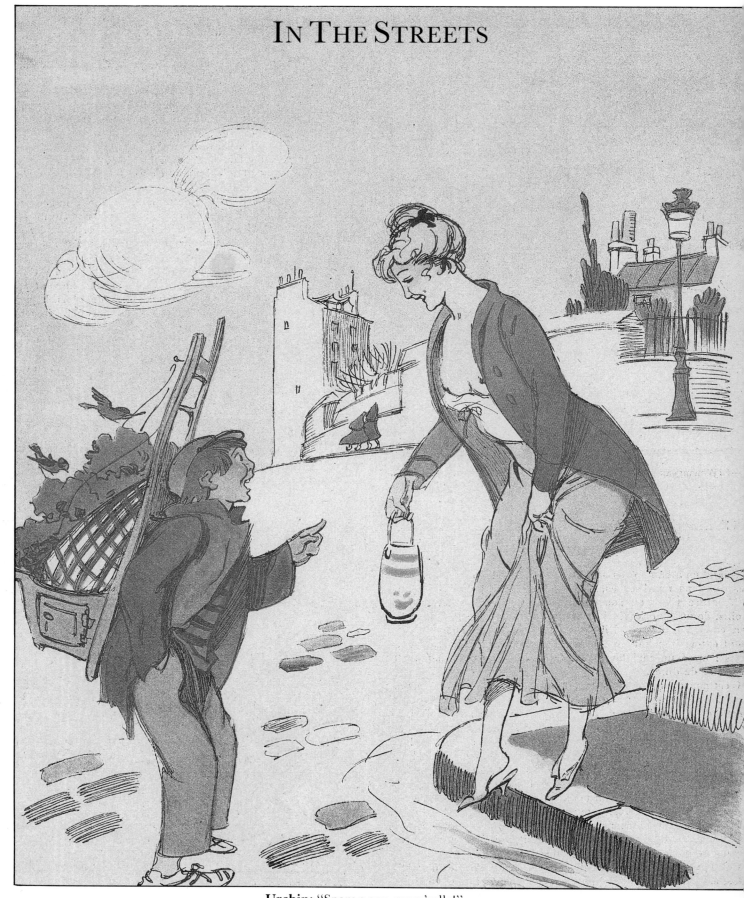

Urchin: "Spare a sou, mam'selle!"
She: "I can't give you anything – charity begins at home."
Urchin: "I'll go home with you!"

Ooh-La-La! The Ladies Of Paris

In The Parks And In The Country

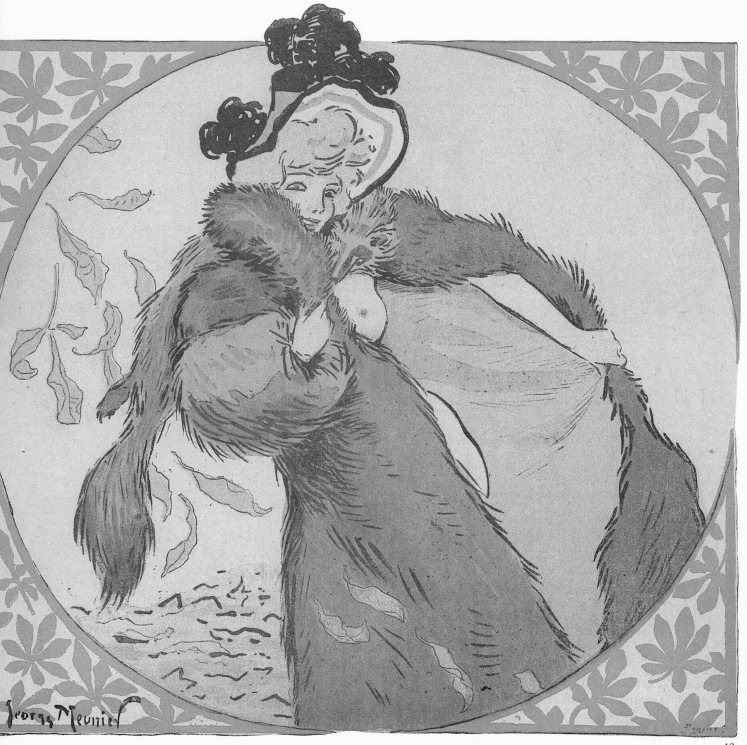

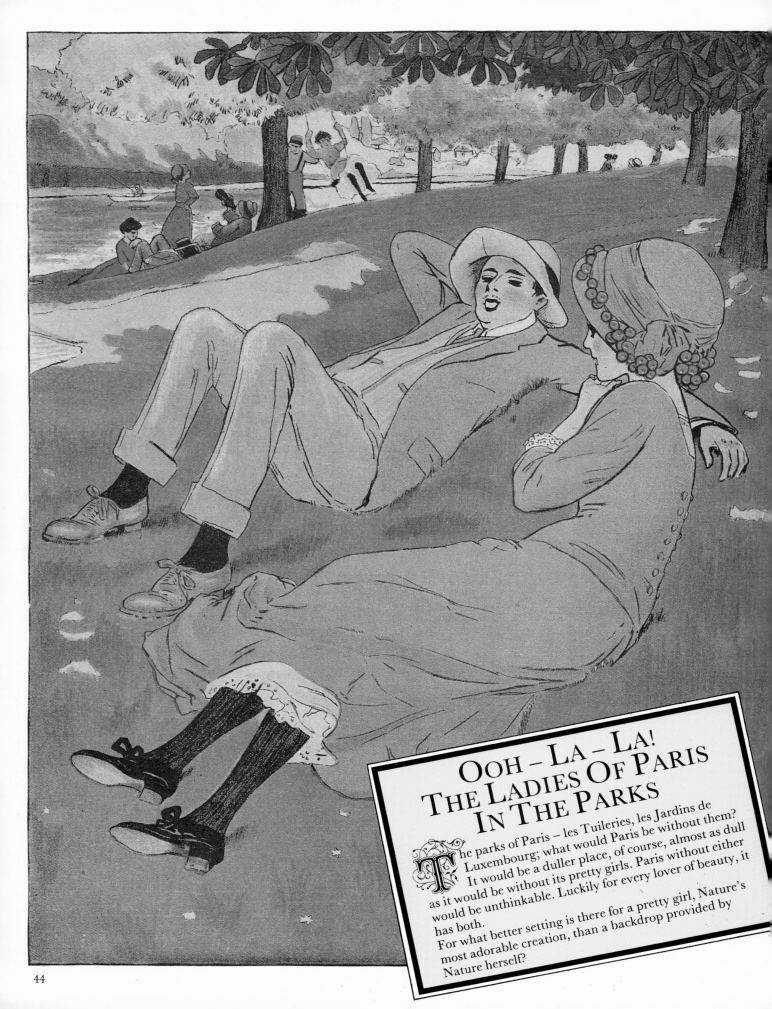

Ooh – La – La!
The Ladies Of Paris In The Parks

The parks of Paris – les Tuileries, les Jardins de Luxembourg; what would Paris be without them? It would be a duller place, of course, almost as dull as it would be without its pretty girls. Paris without either would be unthinkable. Luckily for every lover of beauty, it has both.

For what better setting is there for a pretty girl, Nature's most adorable creation, than a backdrop provided by Nature herself?

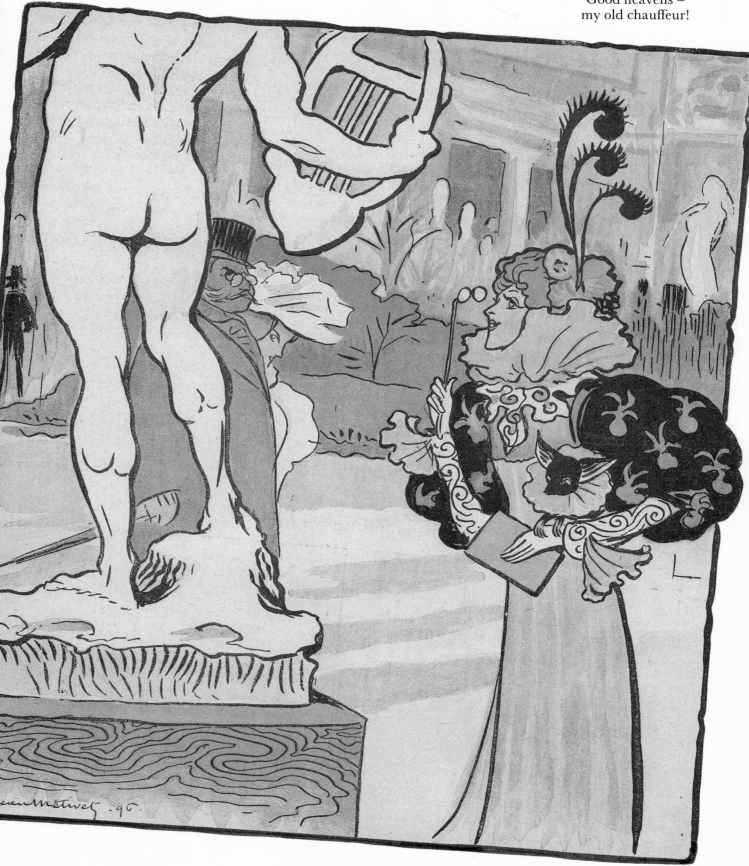

Good heavens –
my old chauffeur!

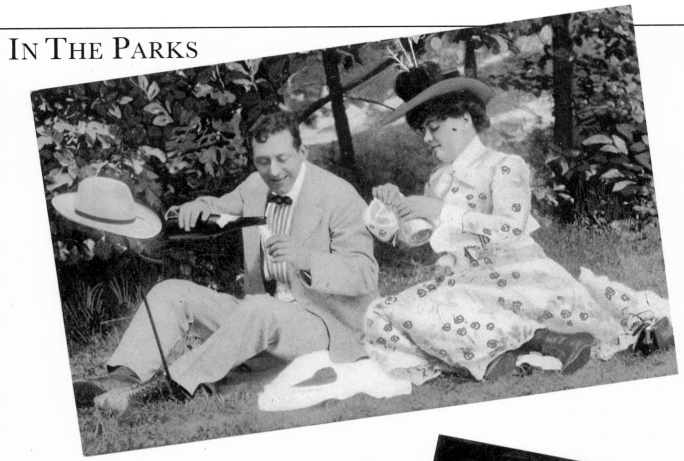

"Albert, could you love me for ever?"
"I'm afraid not, chérie – I promised to
be home by six."

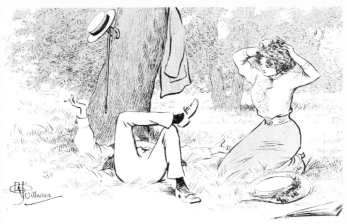

"Do you believe in love at
first sight?"
"No – I believe in love at the
first opportunity."

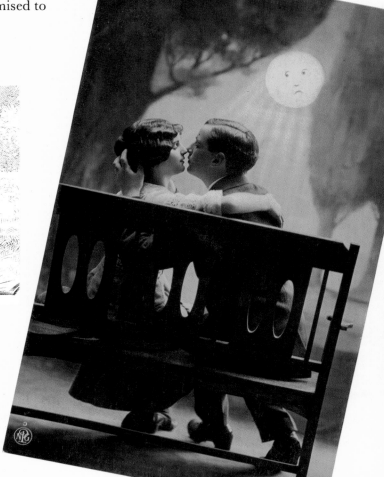

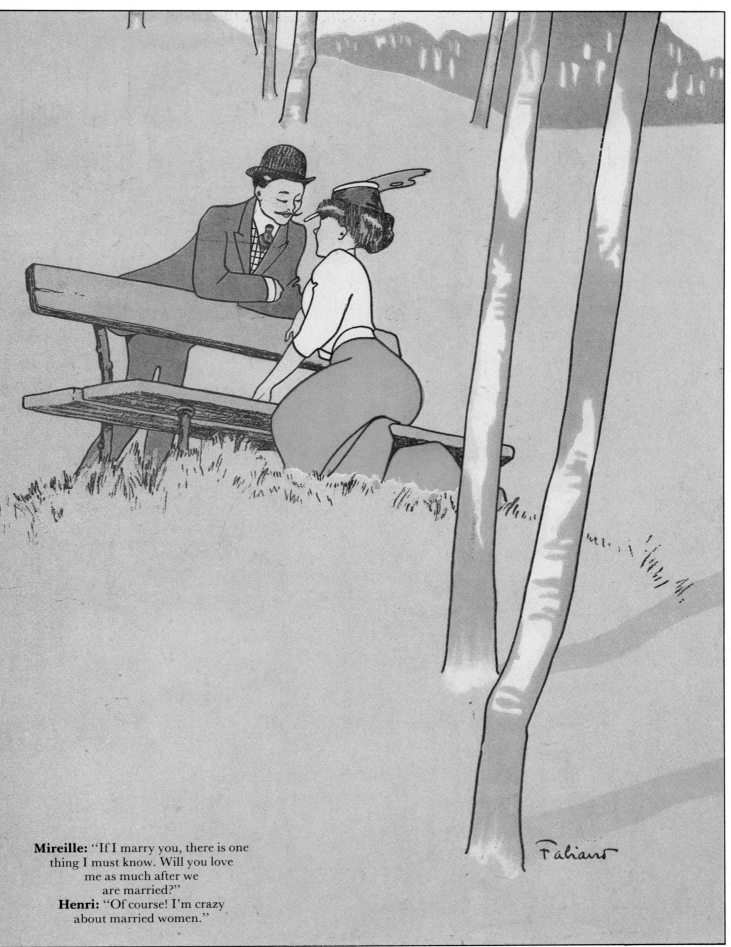

Mireille: "If I marry you, there is one thing I must know. Will you love me as much after we are married?"

Henri: "Of course! I'm crazy about married women."

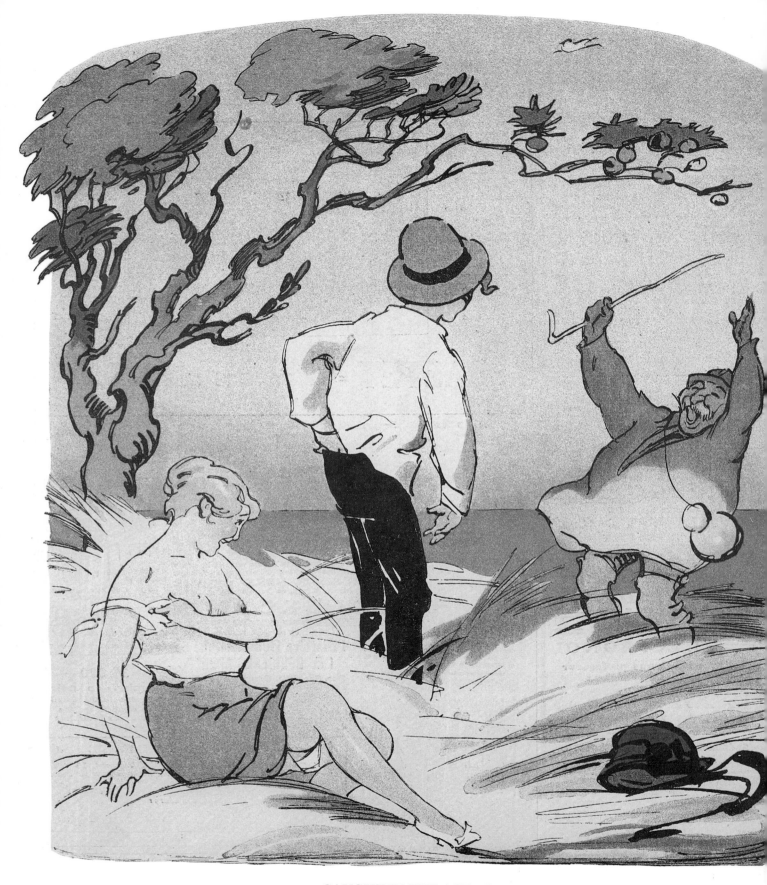

CAUGHT IN THE ACT – I
Old man: "Don't worry, monsieur. I understand.
Gentlemen prefer blondes, n'est-ce pas?"
Young beauty: "But I'm not really a blonde!"
Old man: "That's all right – your friend isn't really a
gentleman."

CAUGHT IN THE ACT – II
"That's my daughter you've got in there, sir!
Are your intentions honourable or dishonourable?"

"You mean I have a choice?"

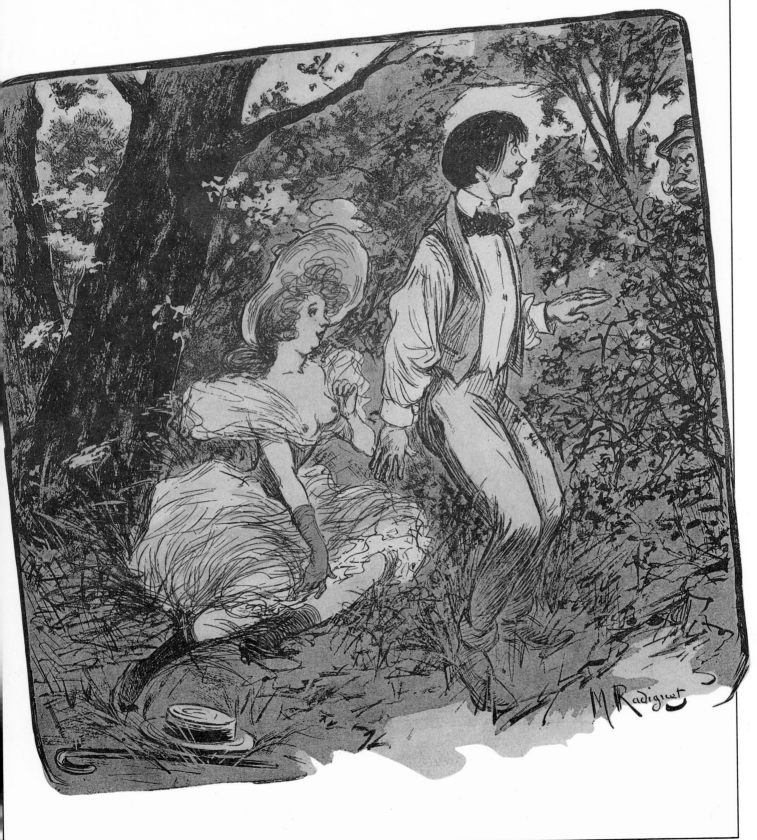

THE
BILLIARD PLAYER'S
DREAM . . .

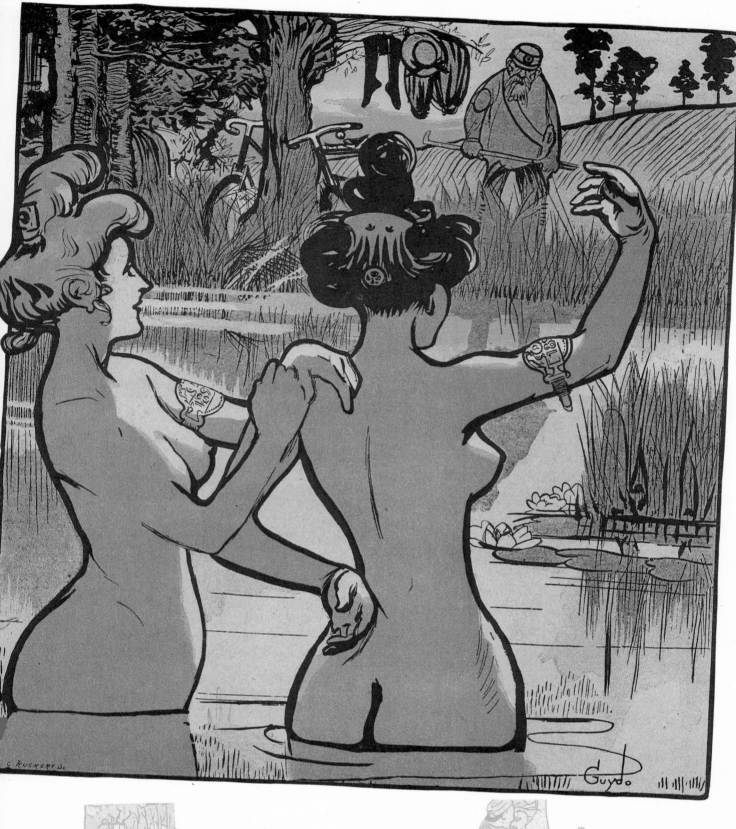

The park keeper's nightmare.

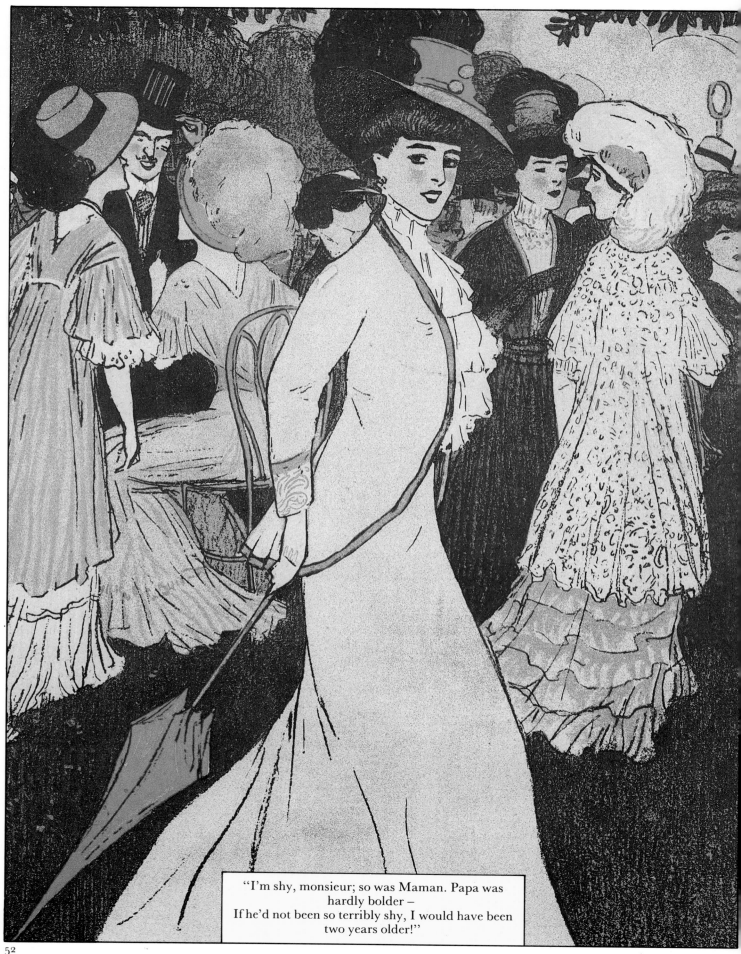

"I'm shy, monsieur; so was Maman. Papa was
hardly bolder –
If he'd not been so terribly shy, I would have been
two years older!"

Ooh-La-La! The Ladies Of Paris
In The Artist's Studio

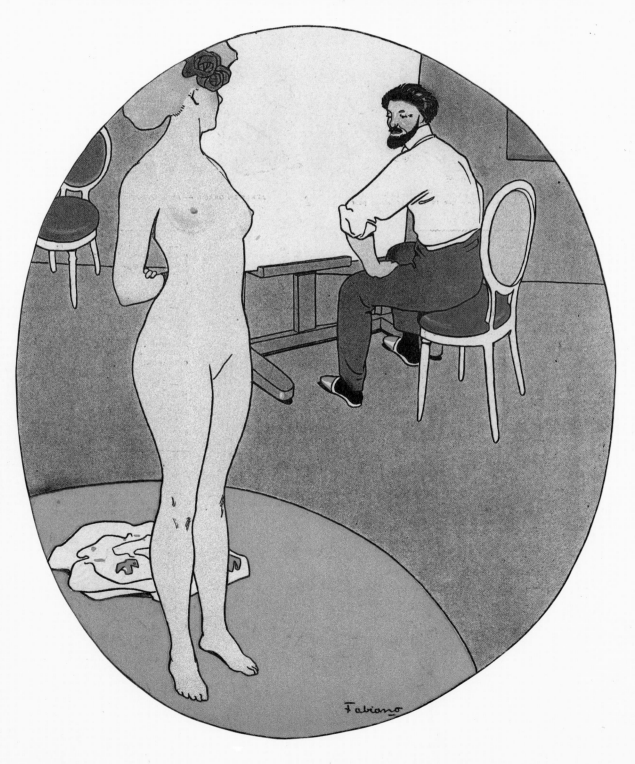

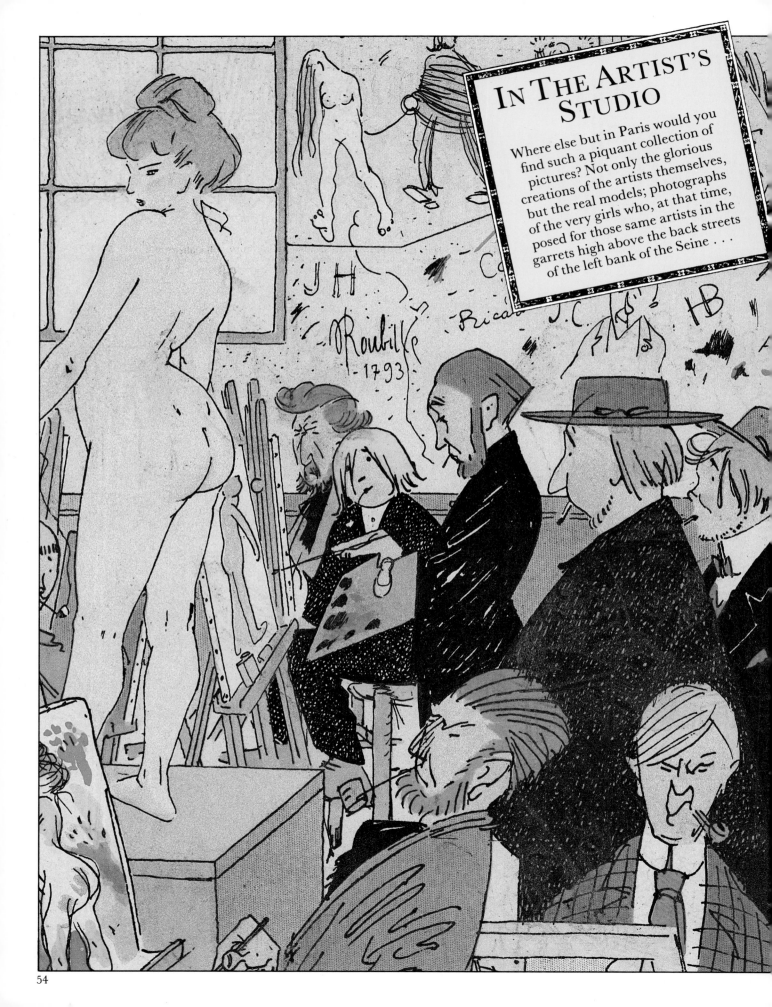

IN THE ARTIST'S STUDIO

Where else but in Paris would you find such a piquant collection of pictures? Not only the glorious creations of the artists themselves, but the real models; photographs of the very girls who, at that time, posed for those same artists in the garrets high above the back streets of the left bank of the Seine . . .

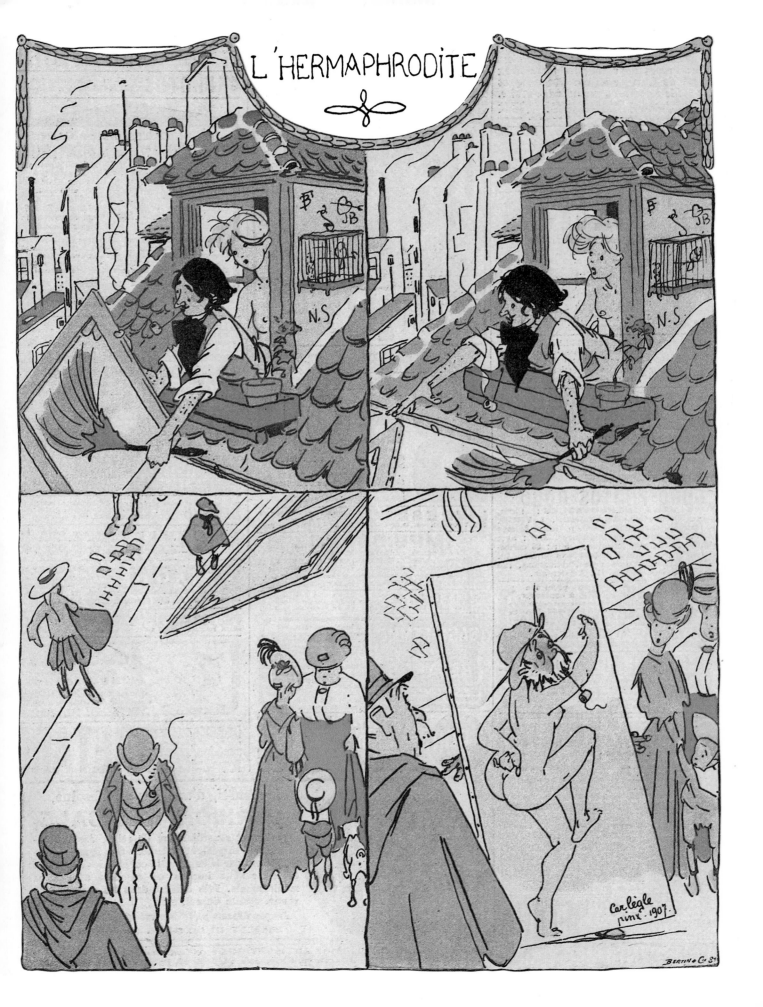

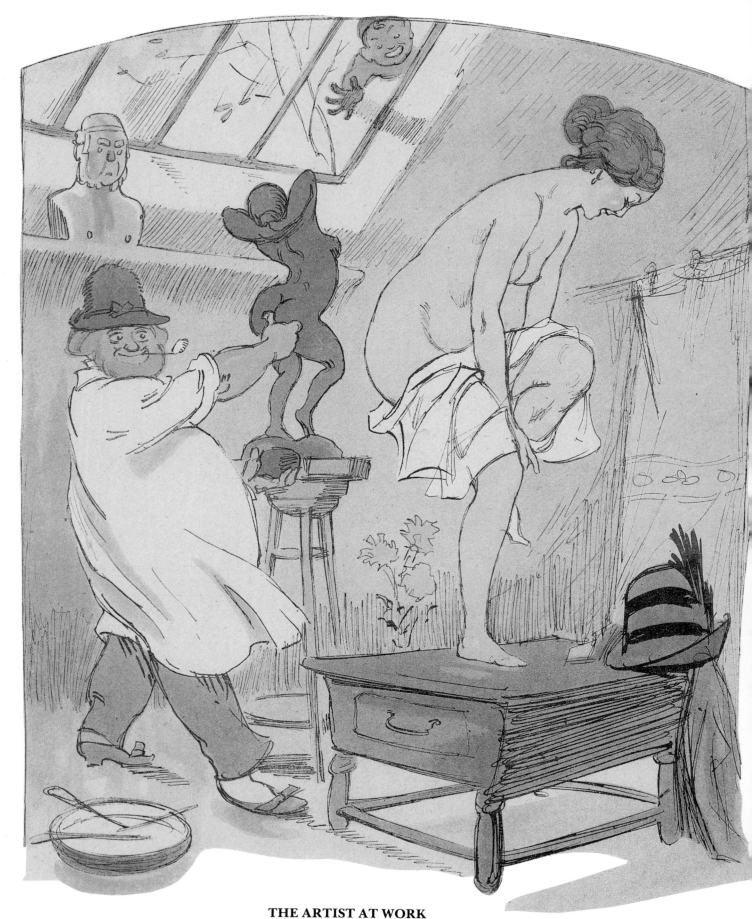

THE ARTIST AT WORK
"Please put your hat back on – I promised the
landlady I wouldn't have any nudes posing in
here."

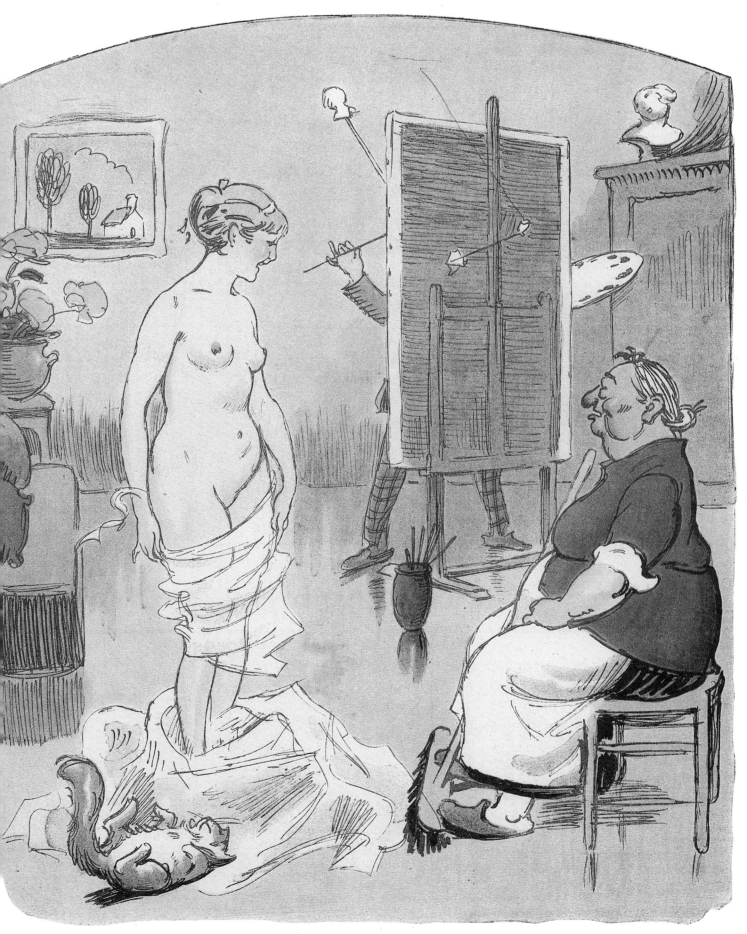

"A curved line – the loveliest distance
between two points."

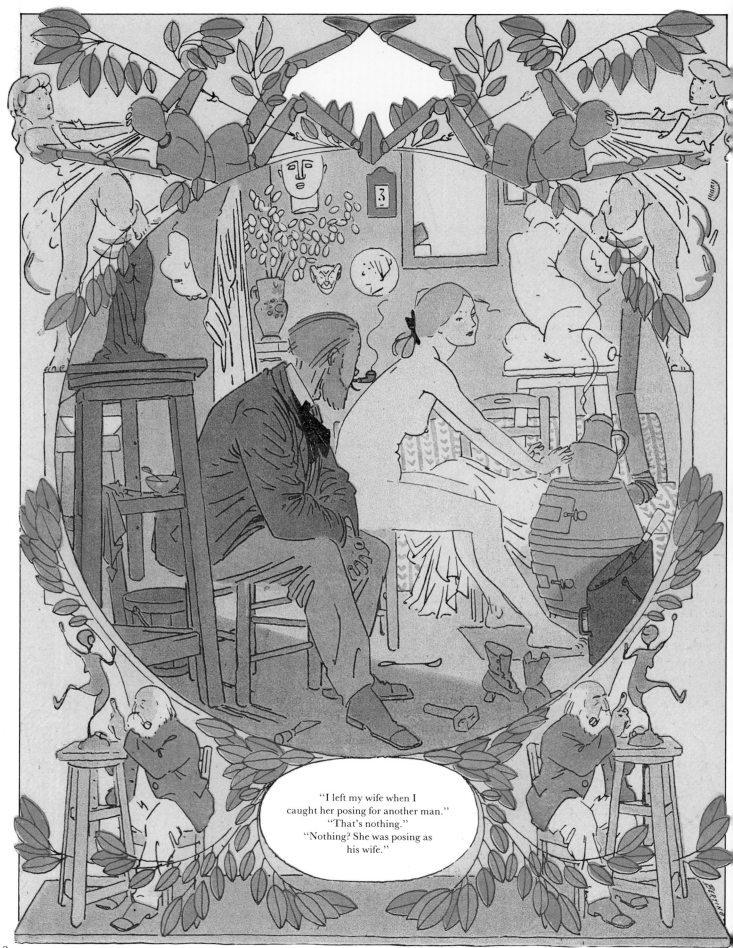

"I left my wife when I
caught her posing for another man."
"That's nothing."
"Nothing? She was posing as
his wife."

A BARE LIVING

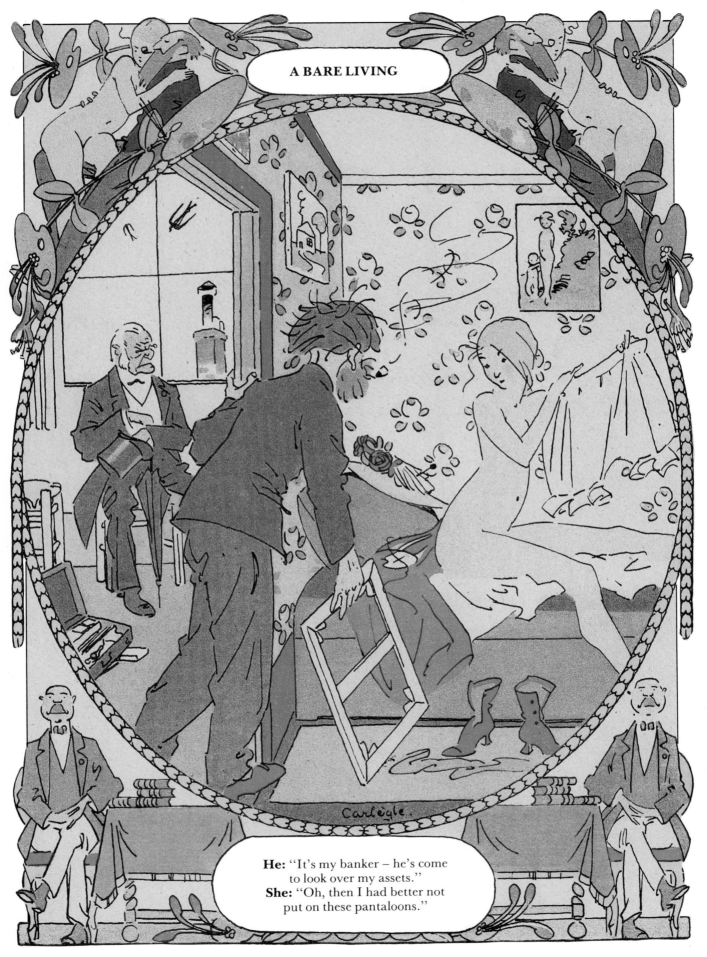

He: "It's my banker – he's come to look over my assets."
She: "Oh, then I had better not put on these pantaloons."

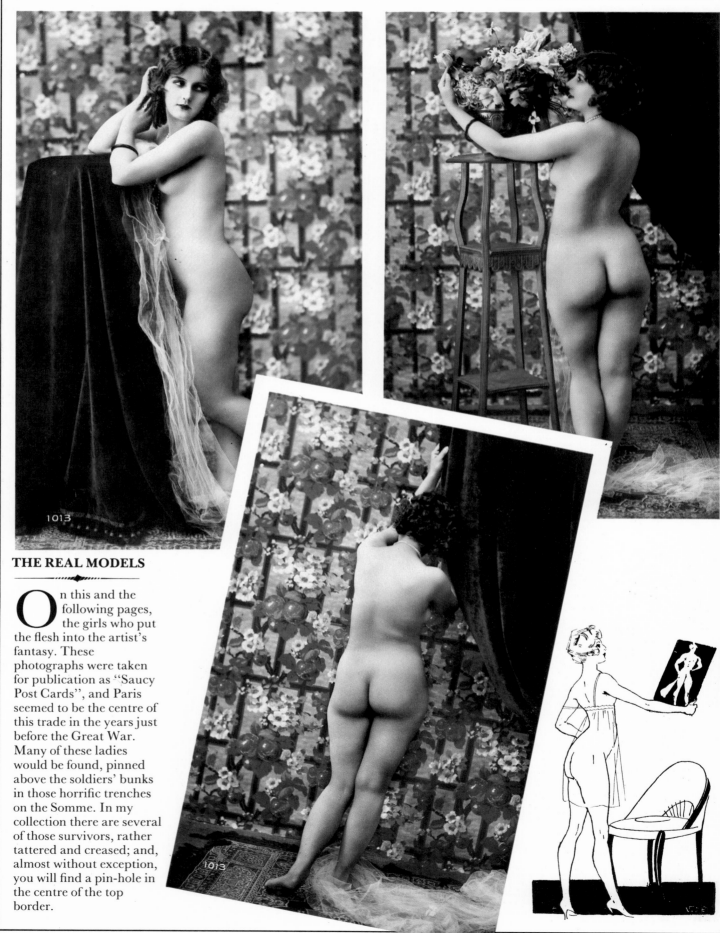

THE REAL MODELS

On this and the following pages, the girls who put the flesh into the artist's fantasy. These photographs were taken for publication as "Saucy Post Cards", and Paris seemed to be the centre of this trade in the years just before the Great War. Many of these ladies would be found, pinned above the soldiers' bunks in those horrific trenches on the Somme. In my collection there are several of those survivors, rather tattered and creased; and, almost without exception, you will find a pin-hole in the centre of the top border.

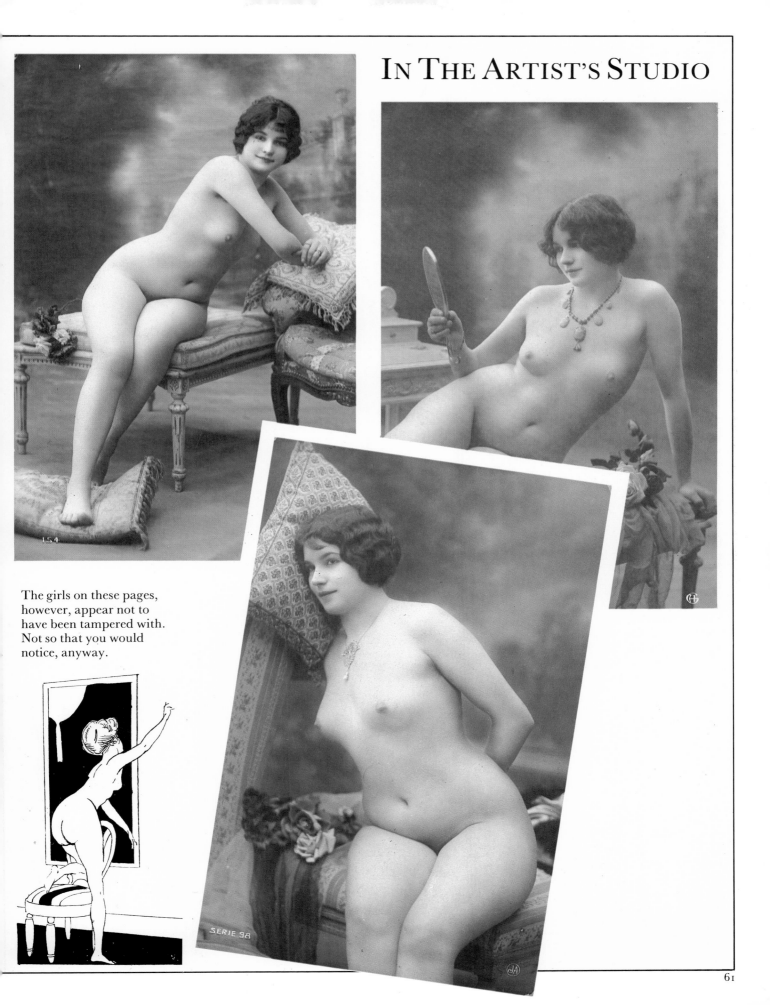

IN THE ARTIST'S STUDIO

The girls on these pages, however, appear not to have been tampered with. Not so that you would notice, anyway.

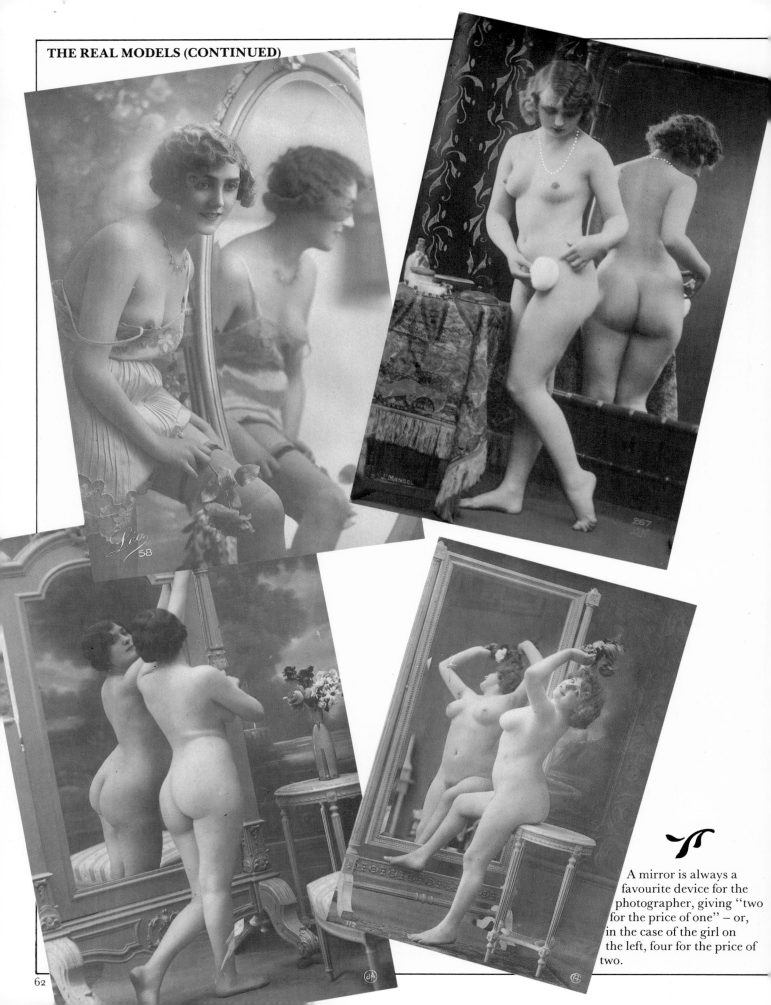

A mirror is always a favourite device for the photographer, giving "two for the price of one" – or, in the case of the girl on the left, four for the price of two.

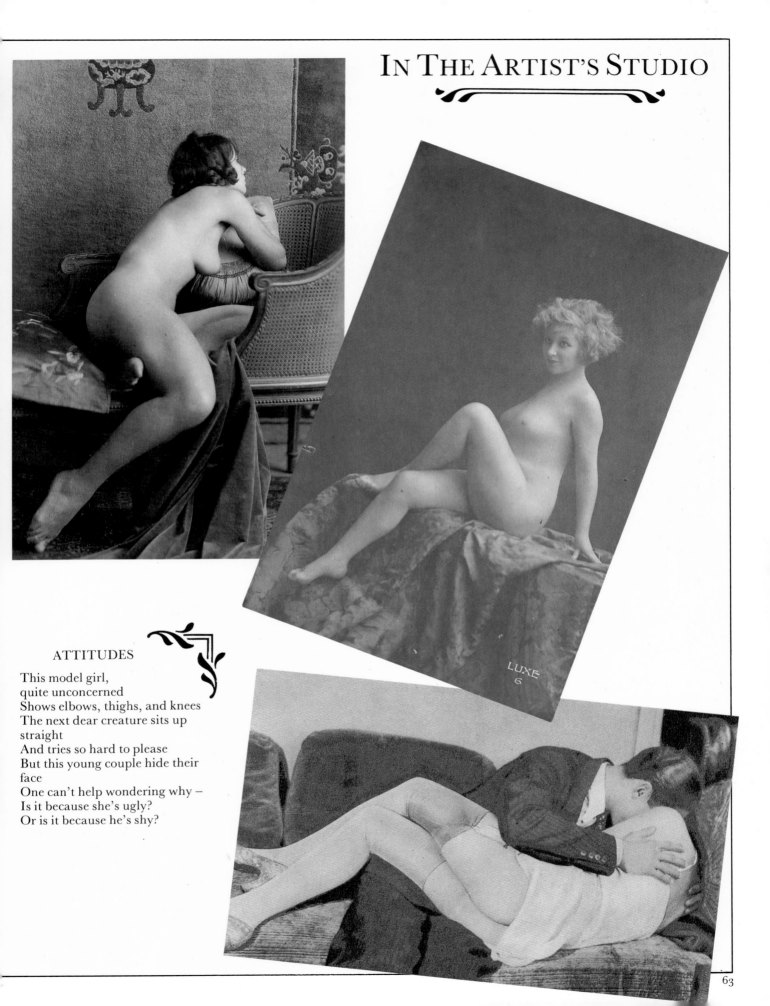

ATTITUDES

This model girl,
quite unconcerned
Shows elbows, thighs, and knees
The next dear creature sits up
straight
And tries so hard to please
But this young couple hide their
face
One can't help wondering why –
Is it because she's ugly?
Or is it because he's shy?

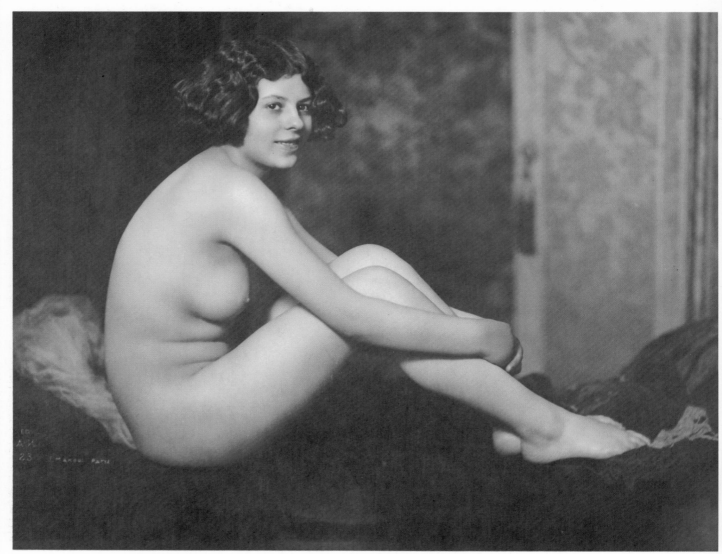

"I went to the riviera, and got
tanned on my holiday."

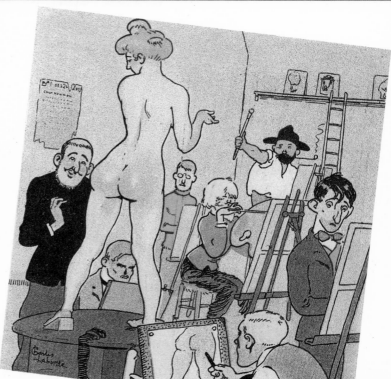

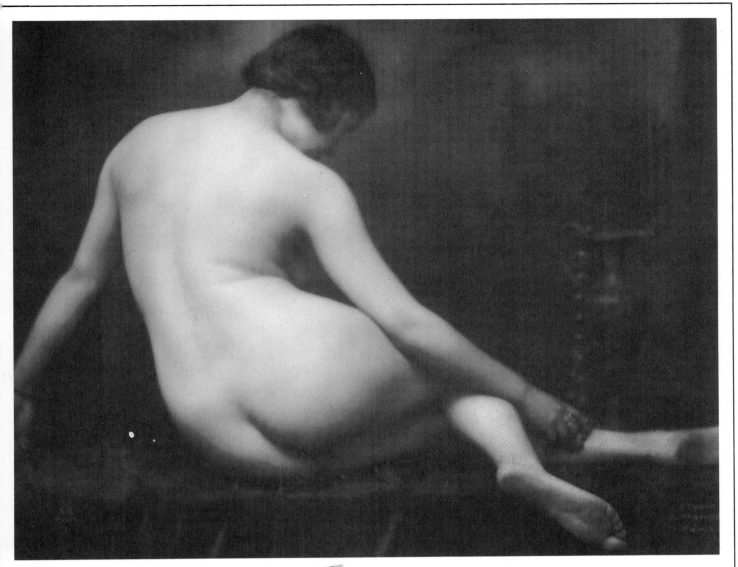

"I went to the nudist camp,
and got sunburned all over
the week-end."

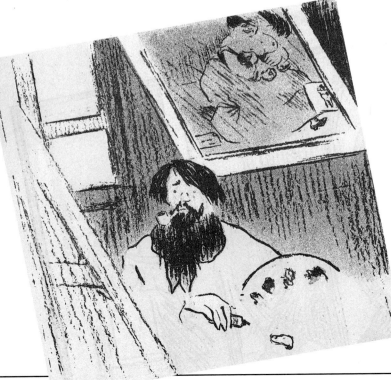

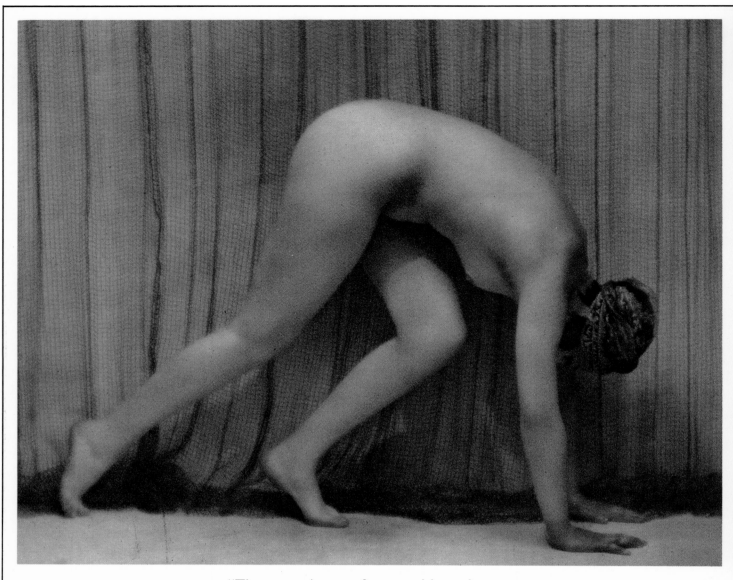

"They get us in some funny positions, these
artists. This one is supposed to be The Beginning
of the Human Race . . ."

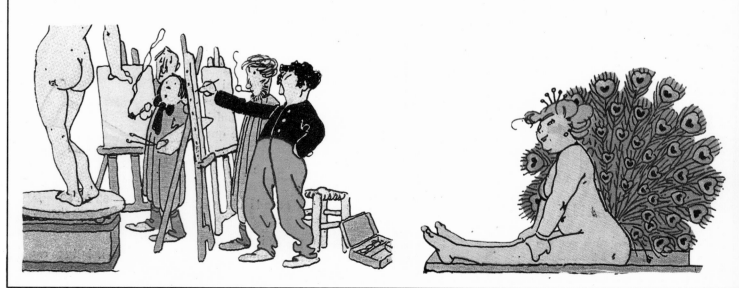

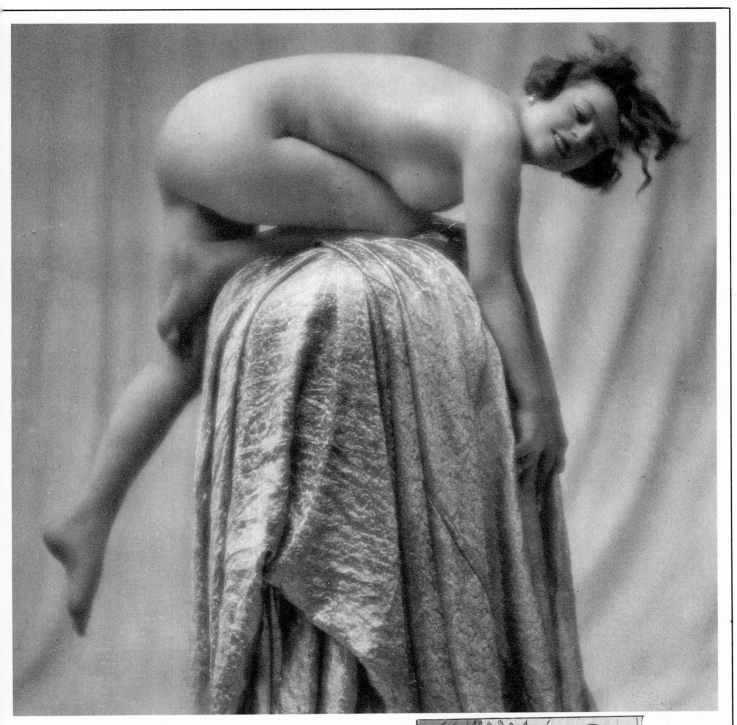

"I think *I* must be in
The Middle of the
Obstacle Race."

IN THE ARTIST'S STUDIO

IN THE ARTIST'S STUDIO

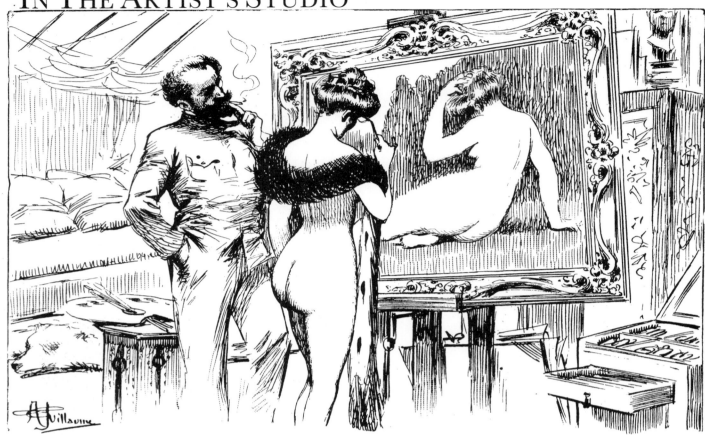

The Society Model: "I can't let it be shown in public. Most of Paris
would recognise my features."
The Artist: "But your face is not showing, madame."
The Society Model: "Not my face. My other features."

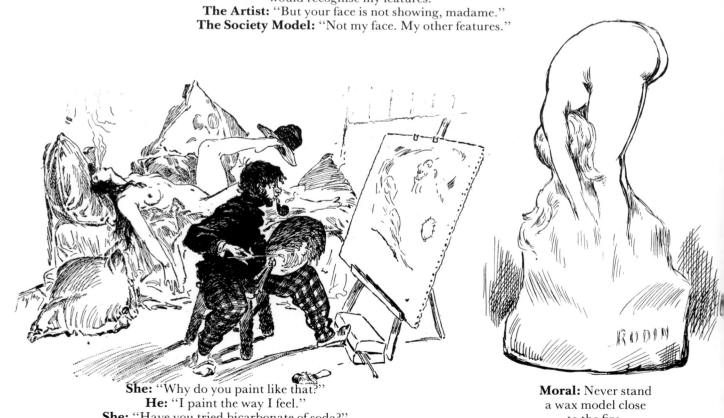

She: "Why do you paint like that?"
He: "I paint the way I feel."
She: "Have you tried bicarbonate of soda?"

Moral: Never stand
a wax model close
to the fire.

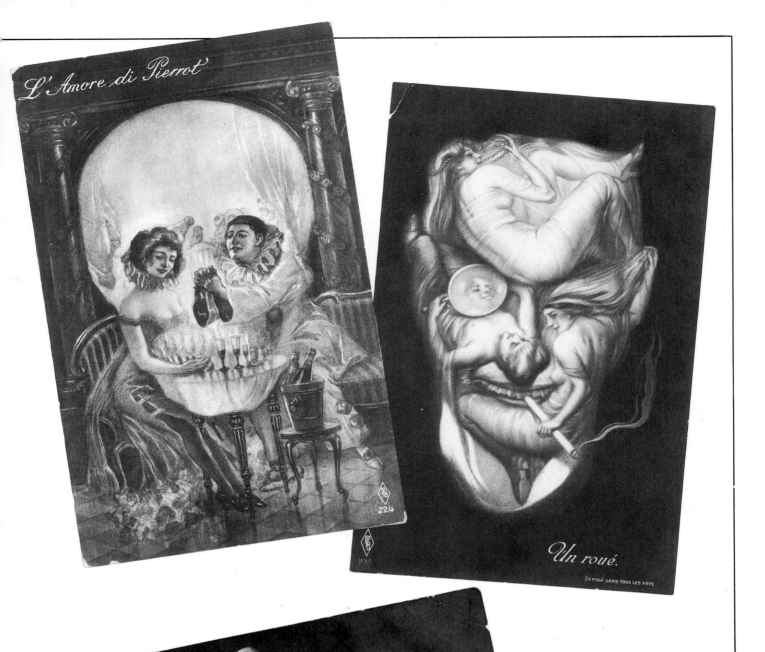

L'Amore di Pierrot

Un roué.

DÉPOSÉ DANS TOUS LES PAYS

Le Vainqueur

FAR AND NEAR

Viewed from afar, these ingenious drawings are a skull, an old roué, a racehorse.
Viewed a little closer, we see how brilliantly the Parisian artists have used the figures of their models to create these trompes-l'oeil of the post-card world.

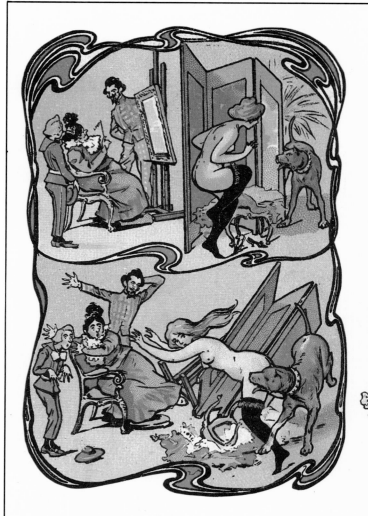

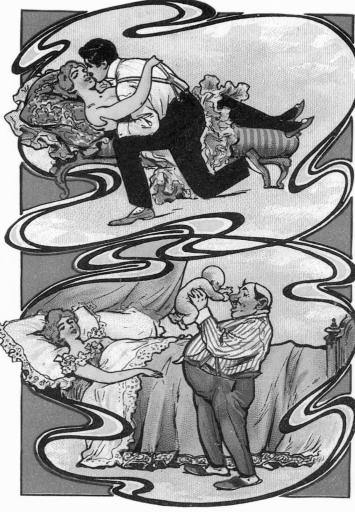

And, of course, the comic artist, who more than anyone, popularised the French post-card. Where could this book be without him?

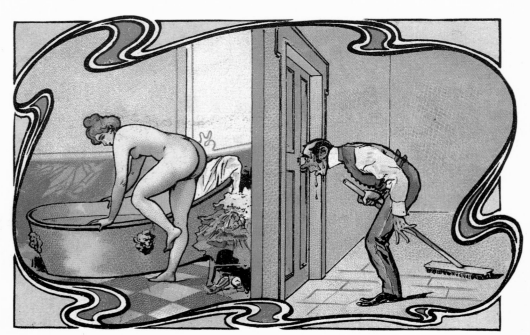

OOH – LA – LA!
THE LADIES OF PARIS
◄────►IN THE◄────►
MUSIC HALL

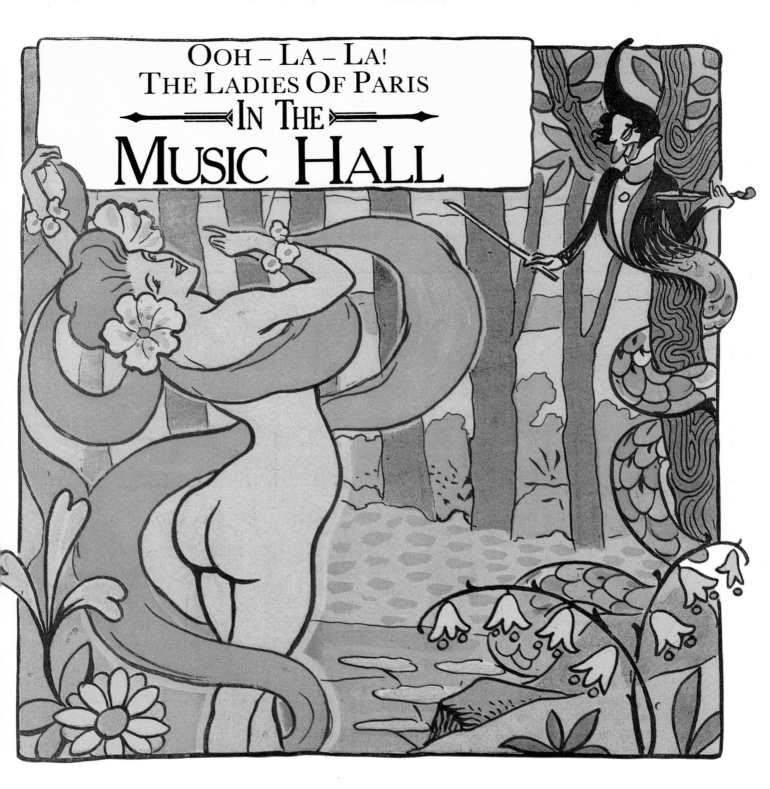

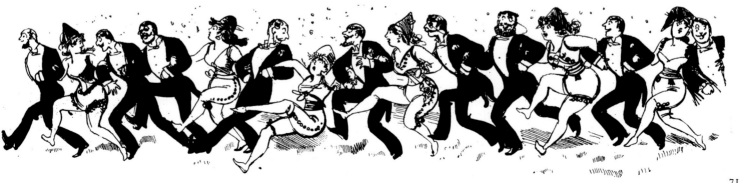

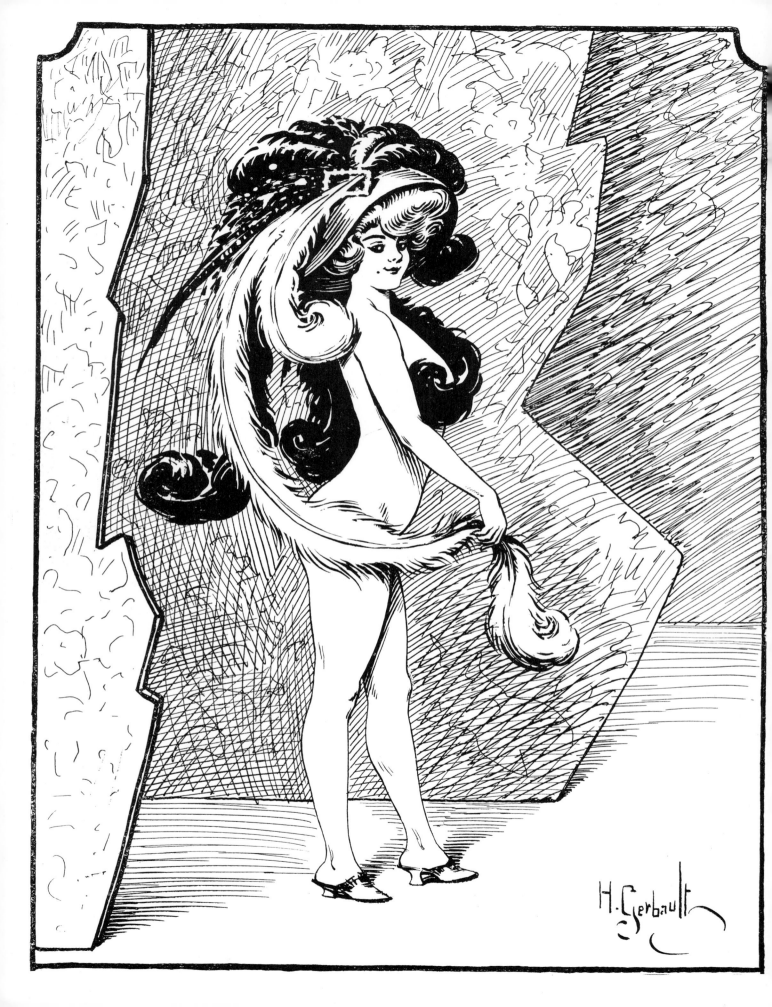

H. Gerbault

IN THE MUSIC HALL

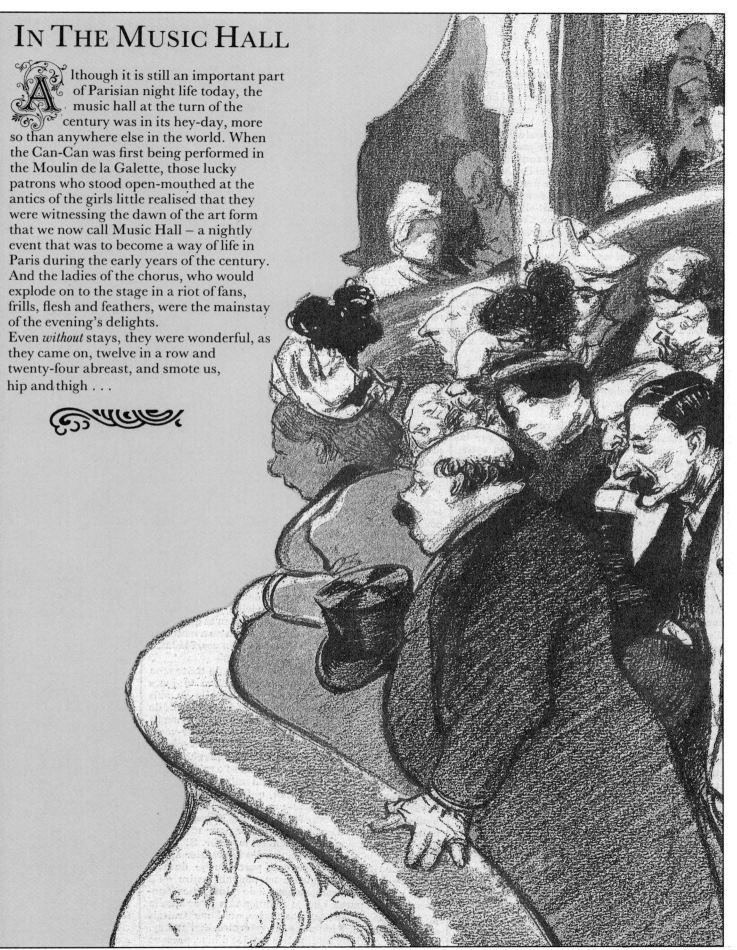

Although it is still an important part of Parisian night life today, the music hall at the turn of the century was in its hey-day, more so than anywhere else in the world. When the Can-Can was first being performed in the Moulin de la Galette, those lucky patrons who stood open-mouthed at the antics of the girls little realised that they were witnessing the dawn of the art form that we now call Music Hall – a nightly event that was to become a way of life in Paris during the early years of the century. And the ladies of the chorus, who would explode on to the stage in a riot of fans, frills, flesh and feathers, were the mainstay of the evening's delights.

Even *without* stays, they were wonderful, as they came on, twelve in a row and twenty-four abreast, and smote us, hip and thigh . . .

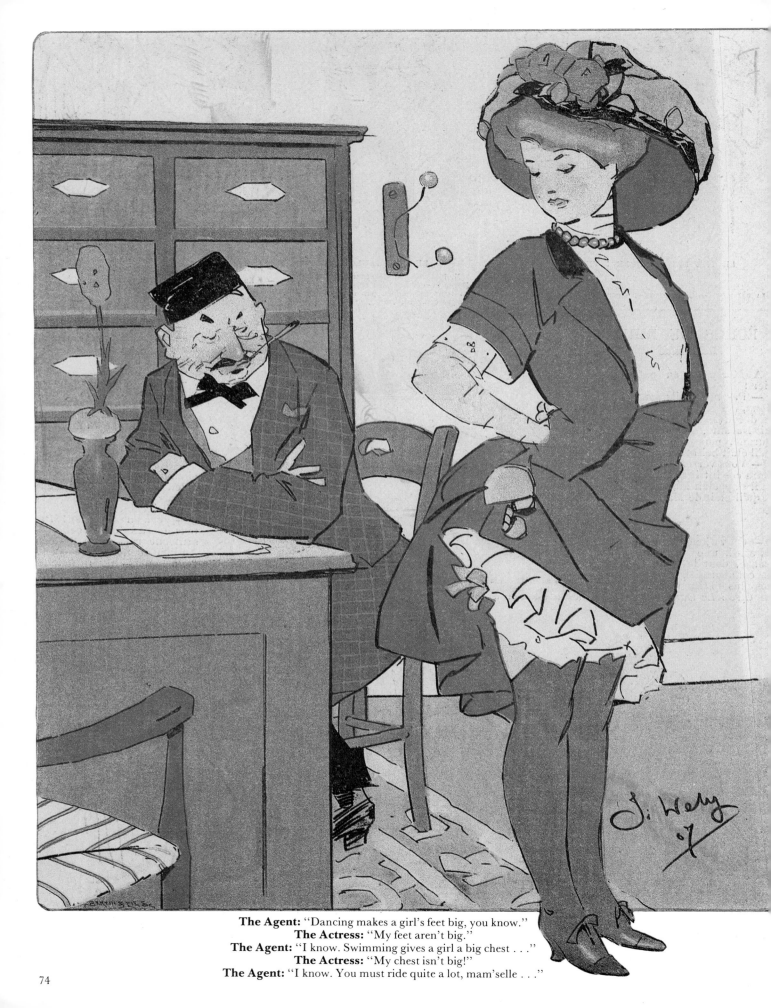

The Agent: "Dancing makes a girl's feet big, you know."
The Actress: "My feet aren't big."
The Agent: "I know. Swimming gives a girl a big chest . . ."
The Actress: "My chest isn't big!"
The Agent: "I know. You must ride quite a lot, mam'selle . . ."

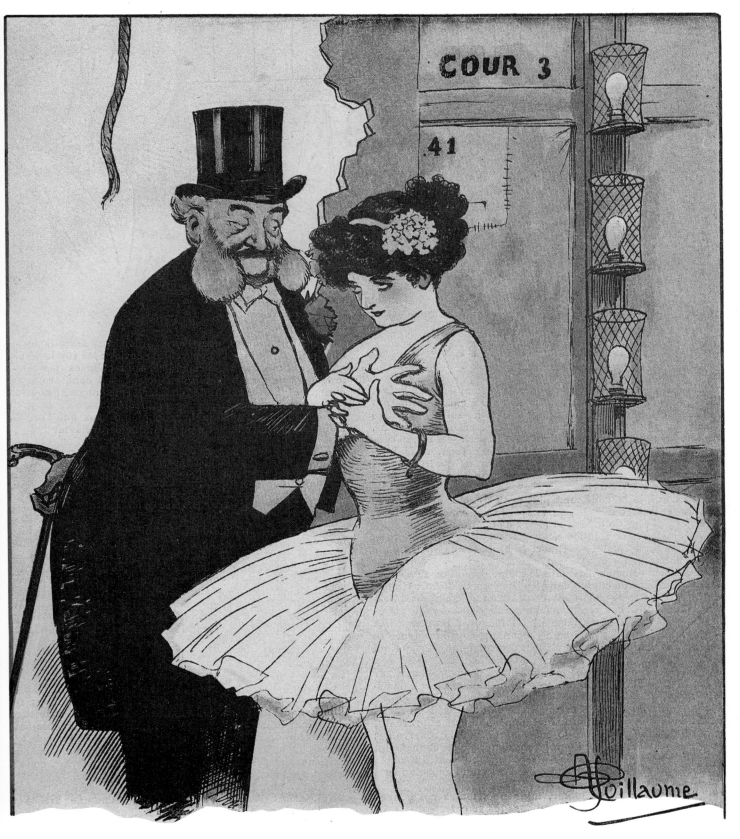

The Ballet-girl: "You are very quick witted, Monsieur le Vicomte."
The Old Boy: "Quick witted?"
The Ballet-girl: "Yes – you're certainly not slow to grasp things, are you?"

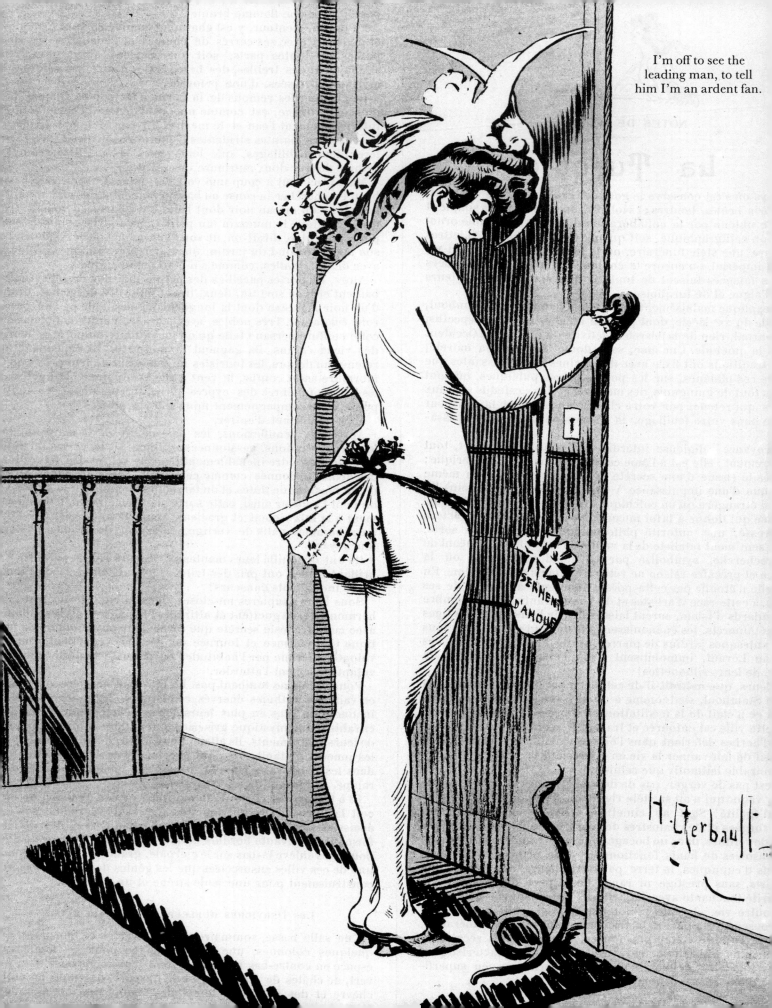

I'm off to see the
leading man, to tell
him I'm an ardent fan.

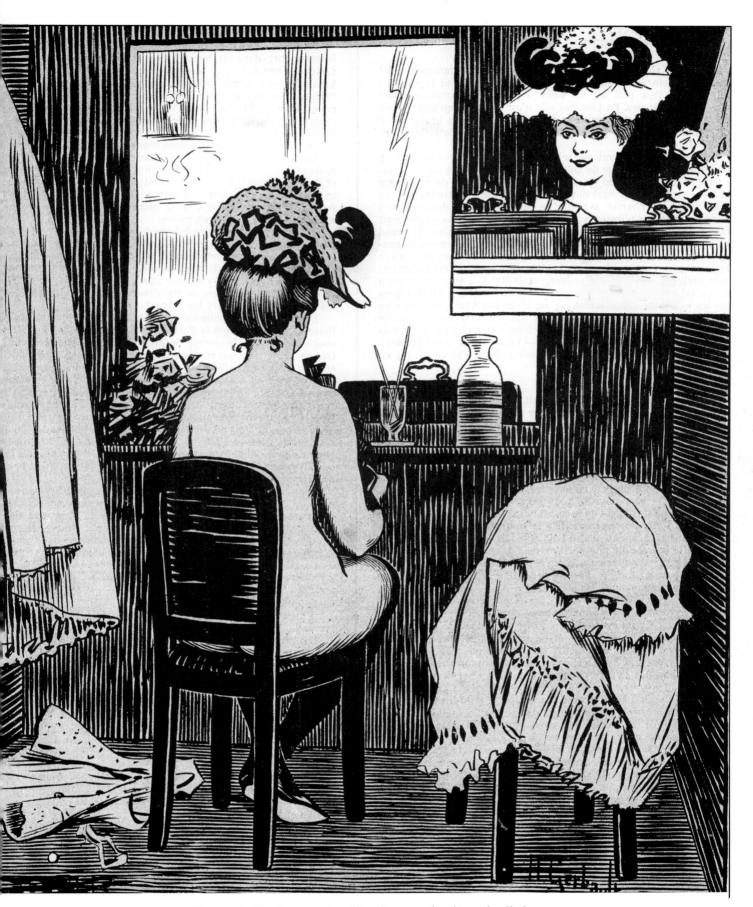

The smoke-filled theatre is still and warm: she sits enthralled as
the cast perform;
So breathless is she at the torrid romance, she sits without her
cloak, and pants.

A FEW COSTUME DESIGNS

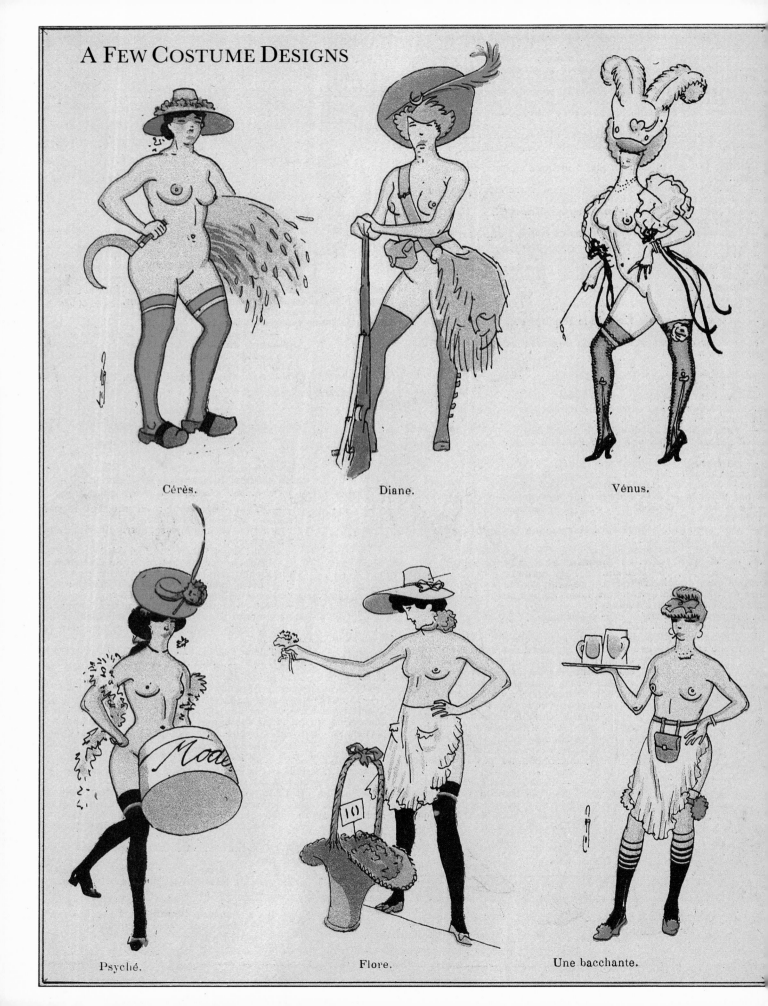

Cérès.

Diane.

Vénus.

Psyché.

Flore.

Une bacchante.

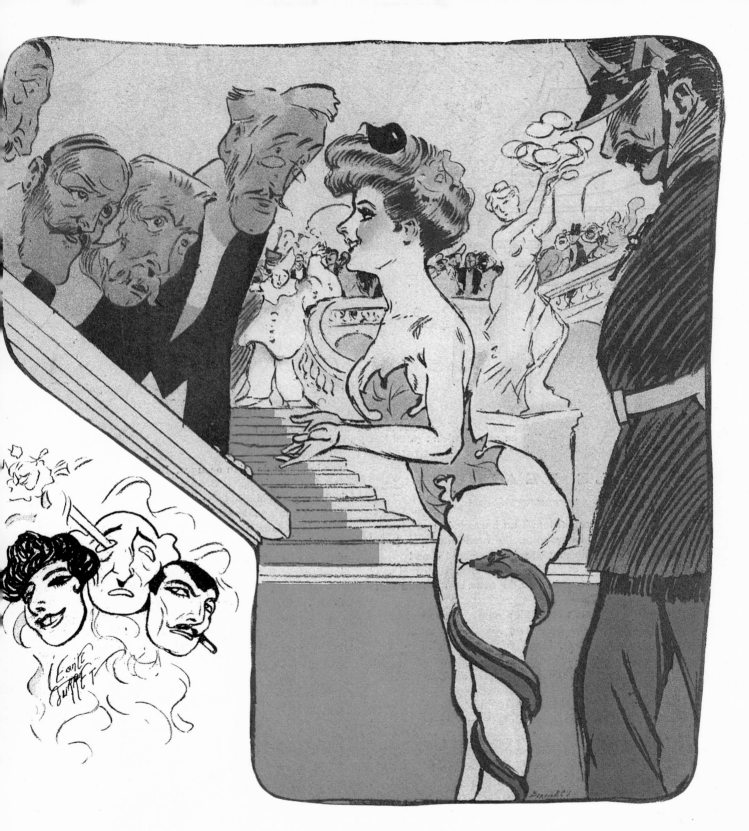

She: "I'm sorry, messieurs, I thought
it was an Adam and Eve Ball.
I misunderstood the invitation."
He: "Why, what did it say?"
She: "Leaves off at midnight."

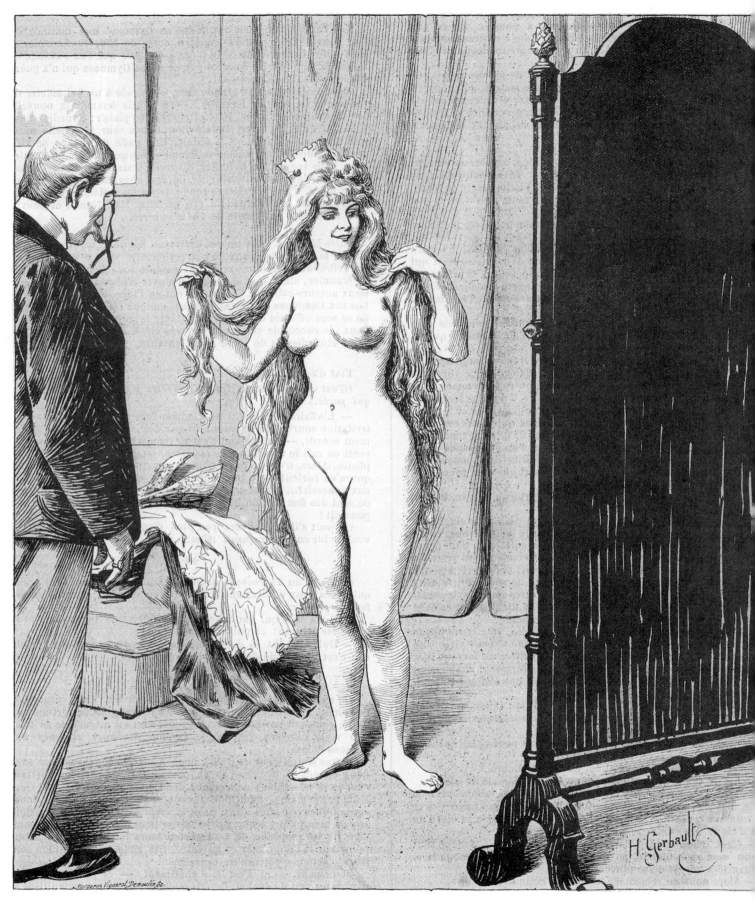

The Nymph: "The manager says I'm as pretty as a picture."
The Designer: "What's wrong with that?"
The Nymph: "Well, he wants to put me up in his bedroom."

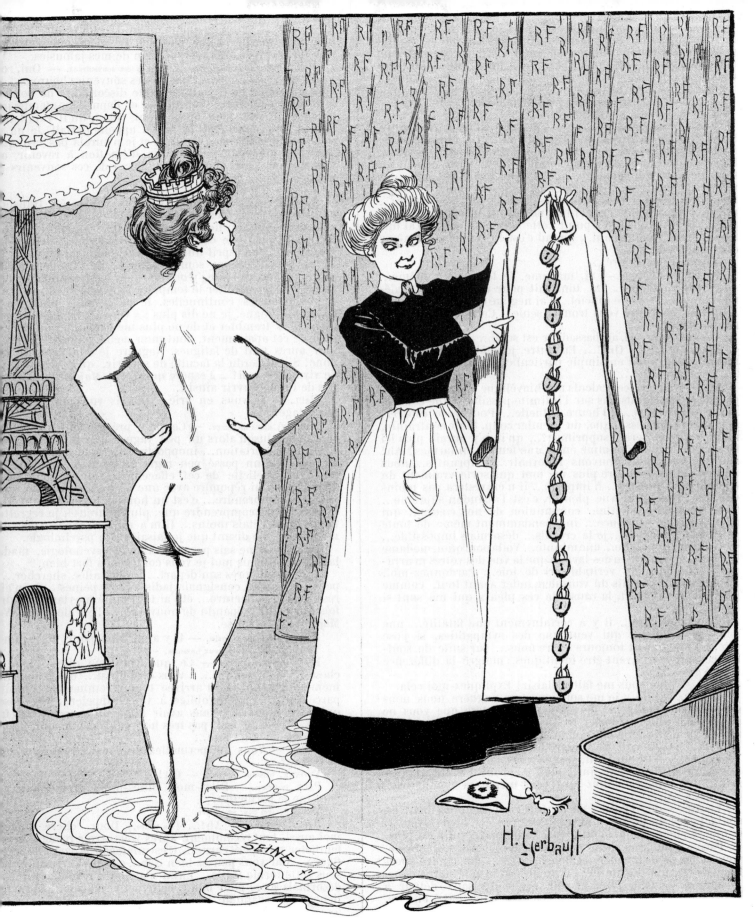

The Dresser: "I know why you're so popular, Janine . . ."
Janine: "Why? Is it my figure?"
The Dresser: "No."
Janine: "My smile? My personality?"

The Dresser: "No."
Janine: "I give in."
The Dresser: "That's it! That's why."

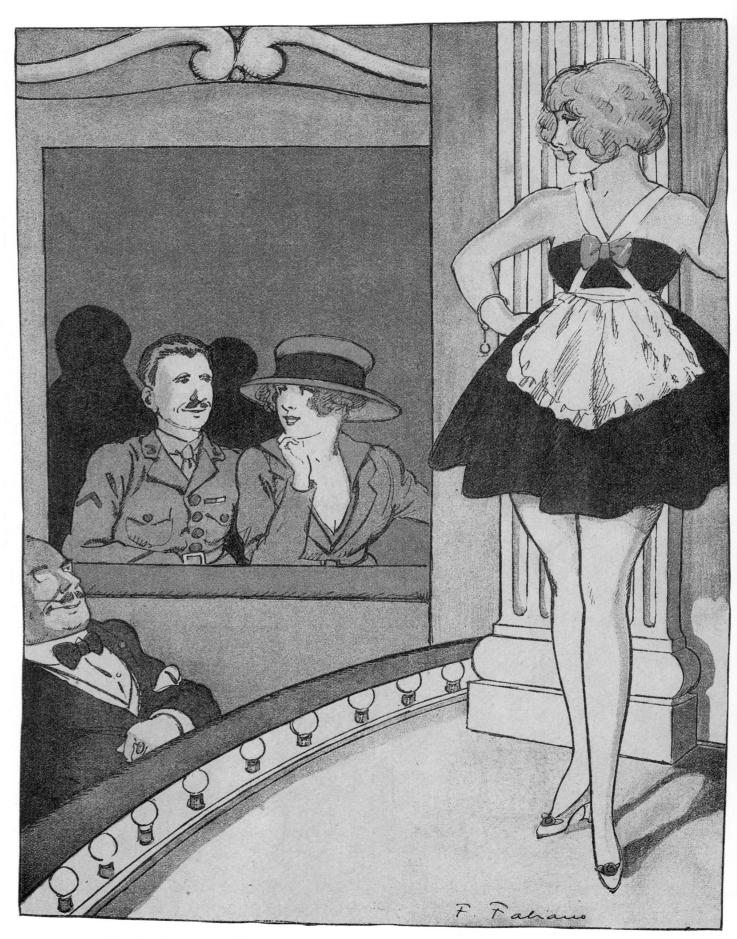

The Man in the Box: "She's awfully clever, you know. At university, she graduated with honour."
The Girl in the Hat: "Yes, but I hear she has since lost it."

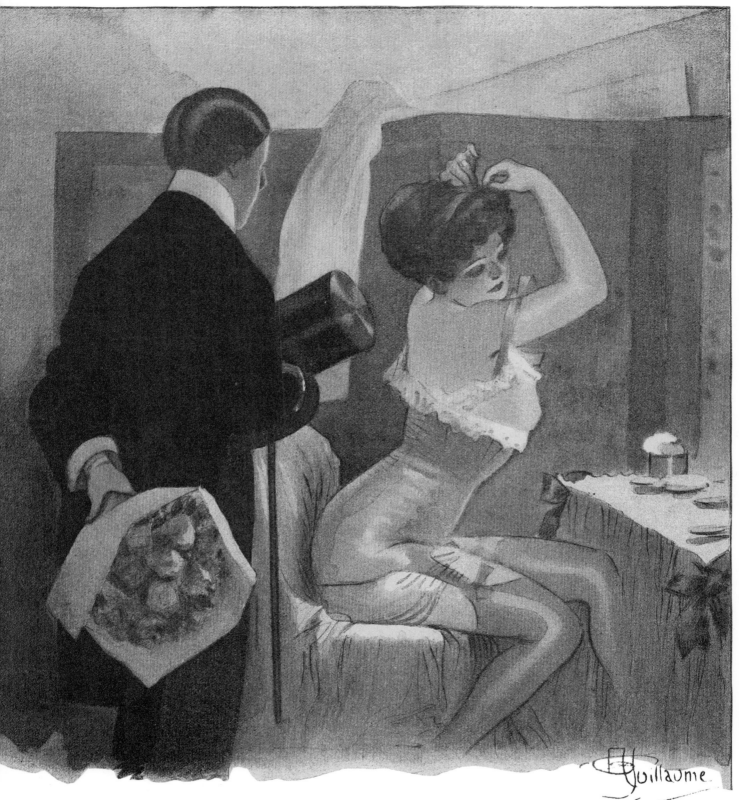

IN THE MUSIC HALL

Admirer: "What happened to the man who took you away for the week-end?"

Frou-Frou: "I've finished with him. Not only did he lie to me about his yacht, but he made me help with the rowing."

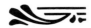

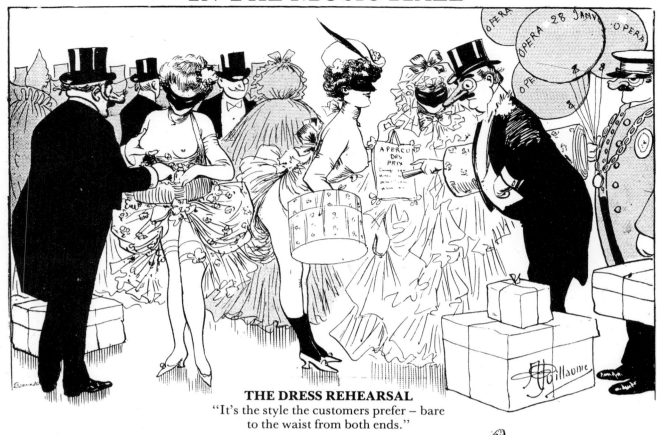

THE DRESS REHEARSAL

"It's the style the customers prefer – bare
to the waist from both ends."

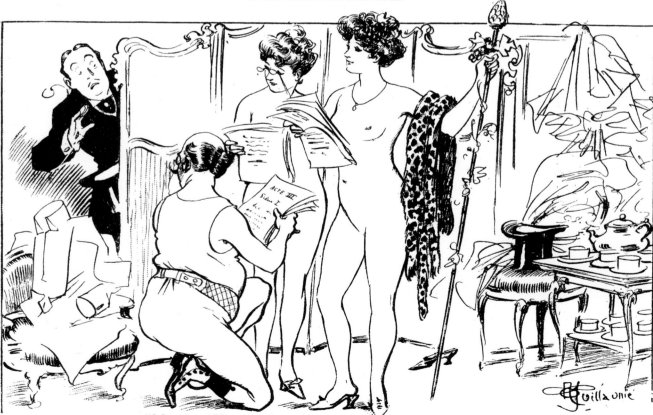

"Monsieur! Your wife is at the stage-door, demanding to see you."

"Mon Dieu! Bring me my fig-leaf immediately. Otherwise she will
never believe this is a dress-rehearsal."

I don't know whether this was ever brought to fruition in the Paris music halls, but the idea (especially the tattooing) is certainly a good one . . .

PILULES DORÉES POUR PERSONNES RICHES

DES PÈRES LIQUEUR

PLUS DE TÊTES CHAUVES

I wonder what this one said?
(Answers on a postcard, please, to the Michelin Tyre Company.)

WATCH THIS SPACE

A FAMOUS BRAND OF WHISKY?

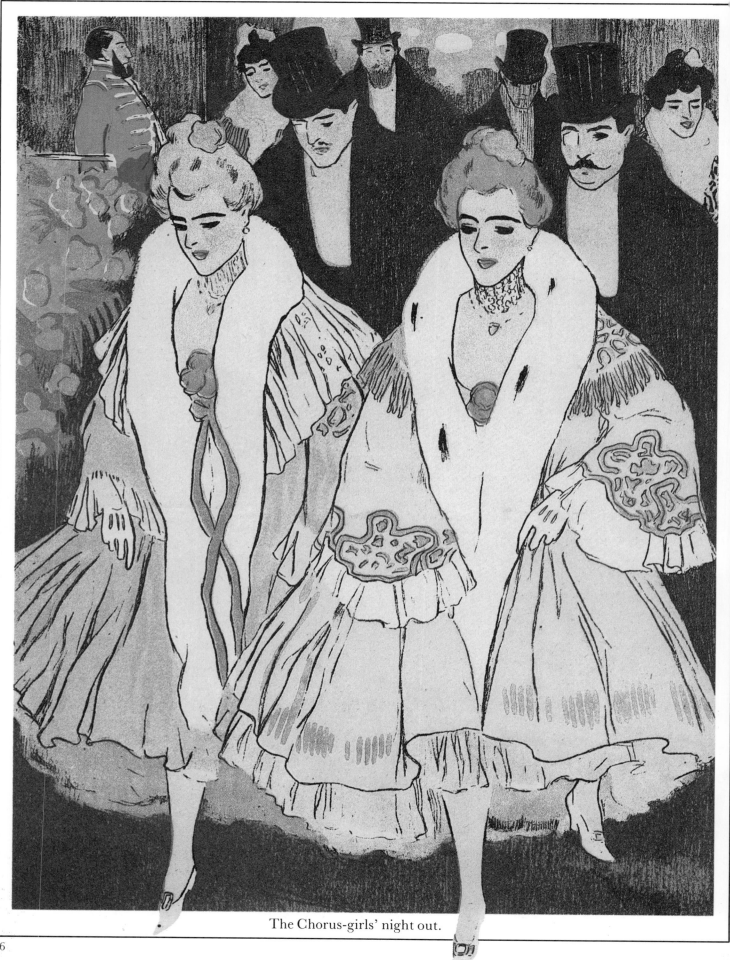

The Chorus-girls' night out.

In The Music Hall

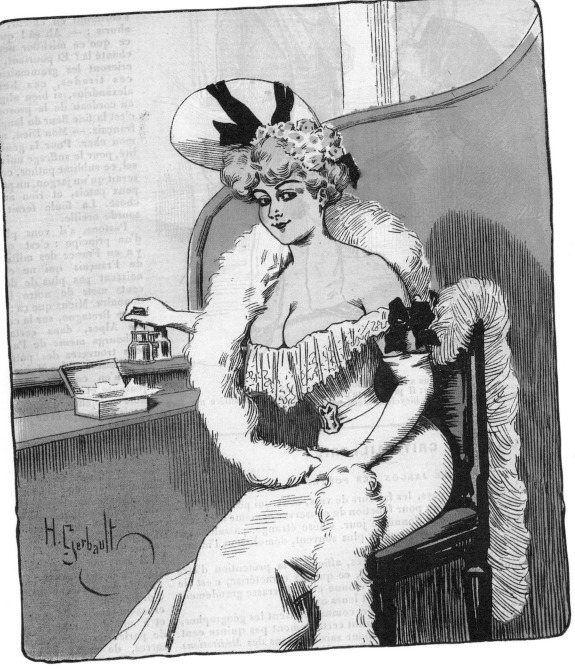

The Theatrical Cocotte

It is strange to think that, while some people die of exposure, others live by it.

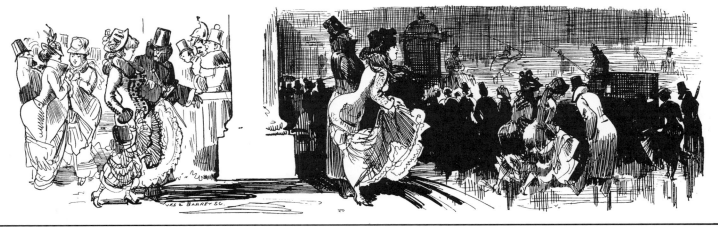

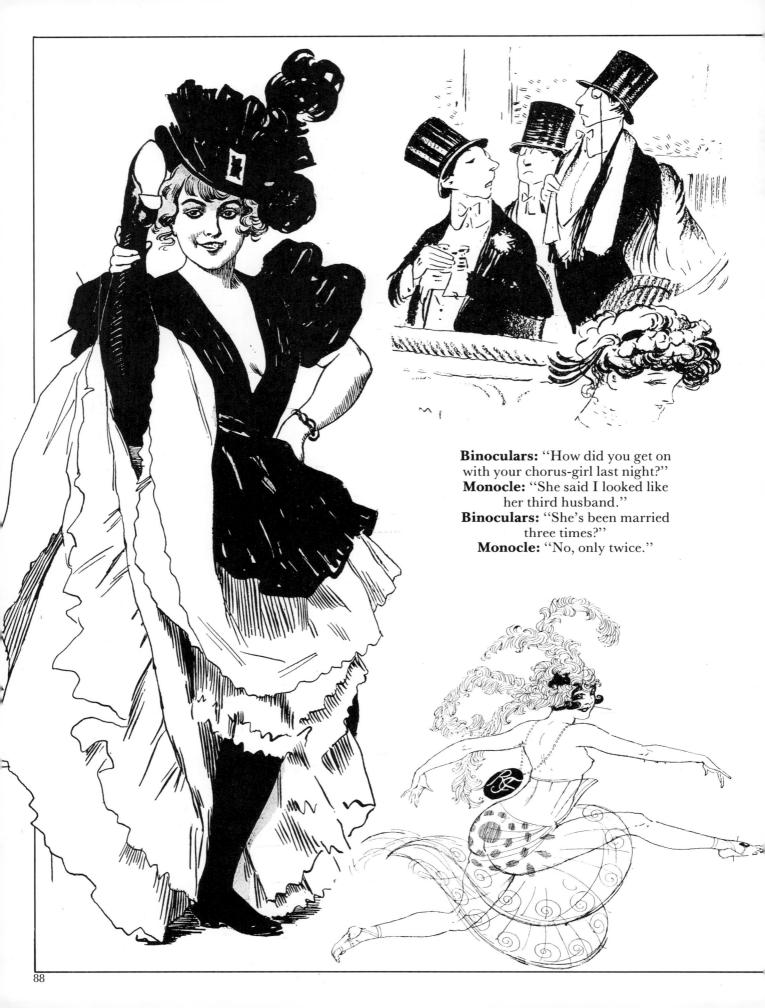

Binoculars: "How did you get on with your chorus-girl last night?"
Monocle: "She said I looked like her third husband."
Binoculars: "She's been married three times?"
Monocle: "No, only twice."

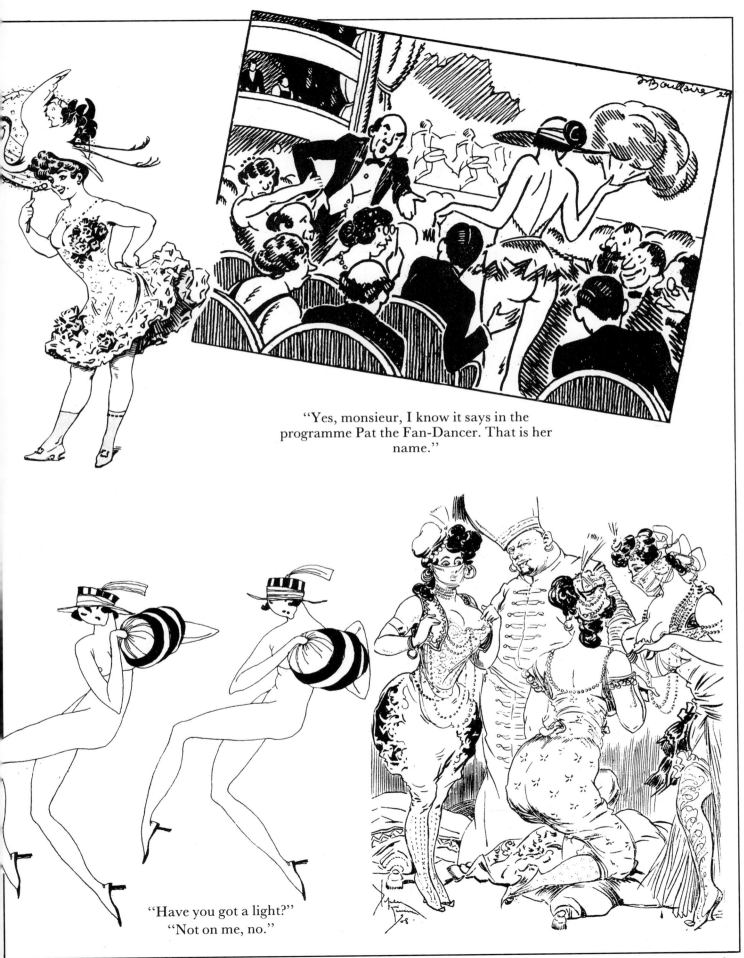

"Yes, monsieur, I know it says in the programme Pat the Fan-Dancer. That is her name."

"Have you got a light?"
"Not on me, no."

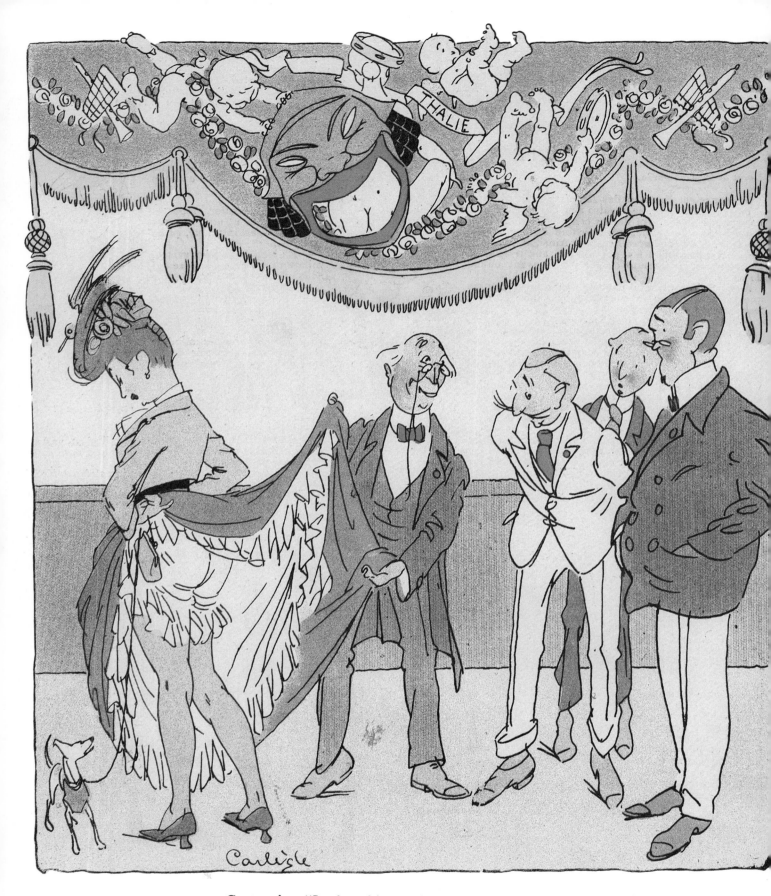

Costumier: "Look at this, gentlemen. I ask you – where else could you get such quality at such a rock-bottom price?"

"For god's sake, Louise, try to smile when you're
showing your face to the public!"

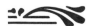

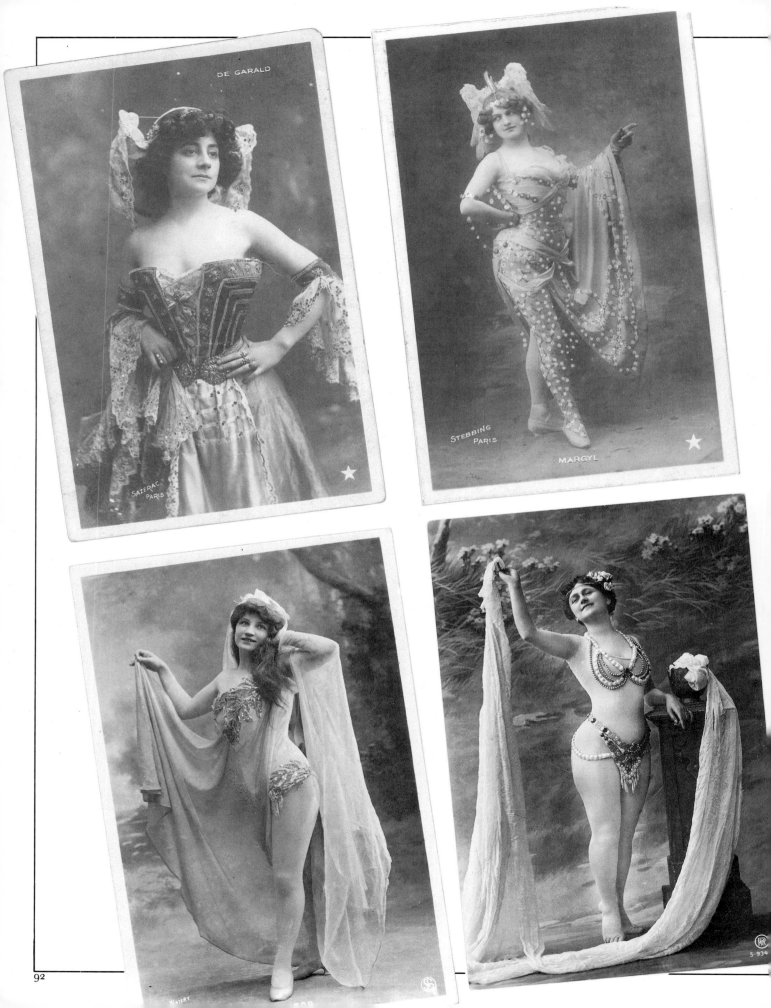

DE GARALD

SAZERAC
PARIS

STEBBING
PARIS

MARGYL

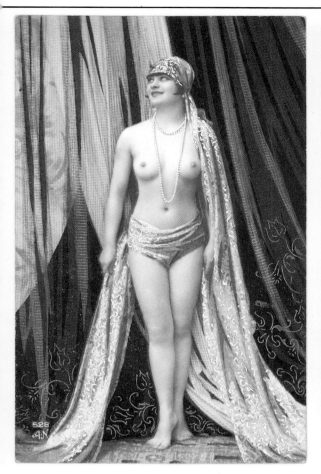

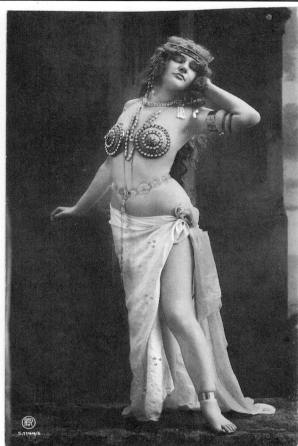

LES GIRLS

Here are some
of the hordes
That trod the
boards
When
grandfather
went to the
Theatre;
Here are some
of the girls
wearing chiffon
and pearls
Some good and
some bad, and
some better.

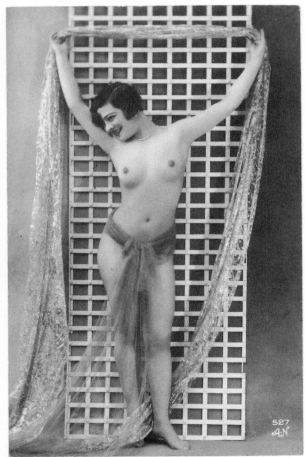

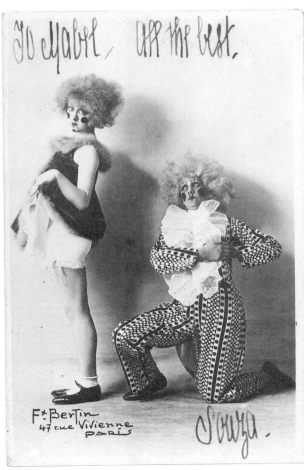

To Mabel, all the best.

Ft Bertin
47 rue Vivienne
PARIS

Souza.

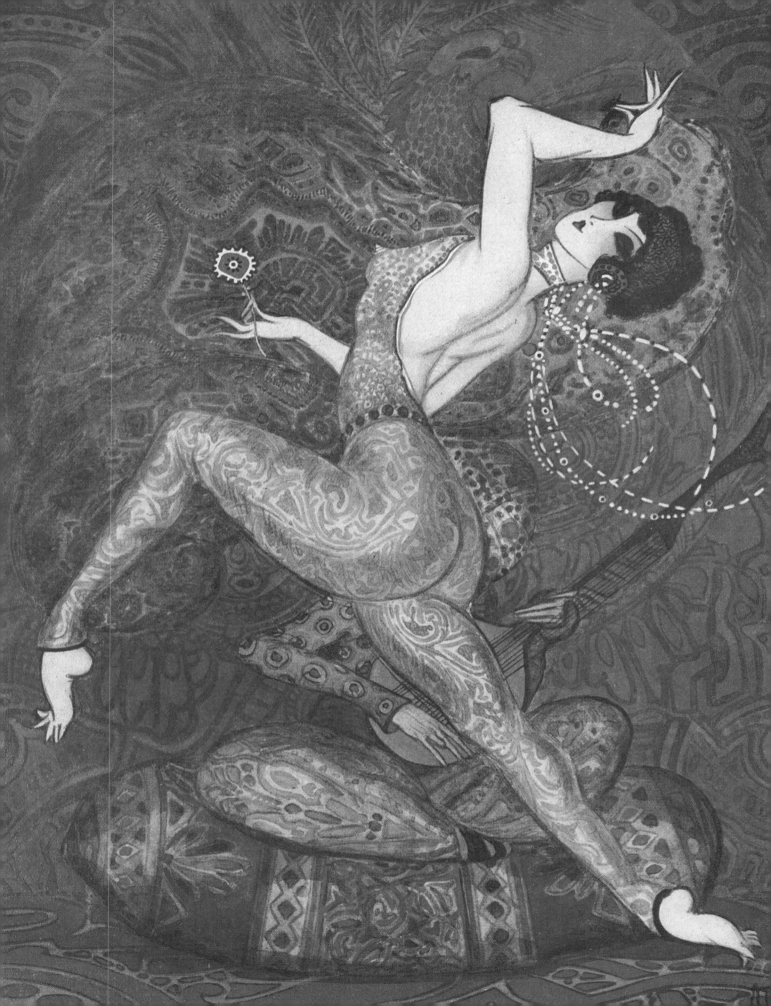

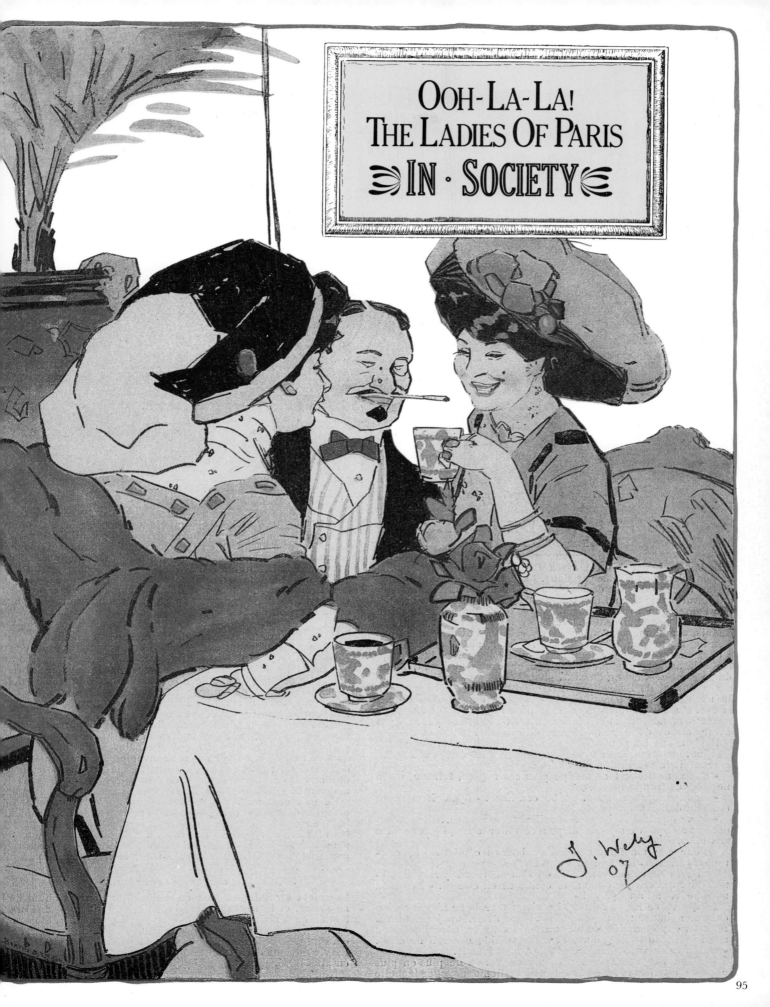

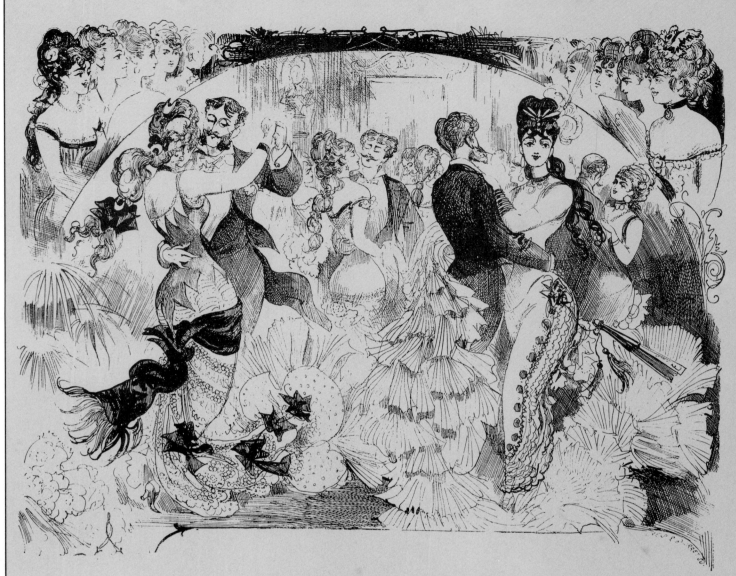

OOH – LA – LA!
THE LADIES OF PARIS
IN SOCIETY

The masked Ball at the Opera, the fashion houses at the start of the season; the "Thé Dansant"; starlit revelries on the slopes of Montmartre, the restless gaiety of the Café society, roaming the length and breadth of Paris in search of the amusing, the bizarre. The George Cinq for breakfast. The mad summer rush for Cannes, Nice, and Boomps-a-Daisy. String orchestras playing in the grand court-yard of the Continental Hotel, and always champagne, champagne . . .

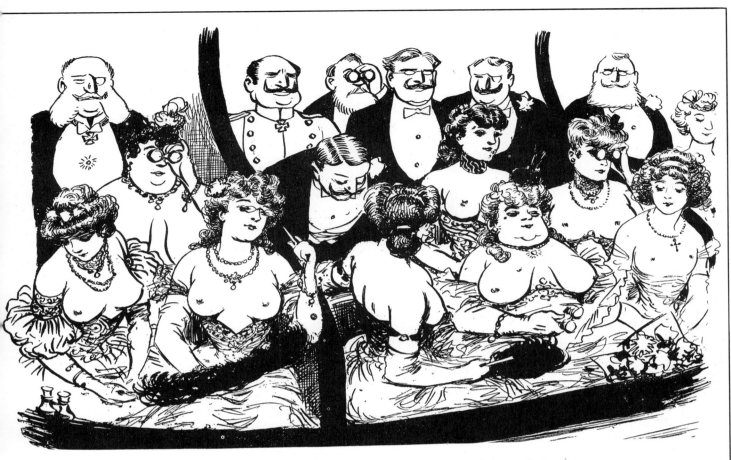

Society at the Theatre. (At the Opera it was announced that no lady
would be admitted unless she was completely décolletée.)

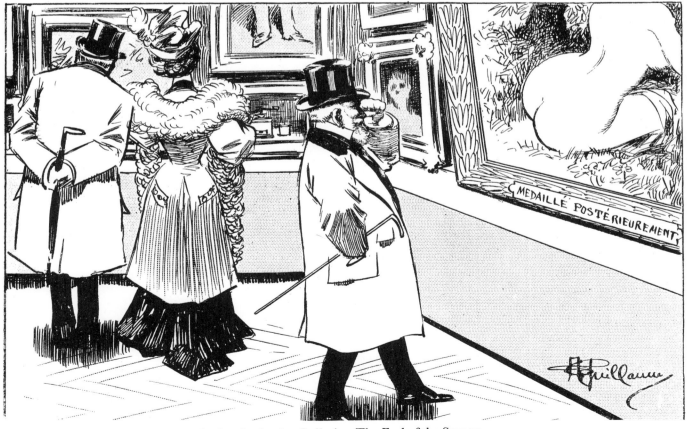

MEDAILLÉ POSTÉRIEUREMENT

Society in the Art Galleries: The End of the Season

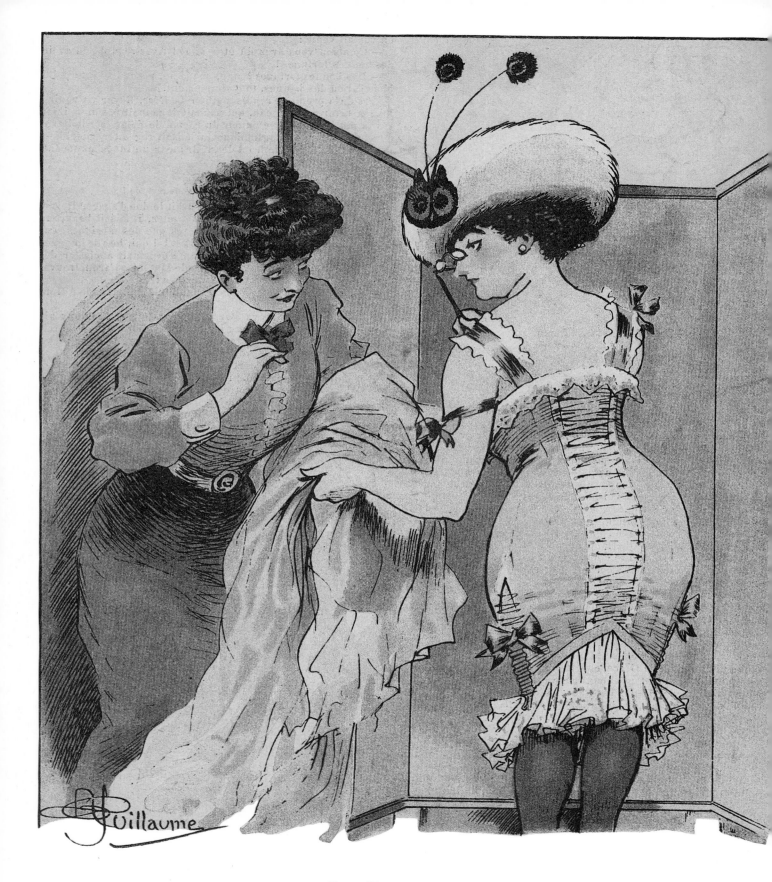

IN SOCIETY

"My husband wants me to reduce my hips."
"How very narrow-minded of him, madame!"

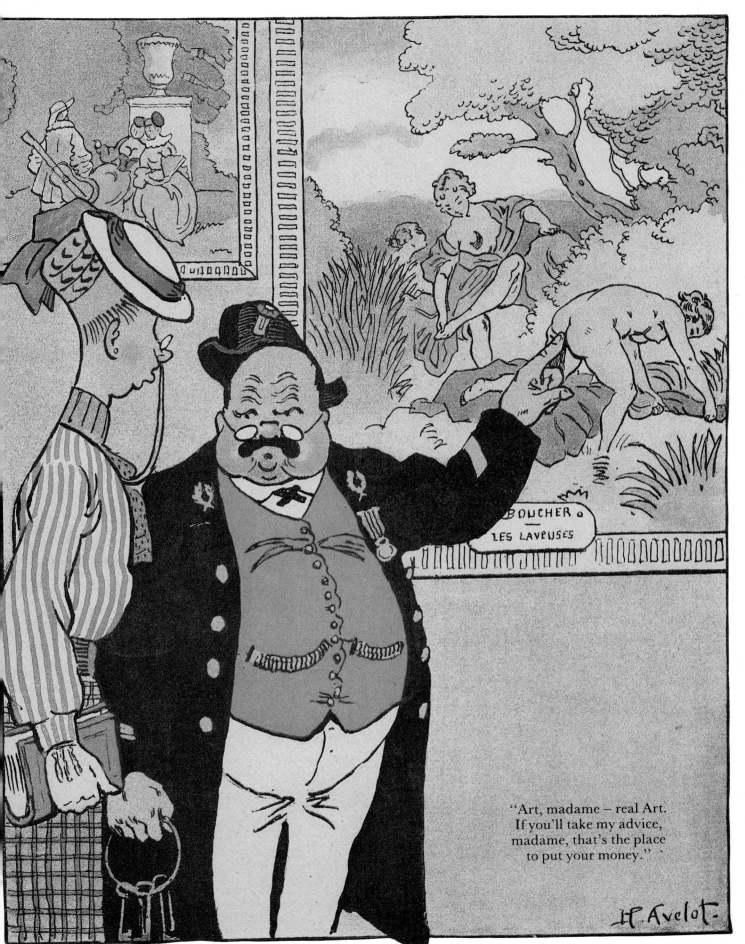

"Art, madame – real Art.
If you'll take my advice,
madame, that's the place
to put your money."

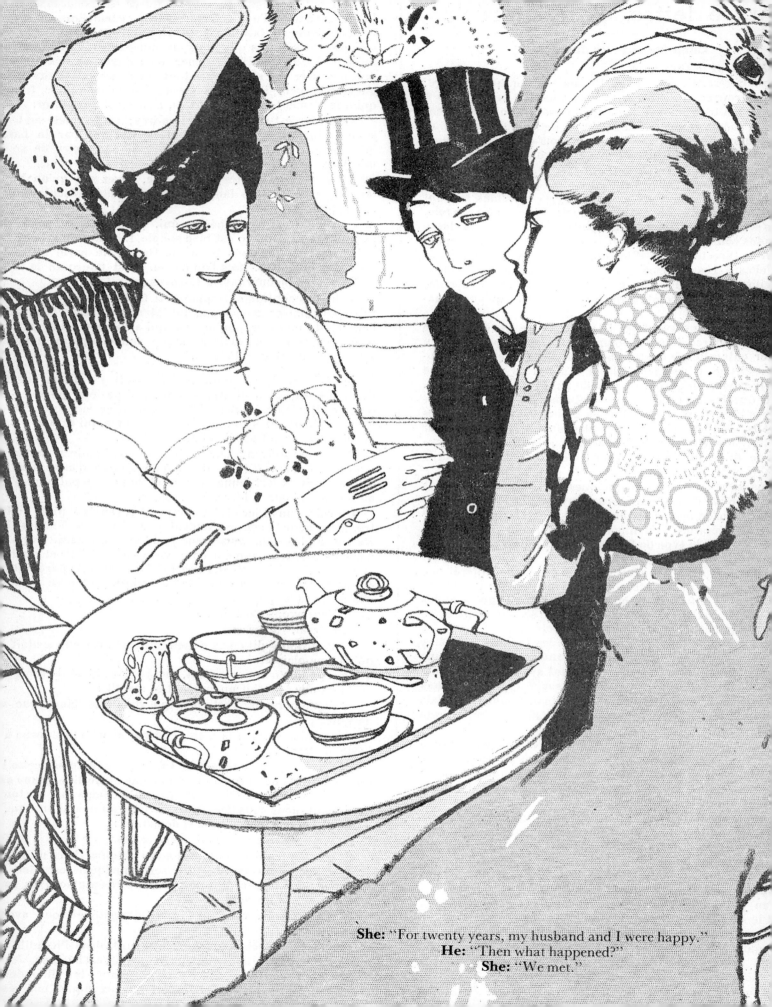

She: "For twenty years, my husband and I were happy."
He: "Then what happened?"
She: "We met."

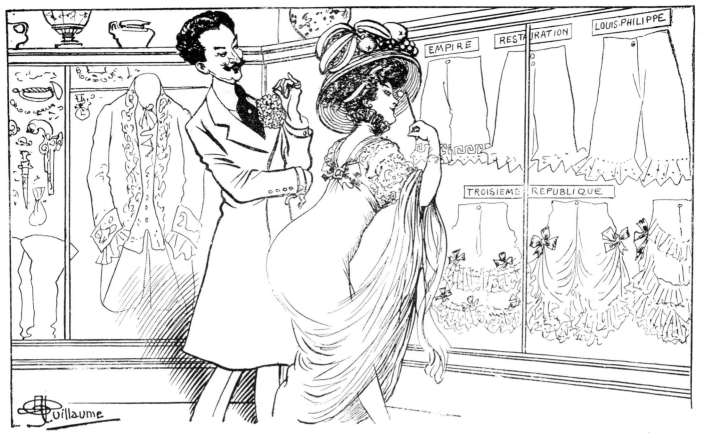

She: "How fascinating! All these have come down through the ages."
He: "Oh yes, madame, many times."

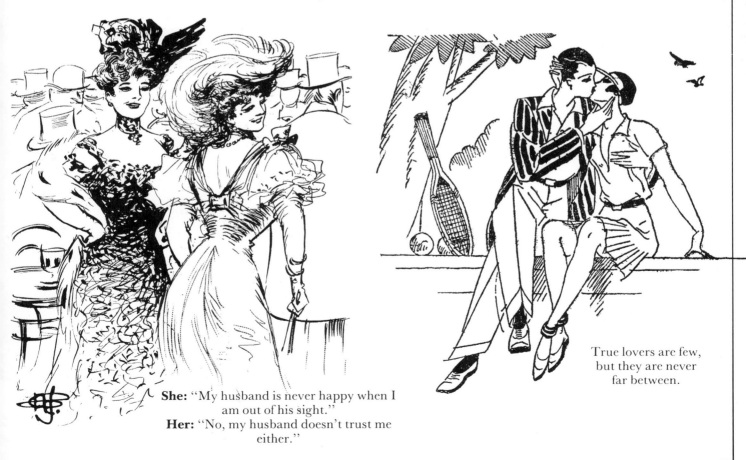

She: "My husband is never happy when I am out of his sight."
Her: "No, my husband doesn't trust me either."

True lovers are few, but they are never far between.

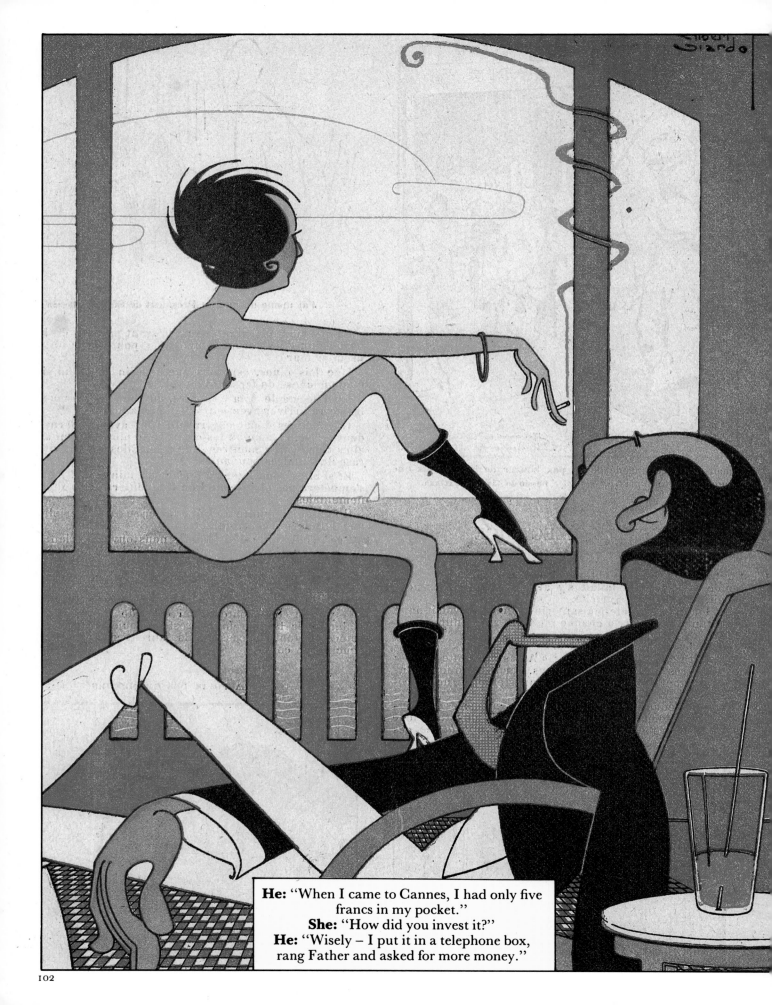

He: "When I came to Cannes, I had only five francs in my pocket."
She: "How did you invest it?"
He: "Wisely – I put it in a telephone box, rang Father and asked for more money."

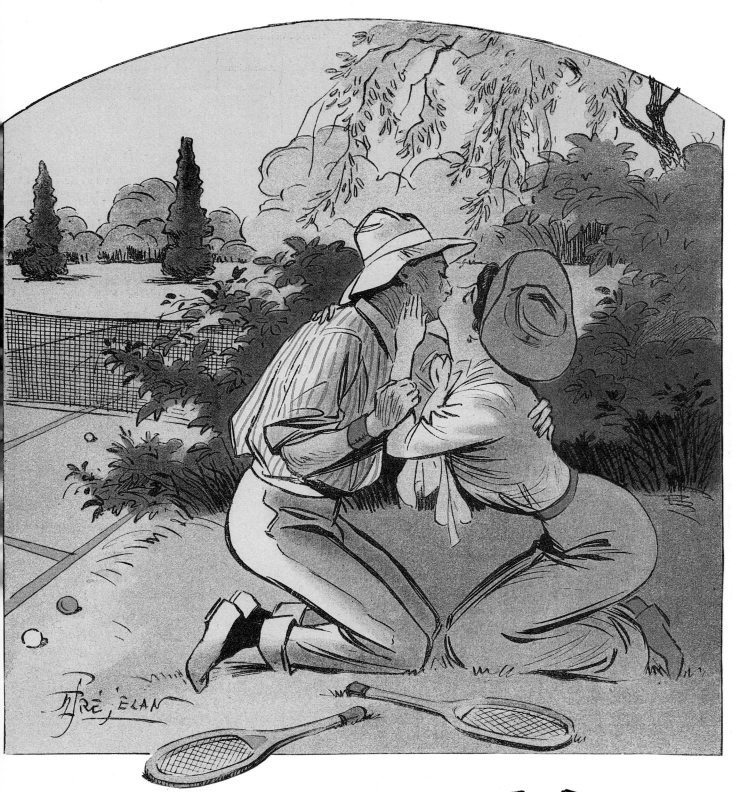

When once she is kissed in a public place,
One kiss will not suffice her.
It's fun to be kissed in a public place,
But the private ones are nicer.

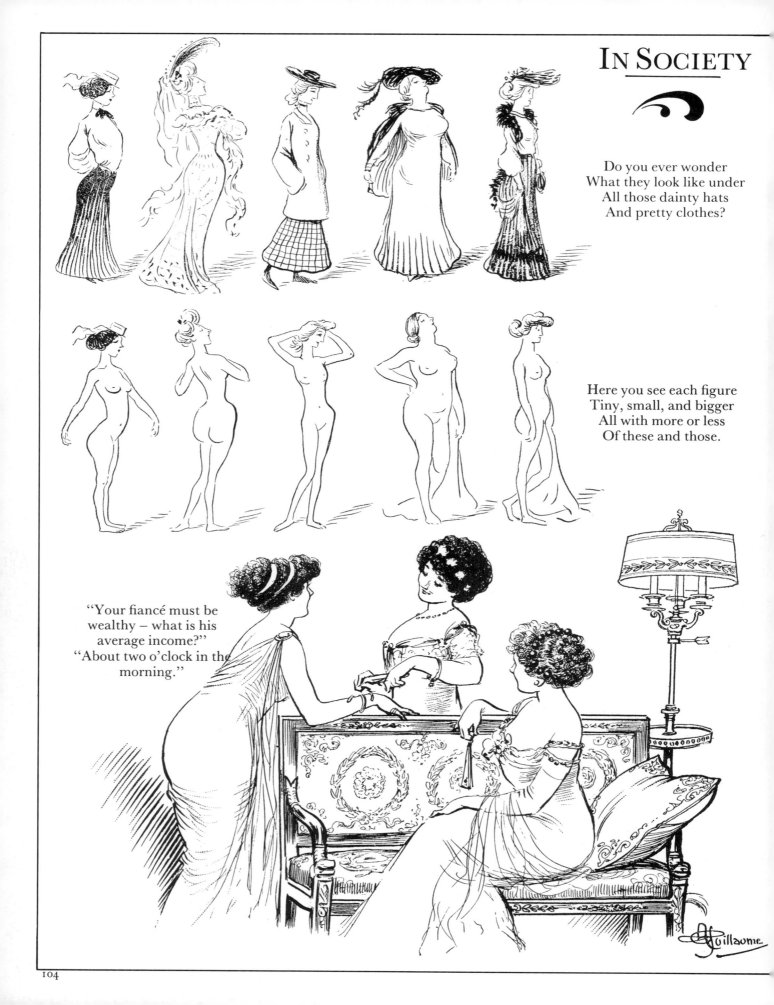

IN SOCIETY

Do you ever wonder
What they look like under
All those dainty hats
And pretty clothes?

Here you see each figure
Tiny, small, and bigger
All with more or less
Of these and those.

"Your fiancé must be
wealthy – what is his
average income?"
"About two o'clock in the
morning."

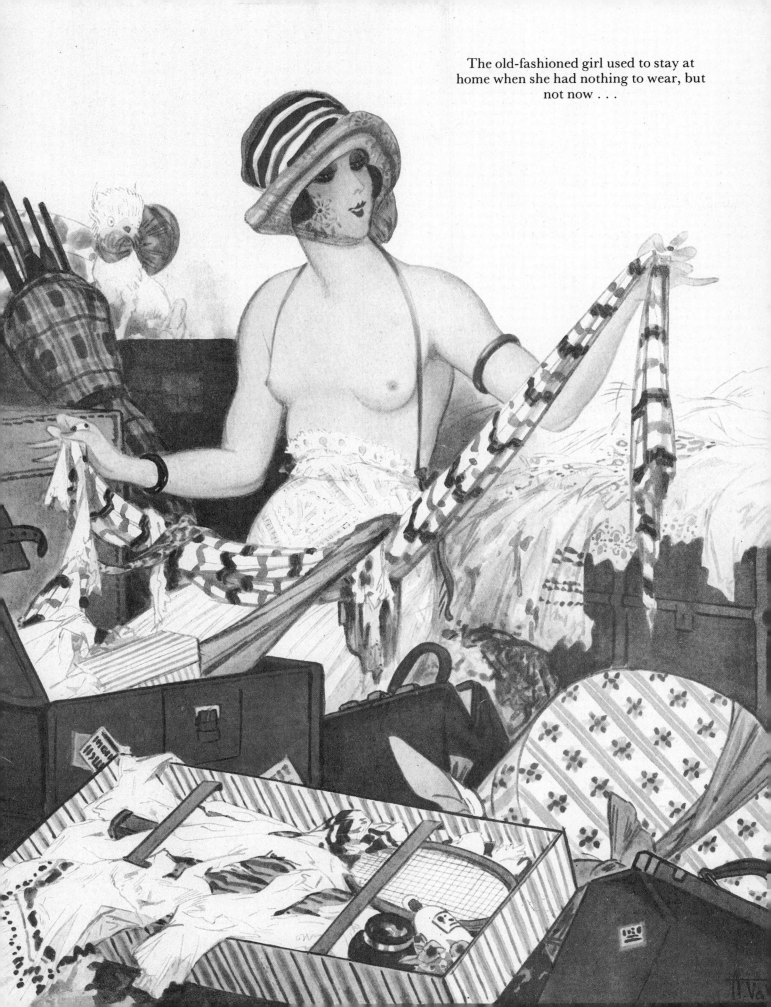

The old-fashioned girl used to stay at home when she had nothing to wear, but not now . . .

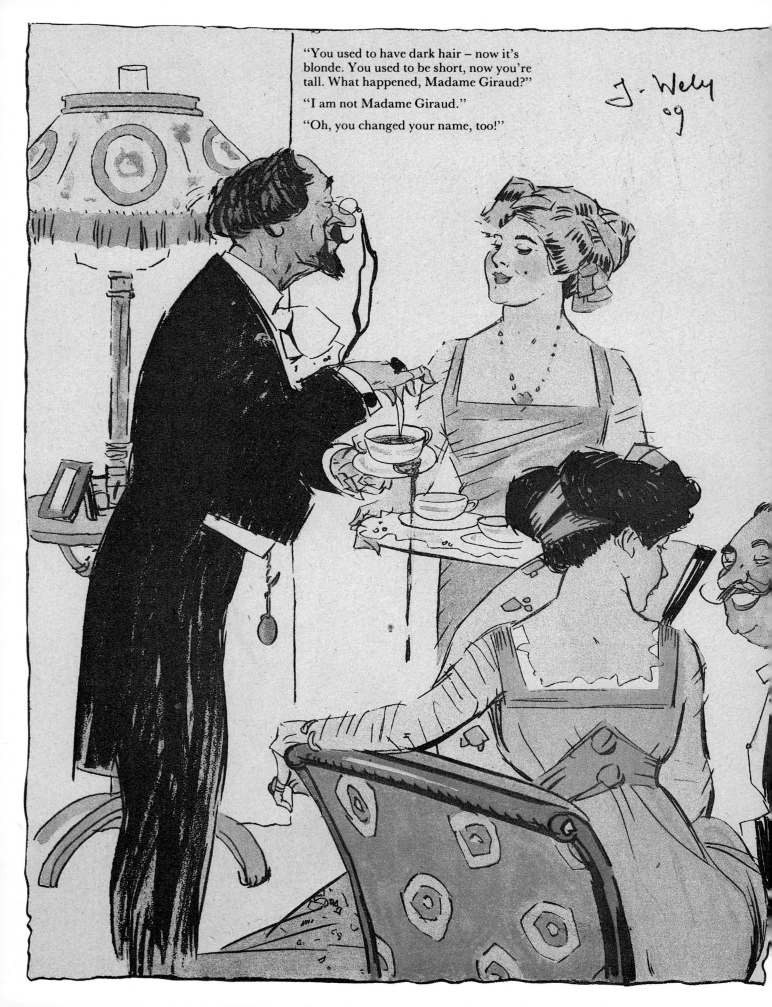

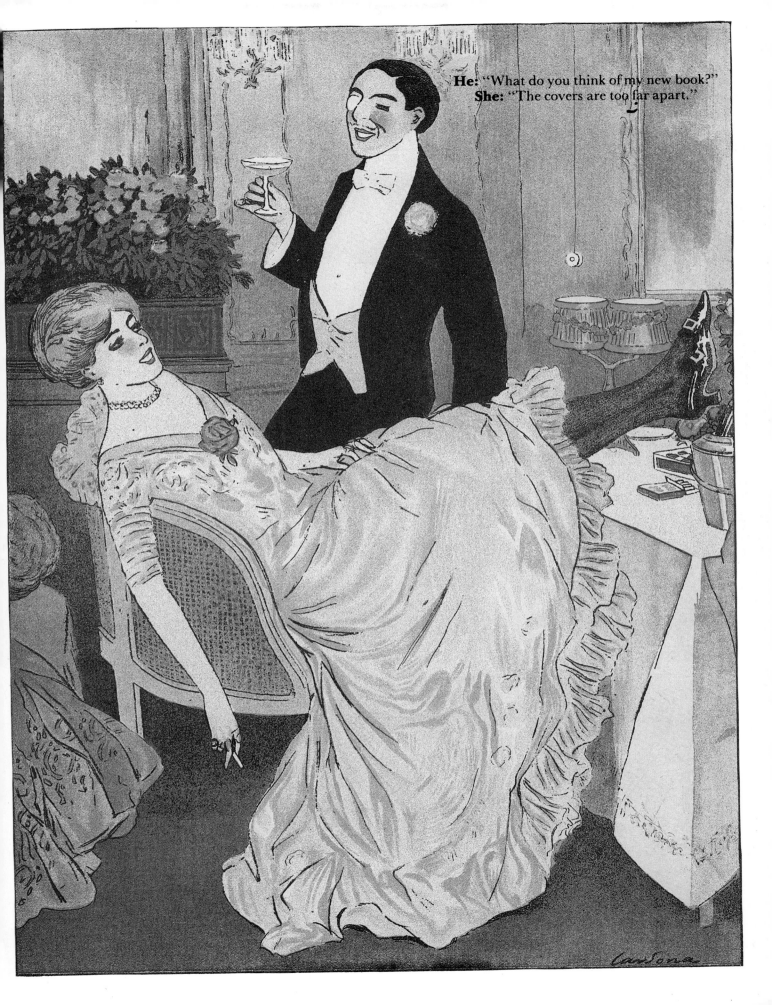

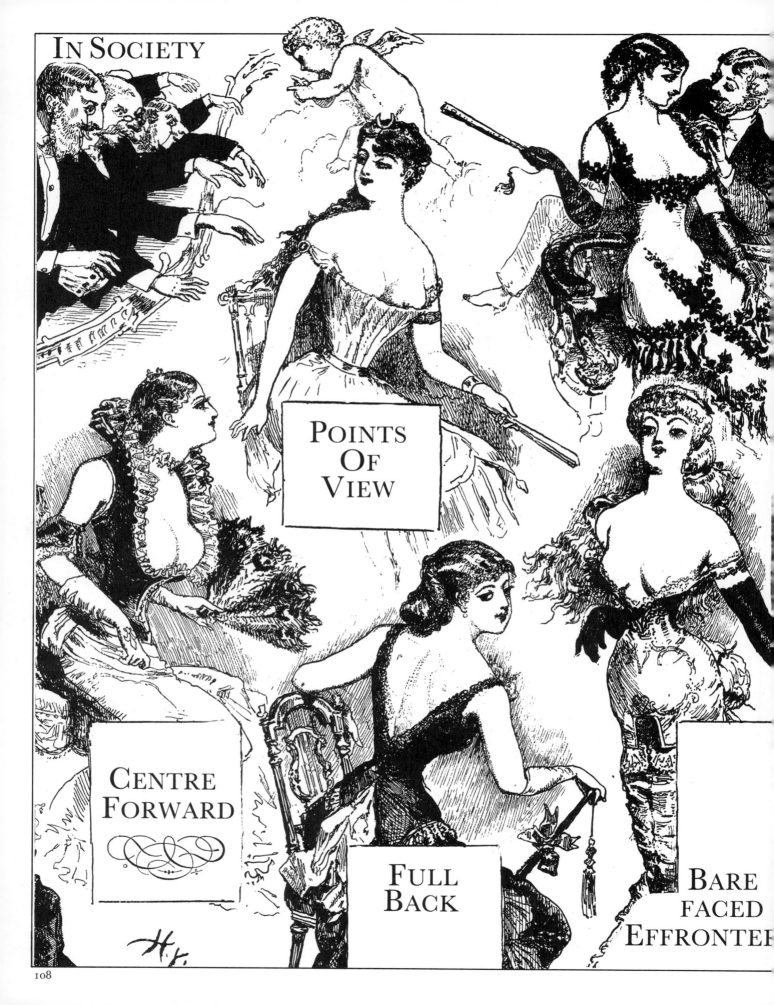

IN SOCIETY

POINTS OF VIEW

CENTRE FORWARD

FULL BACK

BARE FACED EFFRONTER

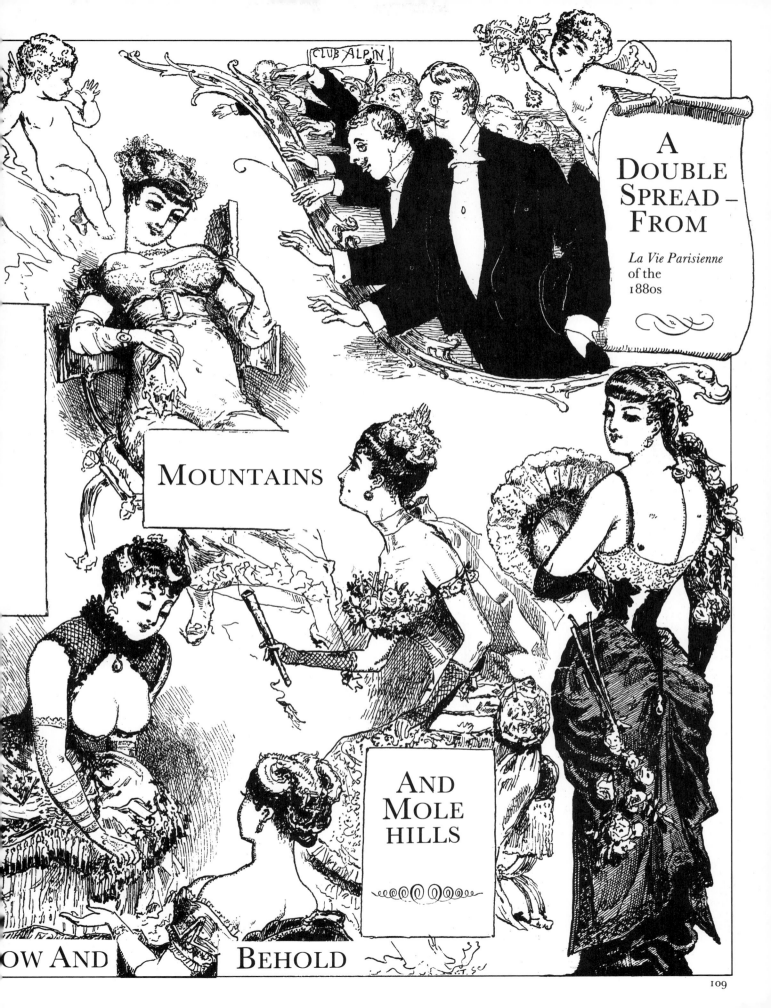

A
DOUBLE
SPREAD –
FROM

La Vie Parisienne
of the
1880s

MOUNTAINS

AND
MOLE
HILLS

OW AND BEHOLD

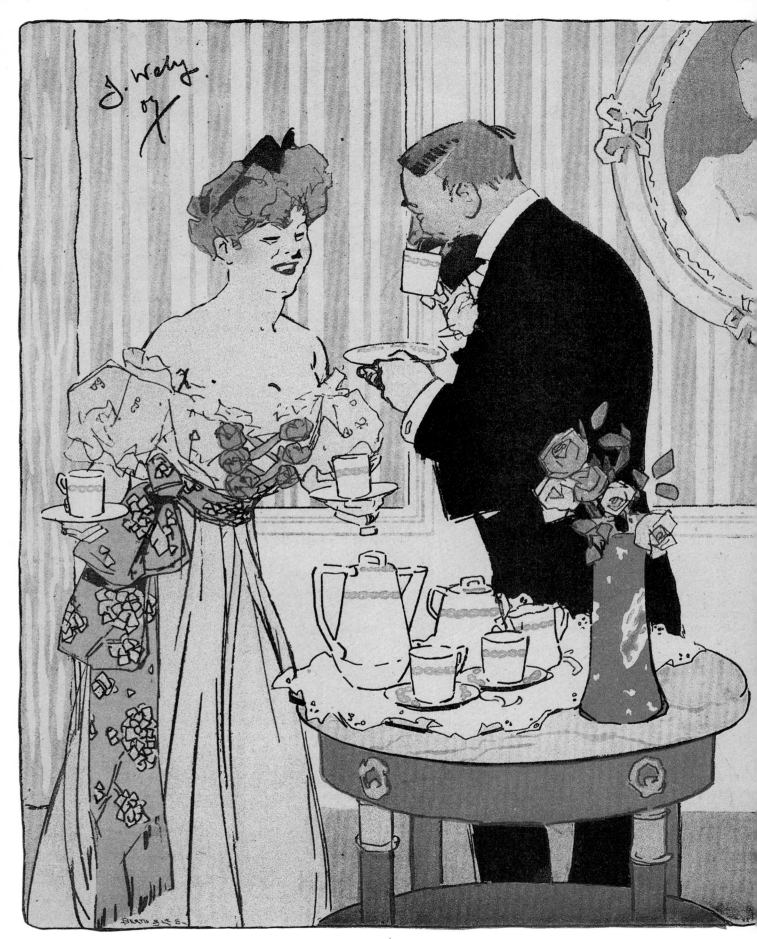

She: "I think your wife needs a change of air."
He: "So do I. I'll get her an electric fan."

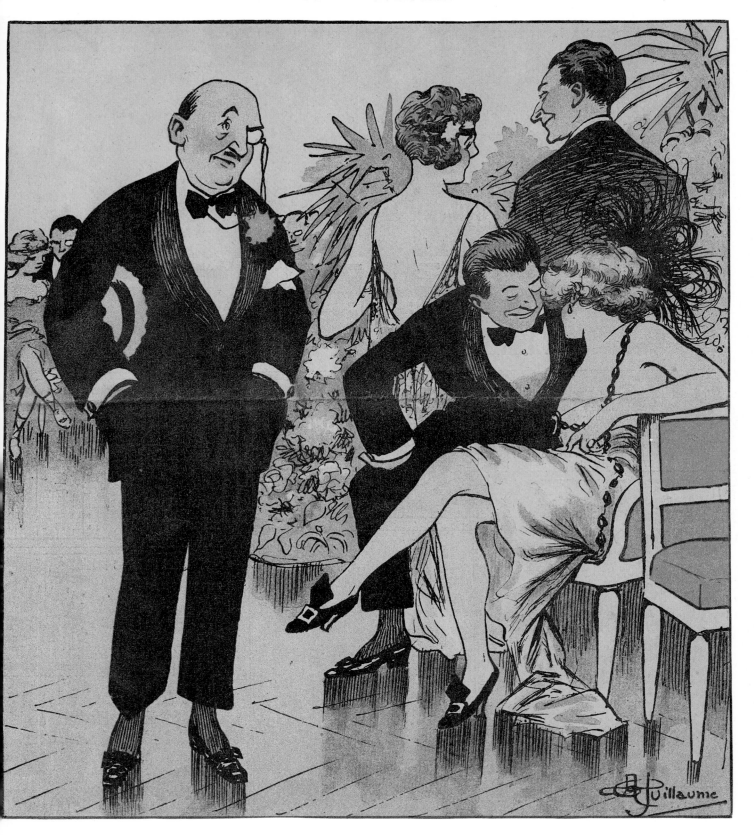

In Society

She: "Did you ever see anything like my husband?"
He: "Only once, but I had to pay admission."

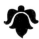

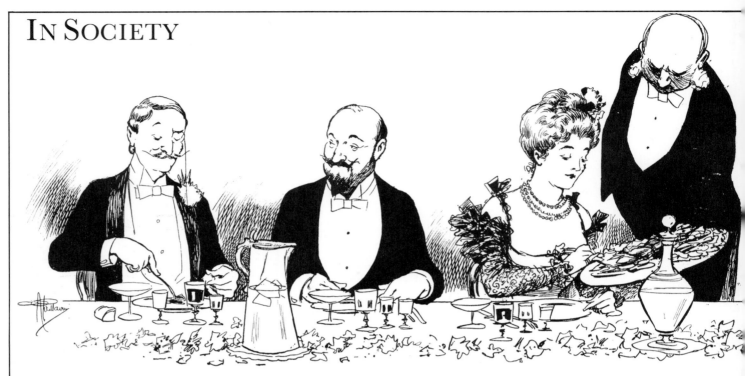

Monocle: "Do you believe in clubs for women?"
Beard: "If kindness fails, yes."

He: "Ah! After you, madame. I'm sorry, I didn't see you."
She: "Really? How kind!"

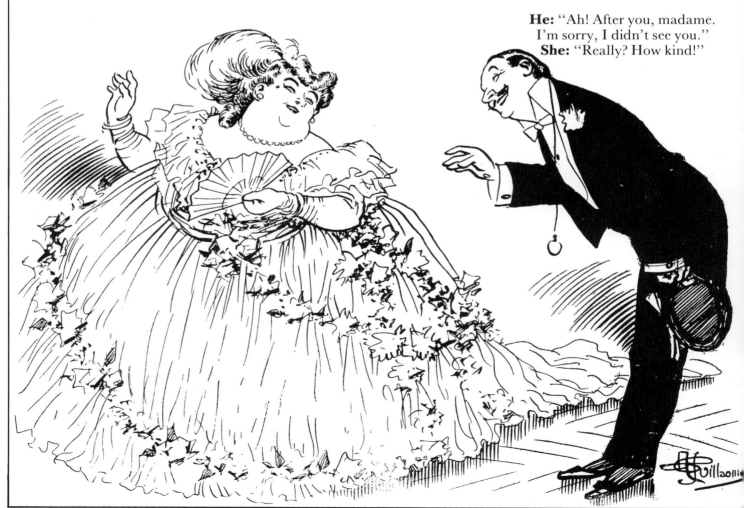

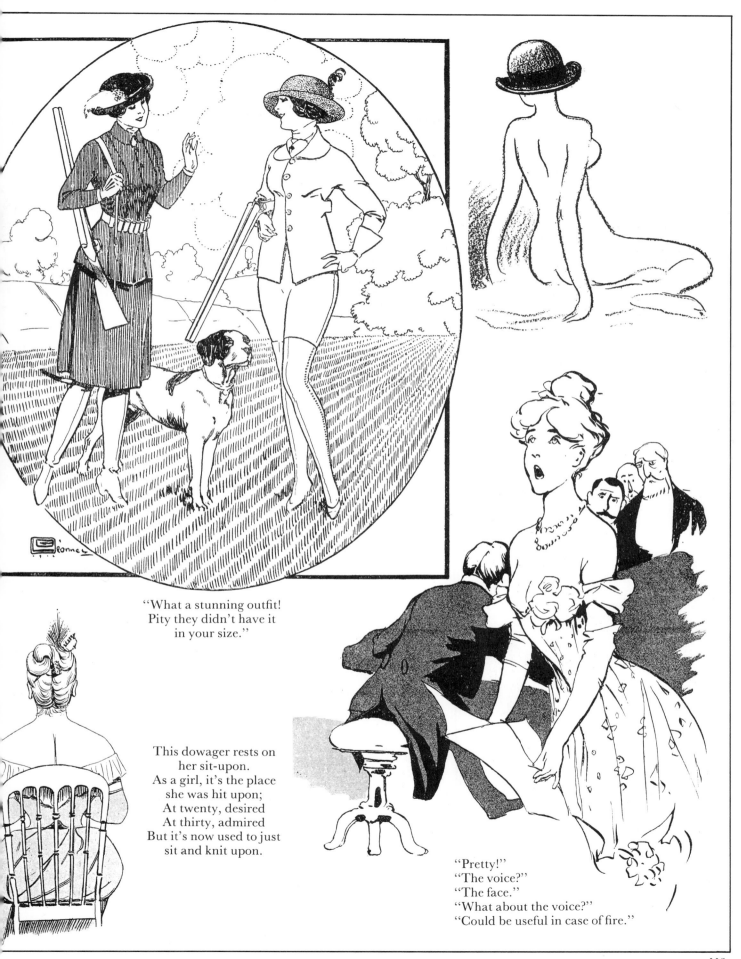

"What a stunning outfit!
Pity they didn't have it
in your size."

This dowager rests on
her sit-upon.
As a girl, it's the place
she was hit upon;
At twenty, desired
At thirty, admired
But it's now used to just
sit and knit upon.

"Pretty!"
"The voice?"
"The face."
"What about the voice?"
"Could be useful in case of fire."

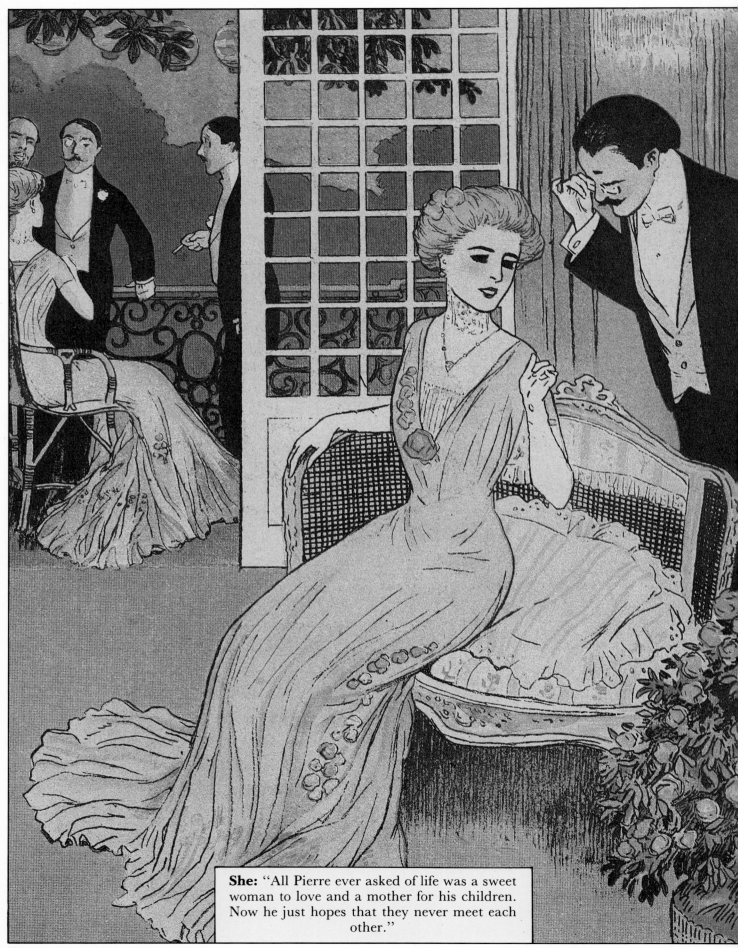

She: "All Pierre ever asked of life was a sweet woman to love and a mother for his children. Now he just hopes that they never meet each other."

OOH-LA-LA! THE LADIES OF PARIS
AN
INTERLUDE
FAWNS FADS AND FANTASIES

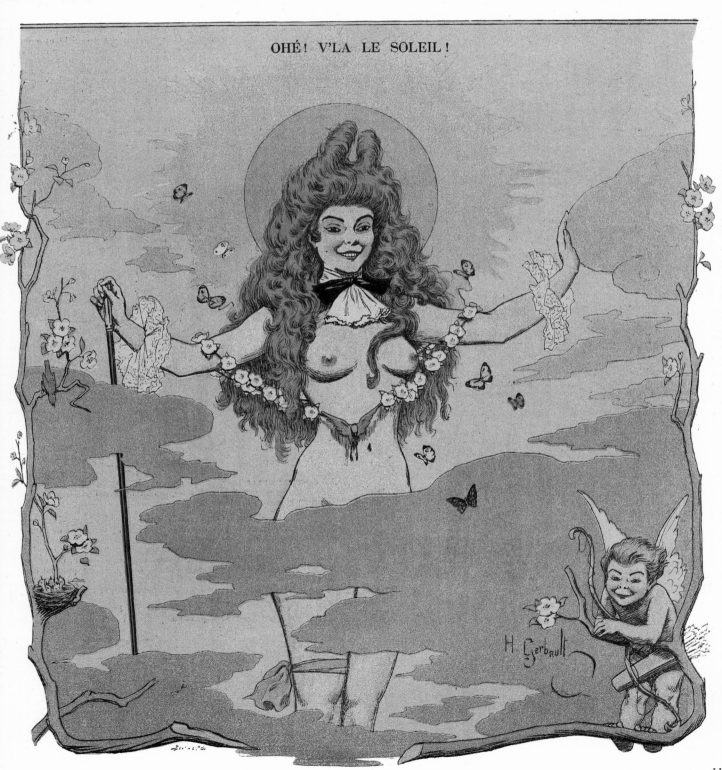

OHÉ! V'LA LE SOLEIL!

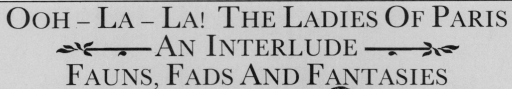

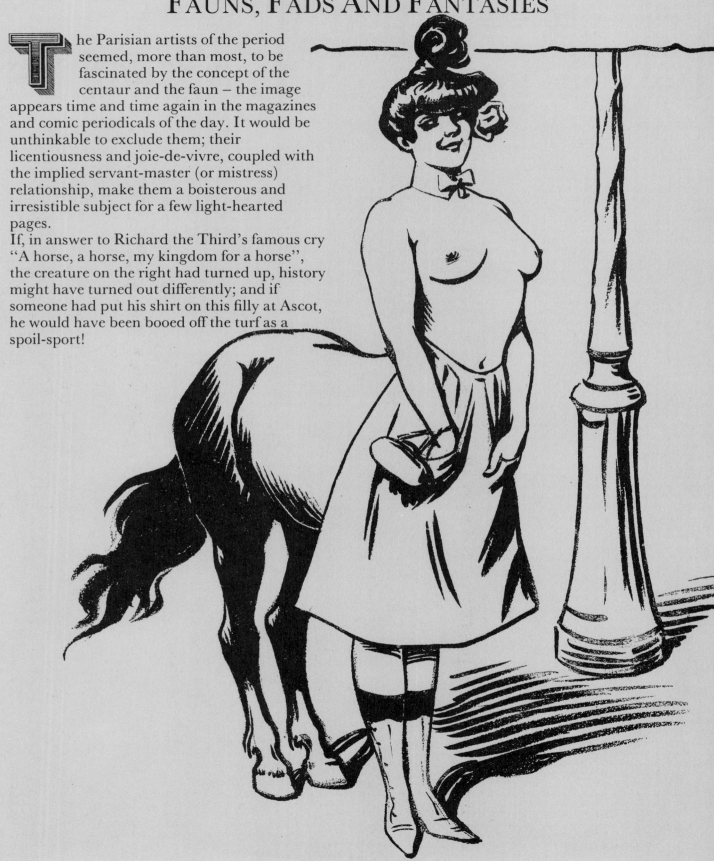

The Parisian artists of the period seemed, more than most, to be fascinated by the concept of the centaur and the faun – the image appears time and time again in the magazines and comic periodicals of the day. It would be unthinkable to exclude them; their licentiousness and joie-de-vivre, coupled with the implied servant-master (or mistress) relationship, make them a boisterous and irresistible subject for a few light-hearted pages.

If, in answer to Richard the Third's famous cry "A horse, a horse, my kingdom for a horse", the creature on the right had turned up, history might have turned out differently; and if someone had put his shirt on this filly at Ascot, he would have been booed off the turf as a spoil-sport!

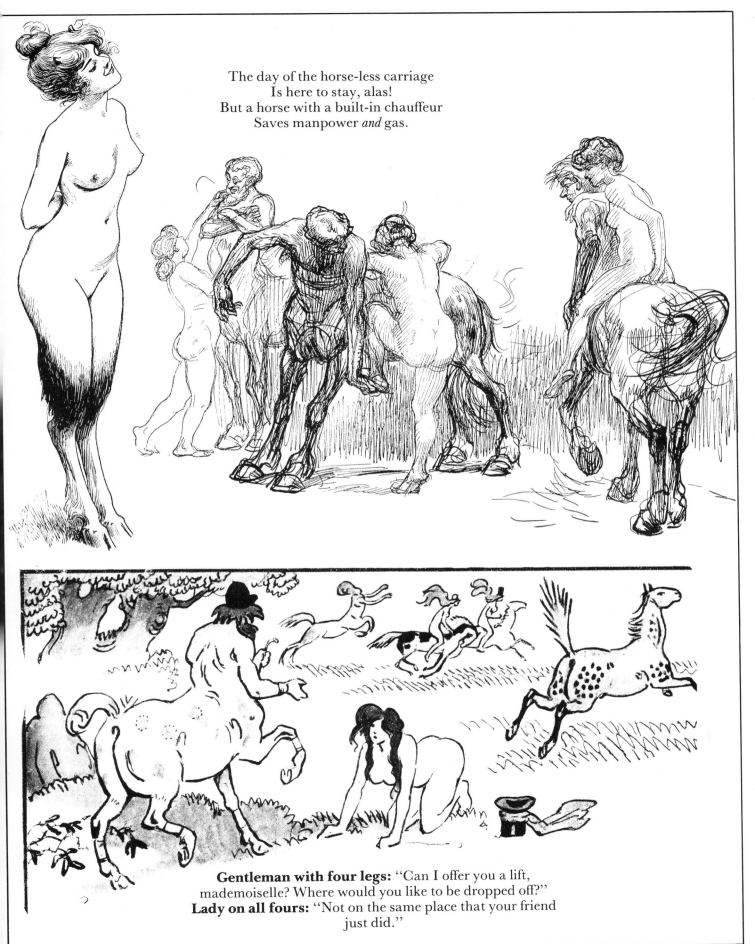

The day of the horse-less carriage
Is here to stay, alas!
But a horse with a built-in chauffeur
Saves manpower *and* gas.

Gentleman with four legs: "Can I offer you a lift, mademoiselle? Where would you like to be dropped off?"
Lady on all fours: "Not on the same place that your friend just did."

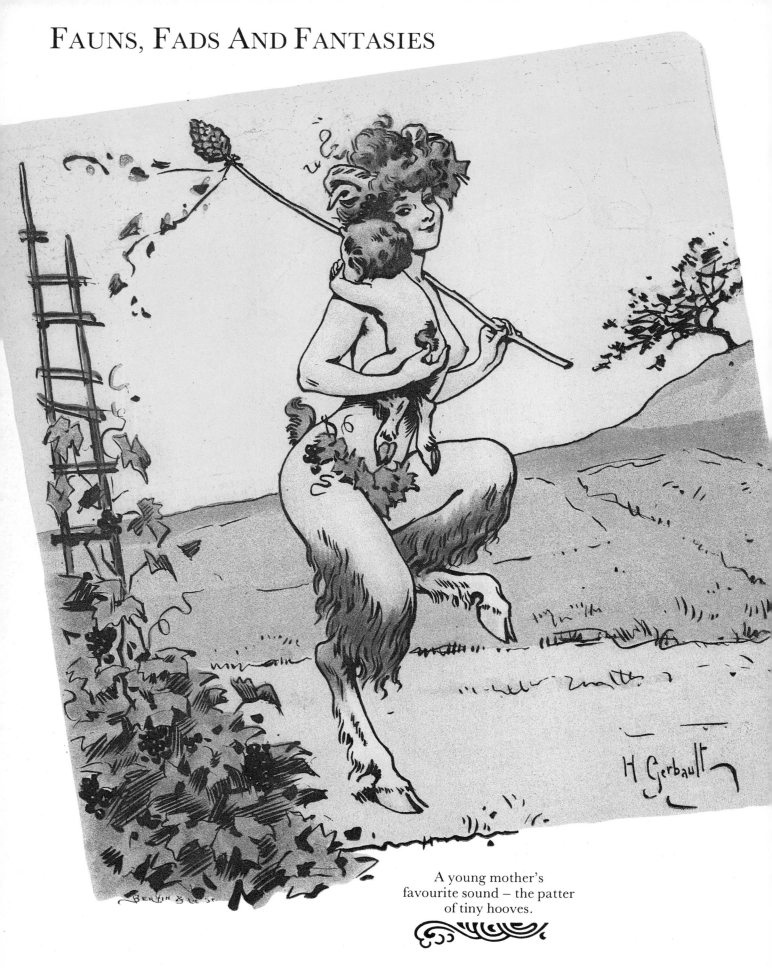

A young mother's
favourite sound – the patter
of tiny hooves.

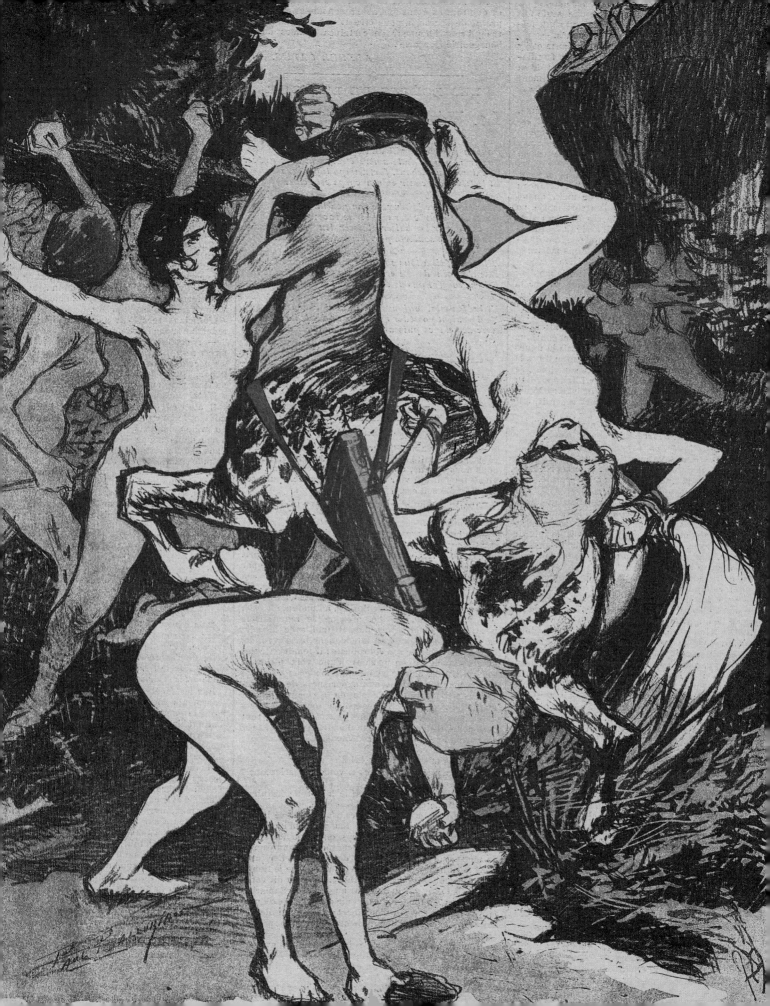

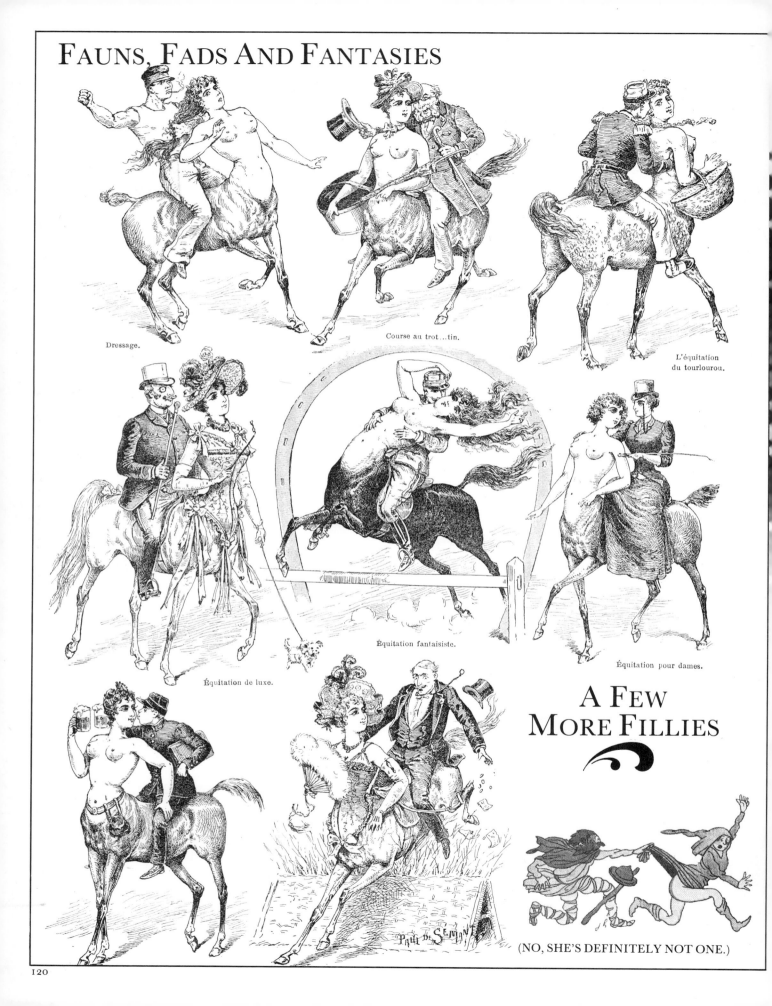

Dressage.

Course au trot...tin.

L'équitation du tourlourou.

Équitation de luxe.

Équitation fantaisiste.

Équitation pour dames.

A FEW MORE FILLIES

(NO, SHE'S DEFINITELY NOT ONE.)

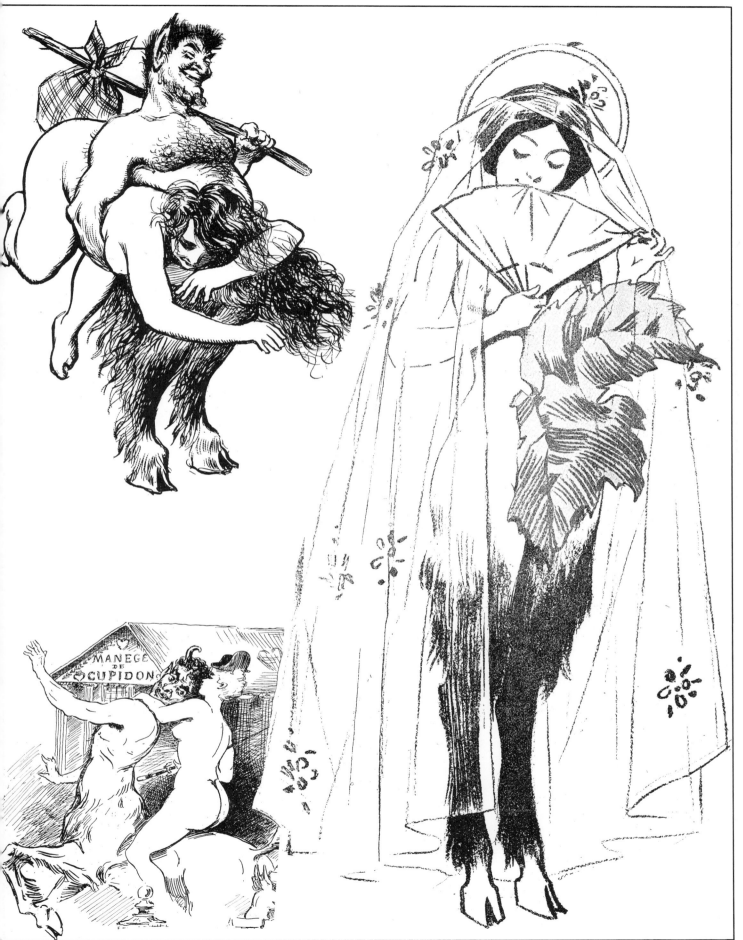

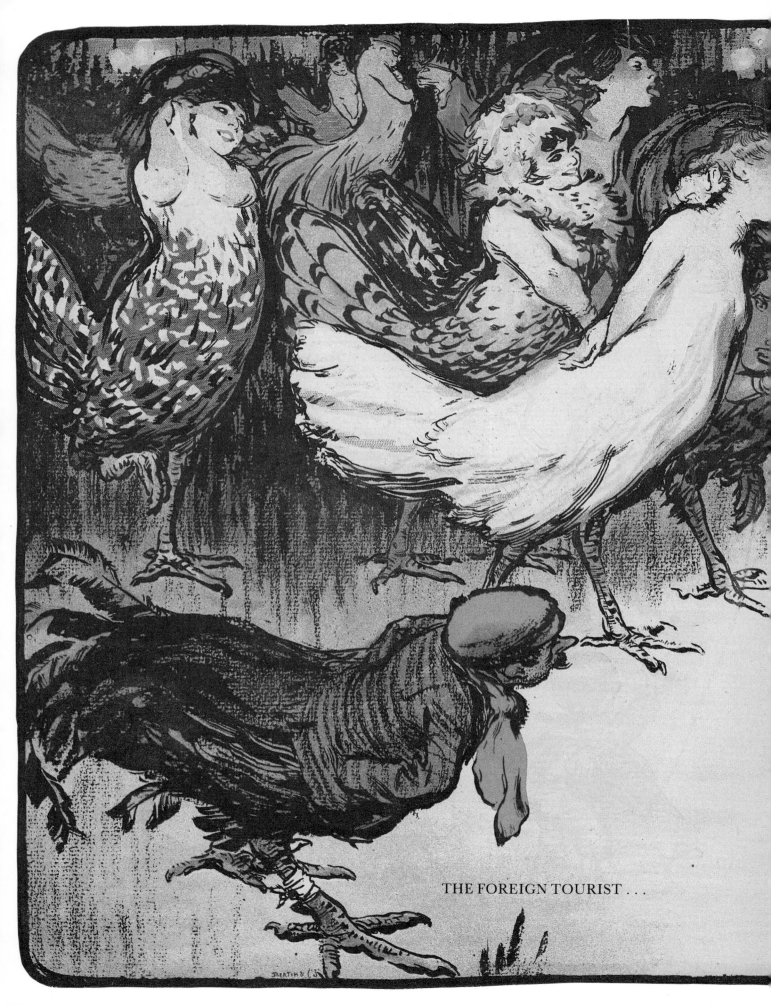

THE FOREIGN TOURIST . . .

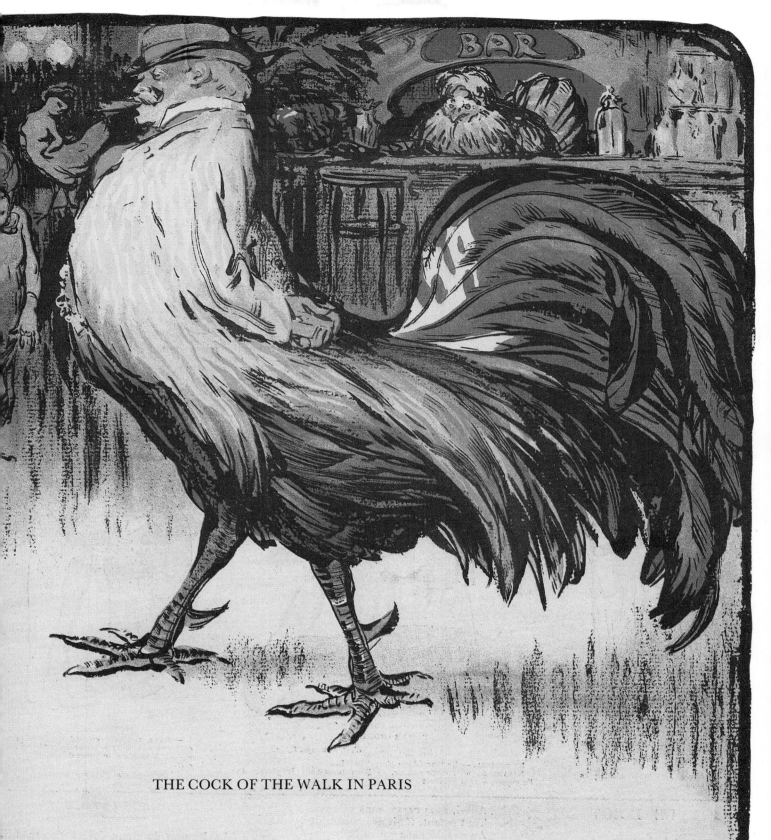

THE COCK OF THE WALK IN PARIS

Kupka

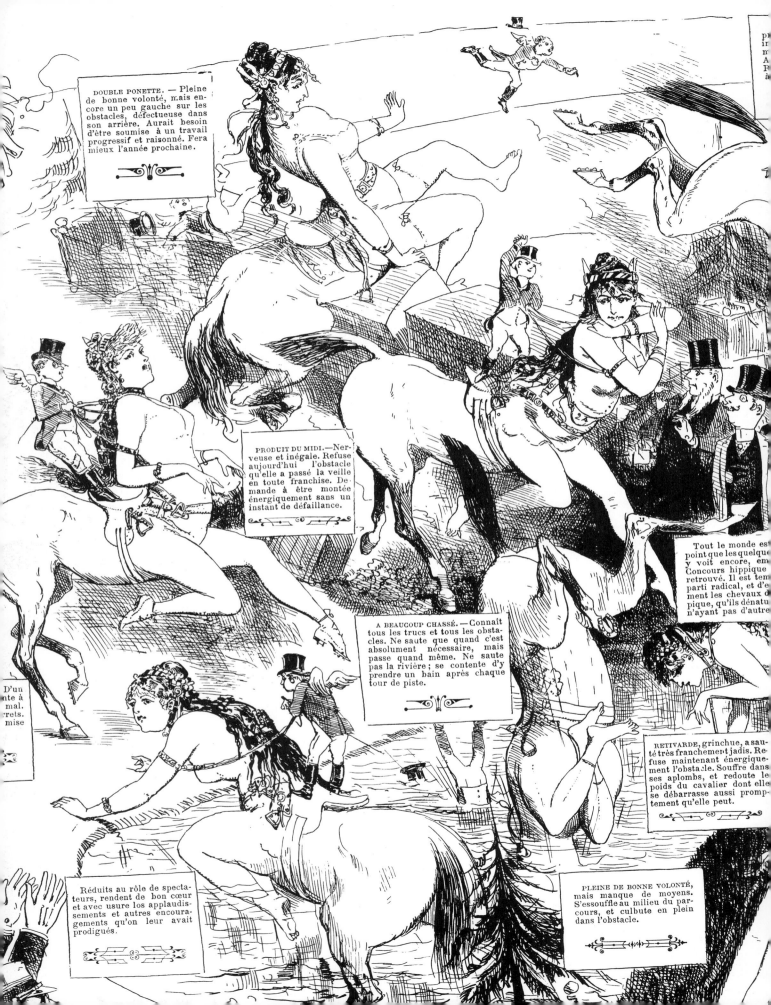

DOUBLE PONETTE. — Pleine de bonne volonté, mais encore un peu gauche sur les obstacles, défectueuse dans son arrière. Aurait besoin d'être soumise à un travail progressif et raisonné. Fera mieux l'année prochaine.

PRODUIT DU MIDI. — Nerveuse et inégale. Refuse aujourd'hui l'obstacle qu'elle a passé la veille en toute franchise. Demande à être montée énergiquement sans un instant de défaillance.

A BEAUCOUP CHASSÉ. — Connaît tous les trucs et tous les obstacles. Ne saute que quand c'est absolument nécessaire, mais passe quand même. Ne saute pas la rivière; se contente d'y prendre un bain après chaque tour de piste.

Tout le monde est point que les quelque y voit encore, en Concours hippique retrouvé. Il est tem parti radical, et d'e ment les chevaux d pique, qu'ils dénatu n'ayant pas d'autre

RETIVARDE, grinchue, a sauté très franchement jadis. Refuse maintenant énergiquement l'obstacle. Souffre dans ses aplombs, et redoute le poids du cavalier dont elle se débarrasse aussi promptement qu'elle peut.

D'un nte à mal. rrets. mise

Réduits au rôle de spectateurs, rendent de bon cœur et avec usure les applaudissements et autres encouragements qu'on leur avait prodigués.

PLEINE DE BONNE VOLONTÉ, mais manque de moyens. S'essouffle au milieu du parcours, et culbute en plein dans l'obstacle.

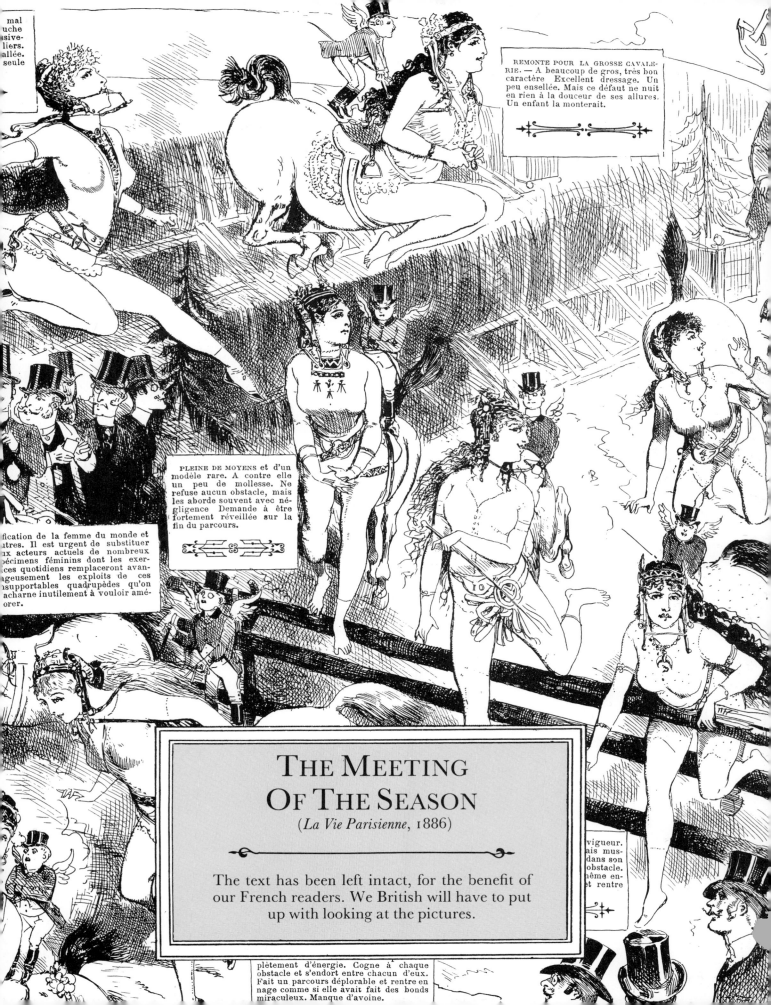

REMONTE POUR LA GROSSE CAVALE-RIE. — A beaucoup de gros, très bon caractère Excellent dressage. Un peu ensellée. Mais ce défaut ne nuit en rien à la douceur de ses allures. Un enfant la monterait.

PLEINE DE MOYENS et d'un modèle rare. A contre elle un peu de mollesse. Ne refuse aucun obstacle, mais les aborde souvent avec né-gligence Demande à être fortement réveillée sur la fin du parcours.

...fication de la femme du monde et ...tres. Il est urgent de substituer ...ux acteurs actuels de nombreux ...pécimens féminins dont les exer-...ces quotidiens remplaceront avan-...ageusement les exploits de ces ...nsupportables quadrupèdes qu'on ...acharne inutilement à vouloir amé-...orer.

THE MEETING OF THE SEASON

(*La Vie Parisienne*, 1886)

The text has been left intact, for the benefit of our French readers. We British will have to put up with looking at the pictures.

...vigueur. ...ais mus-...dans son ...obstacle. ...ême en-...t rentre

plètement d'énergie. Cogne à chaque obstacle et s'endort entre chacun d'eux. Fait un parcours déplorable et rentre en nage comme si elle avait fait des bonds miraculeux. Manque d'avoine.

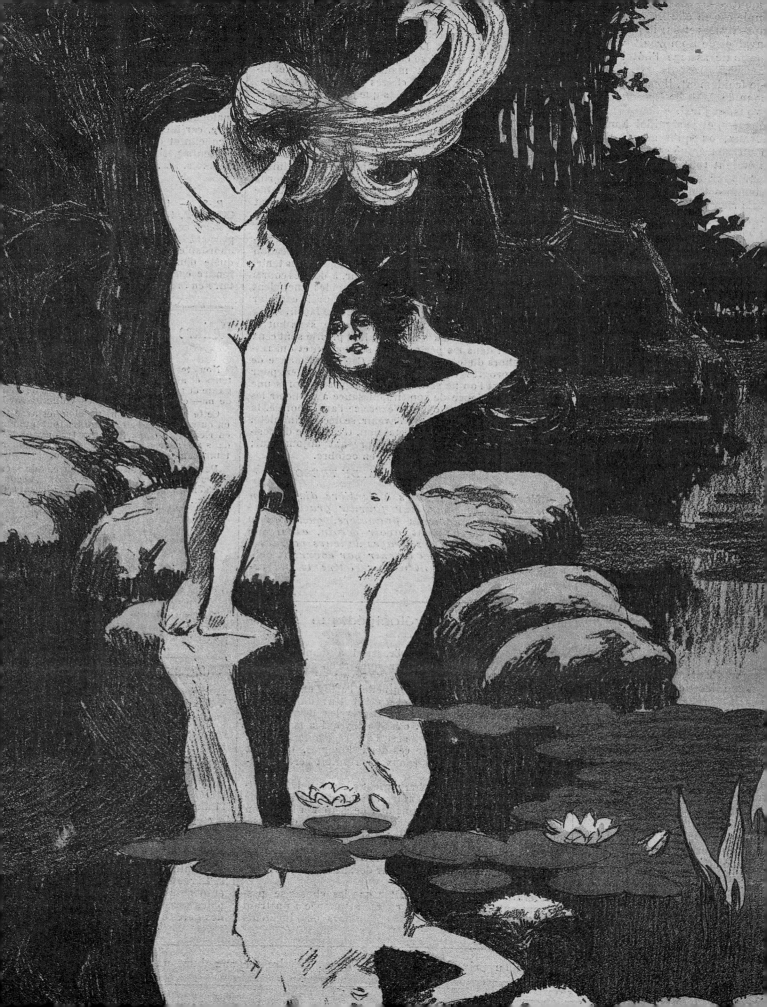

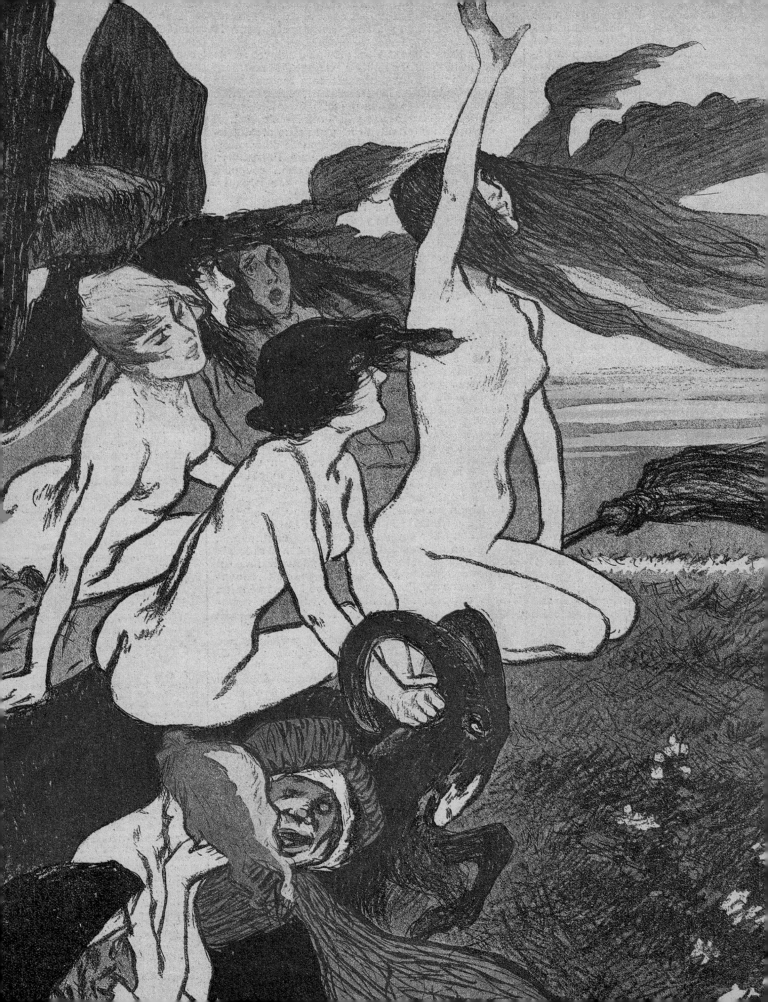

THE STOCKING THROUGH THE AGES

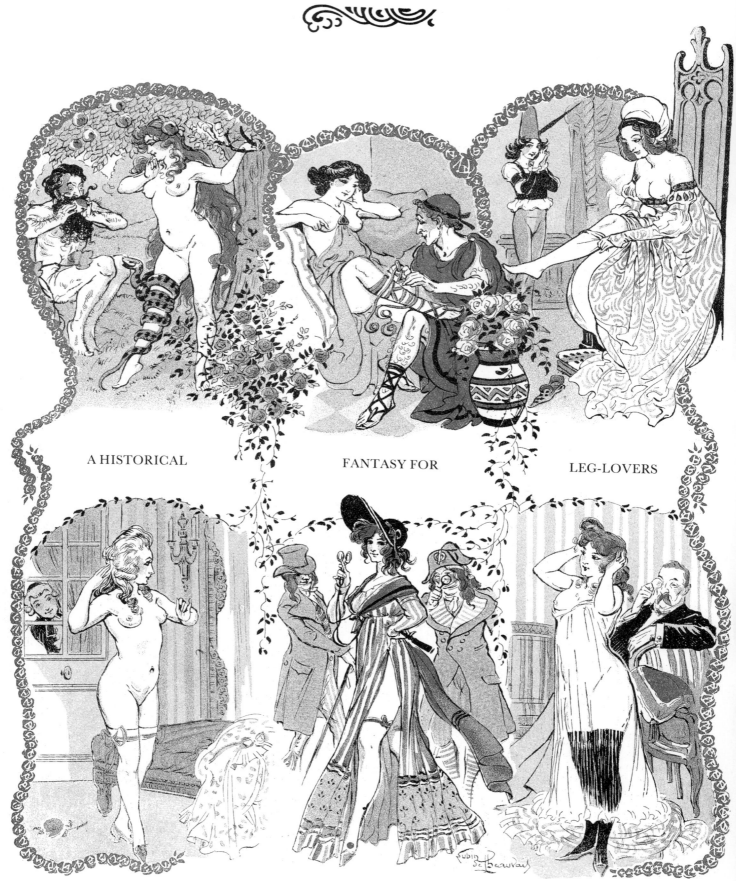

A HISTORICAL FANTASY FOR LEG-LOVERS

OOH-LA-LA!
THE LADIES OF PARIS
IN THE BATH

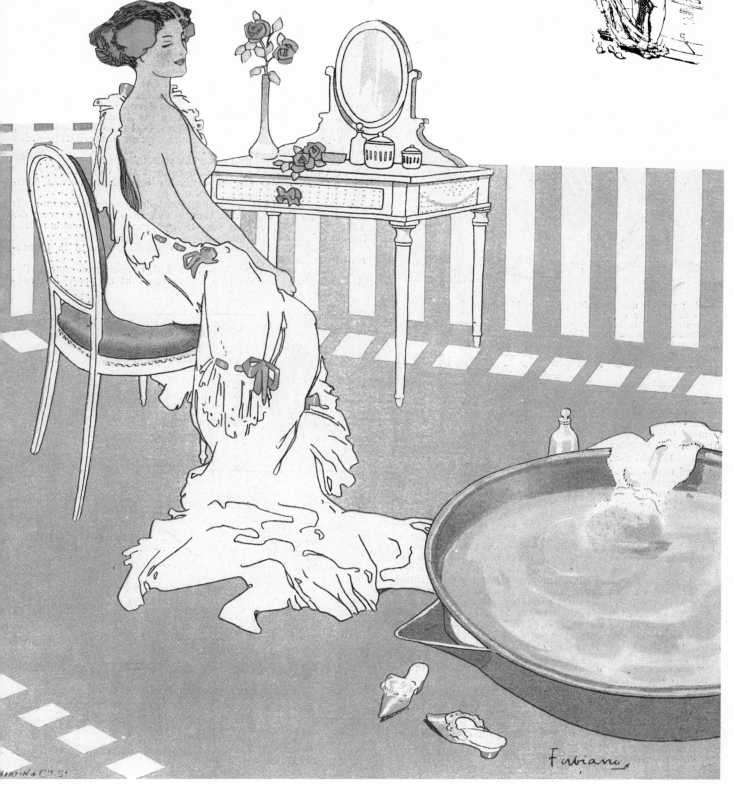

OOH – LA – LA!
THE LADIES OF PARIS
IN THE BATH

It might be argued that in the bath the Parisienne looks like any other girl – one nose, one navel, and two of most other things. But these delightful drawings are proof to the contrary. The tilt of the hand, the pride in the figure, the unselfconscious, almost over-bold stance – these creatures could have blossomed only in the Paris of the Belle Epoque – and, come to think of it, a chap would be jolly lucky to find one even then.

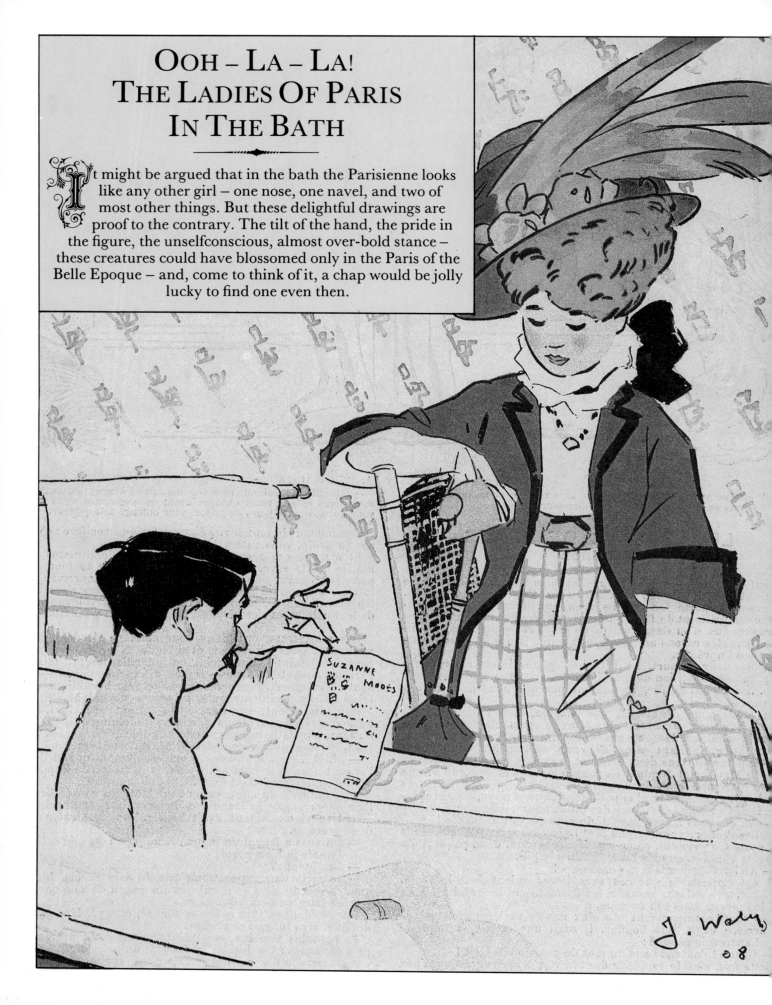

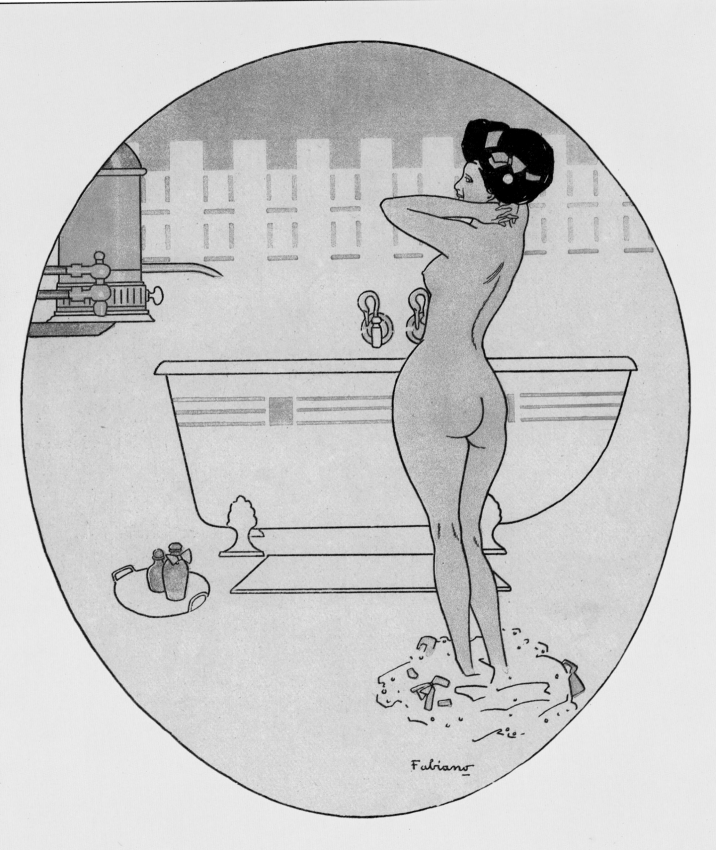

This nymph of the bath treads the middle path,
She's neither a bean nor a marrow.
She keeps her curves, for no man likes,
To follow the straight and narrow.

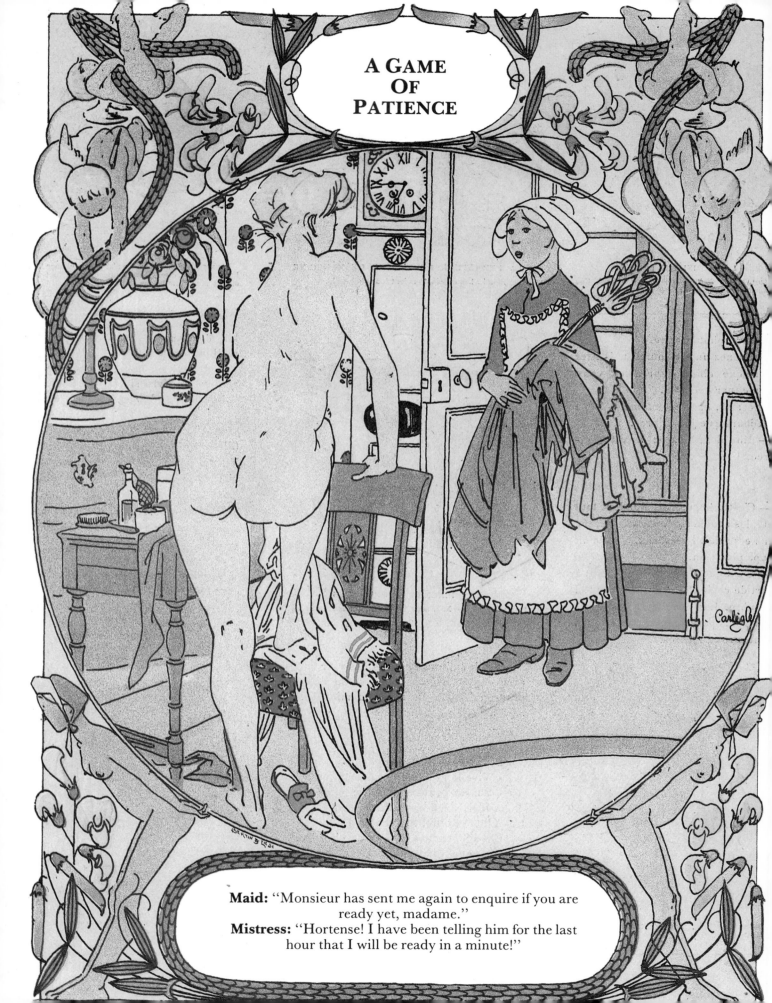

A GAME OF PATIENCE

Maid: "Monsieur has sent me again to enquire if you are ready yet, madame."
Mistress: "Hortense! I have been telling him for the last hour that I will be ready in a minute!"

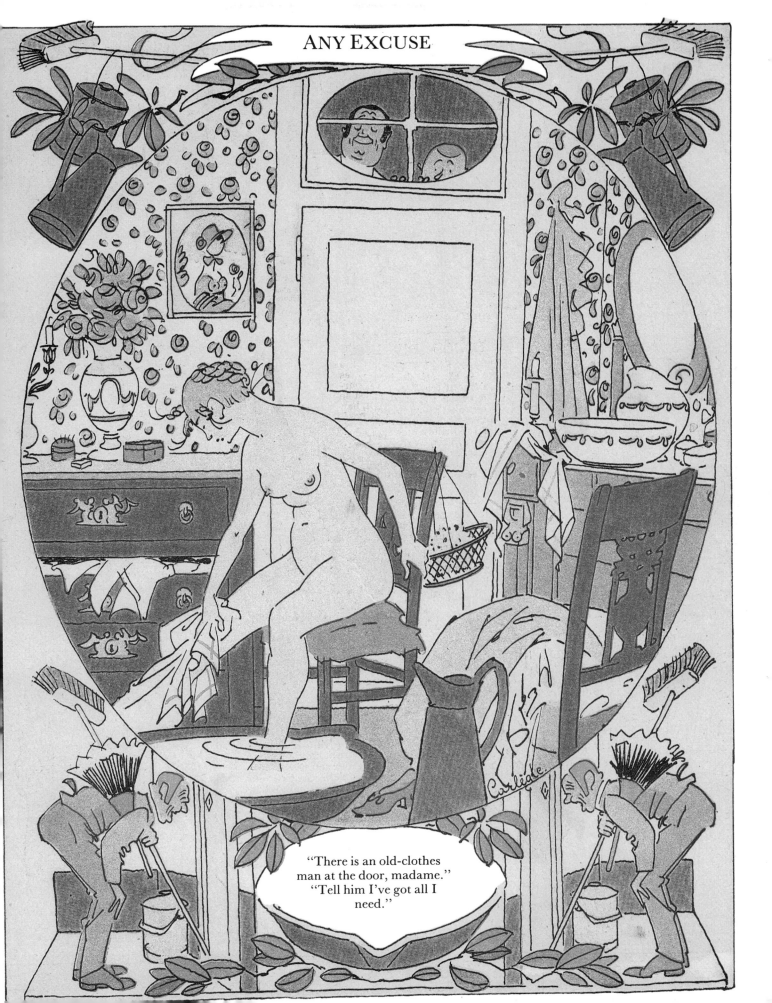

ANY EXCUSE

"There is an old-clothes
man at the door, madame."
"Tell him I've got all I
need."

In The Bath

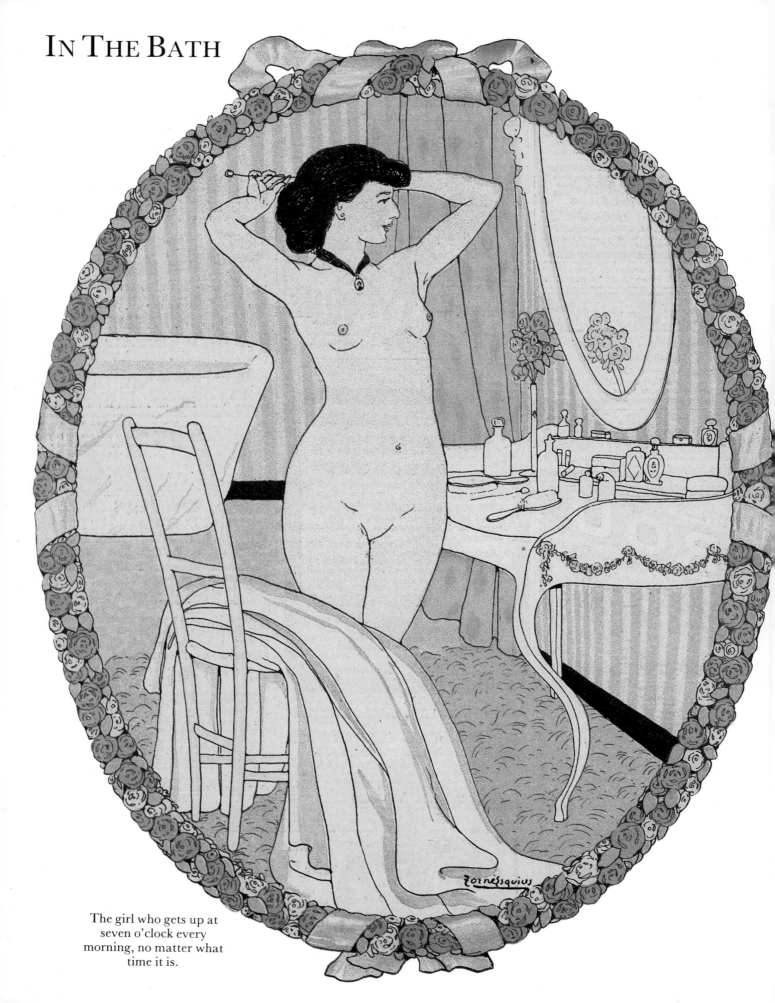

The girl who gets up at
seven o'clock every
morning, no matter what
time it is.

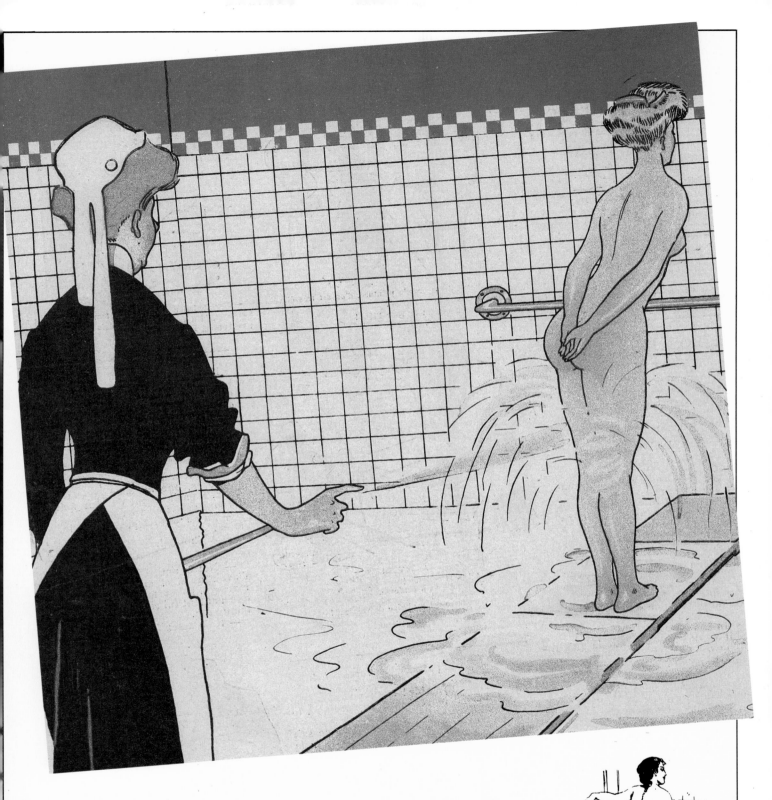

A terrible thing is the douche
It arrives with a fizz and a whoosh
And when you're standing there
With a bare derrière,
It's worse than a smack in the bouche.

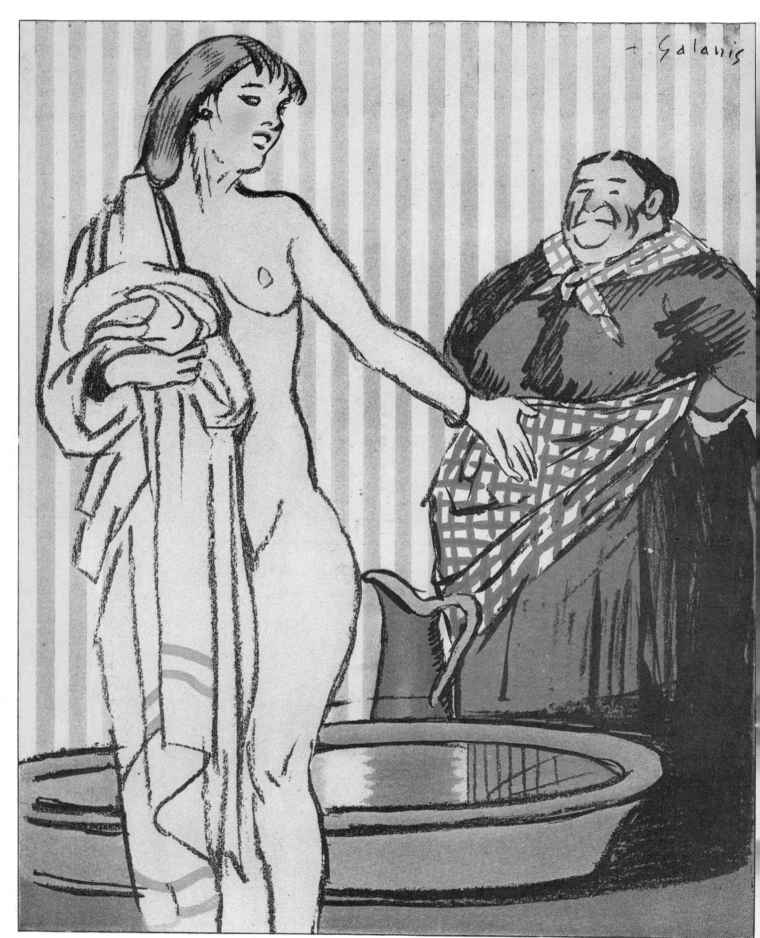

"Did you take a bath this morning?"
"Why, is there one missing?"

"I am leaving this hotel – there is no privacy."
"I am sorry, madame . . ."
"Last night when I came out of the bath, my eyes full of soap,
I could not find the towel, and a voice through the keyhole said –
'It's behind you, dear.'"

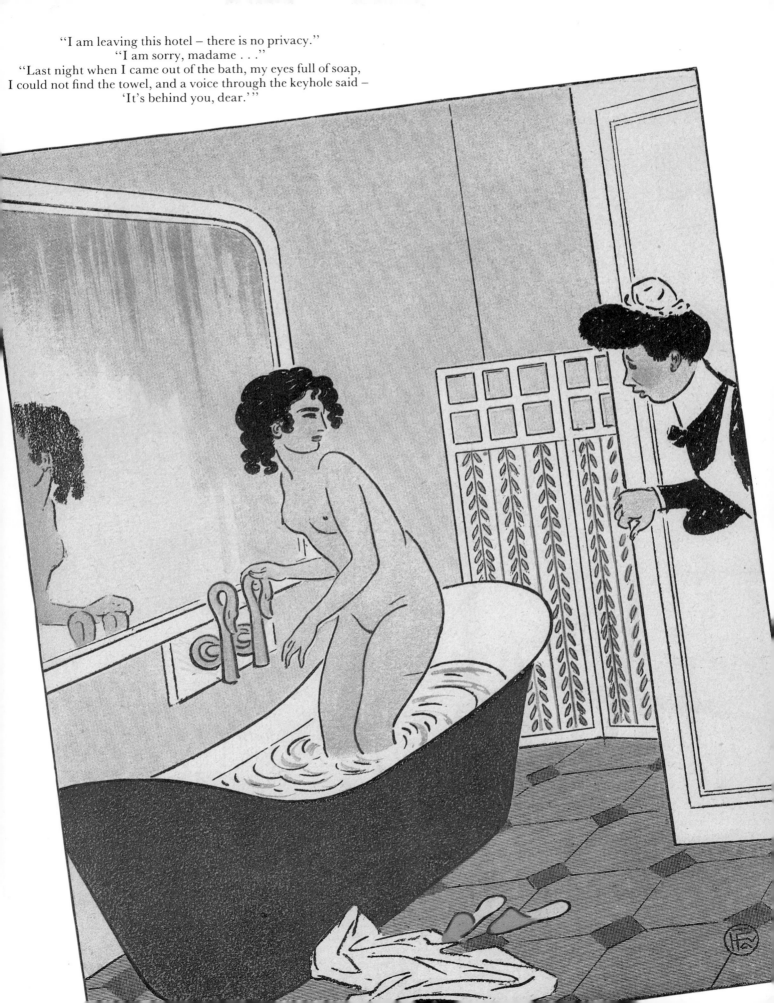

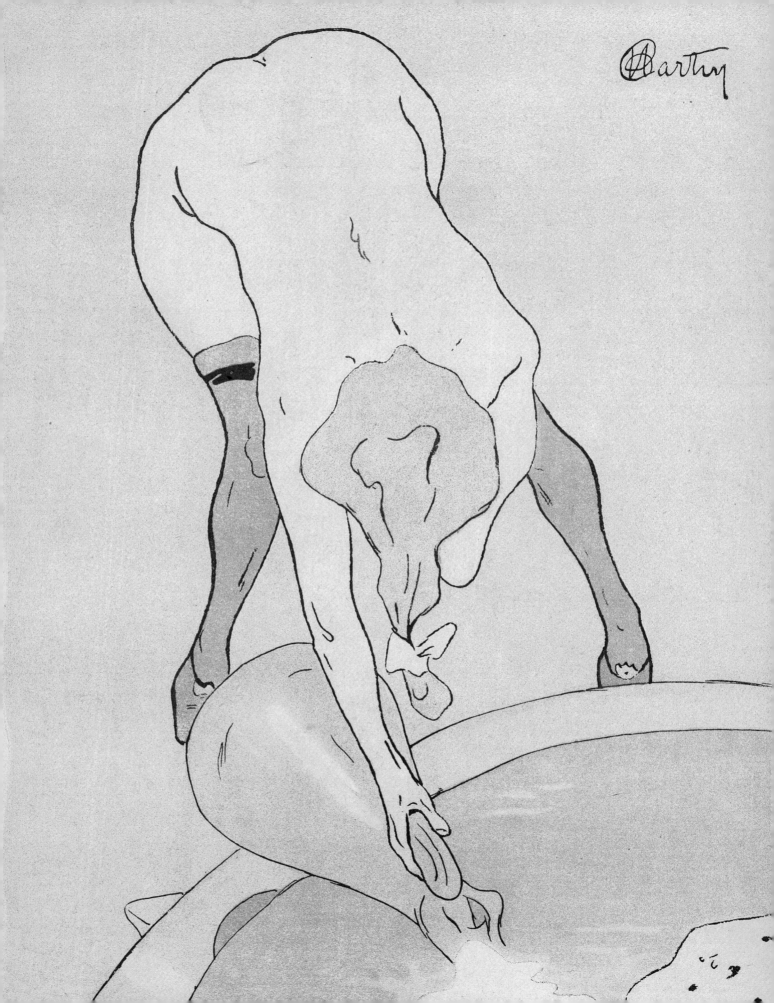

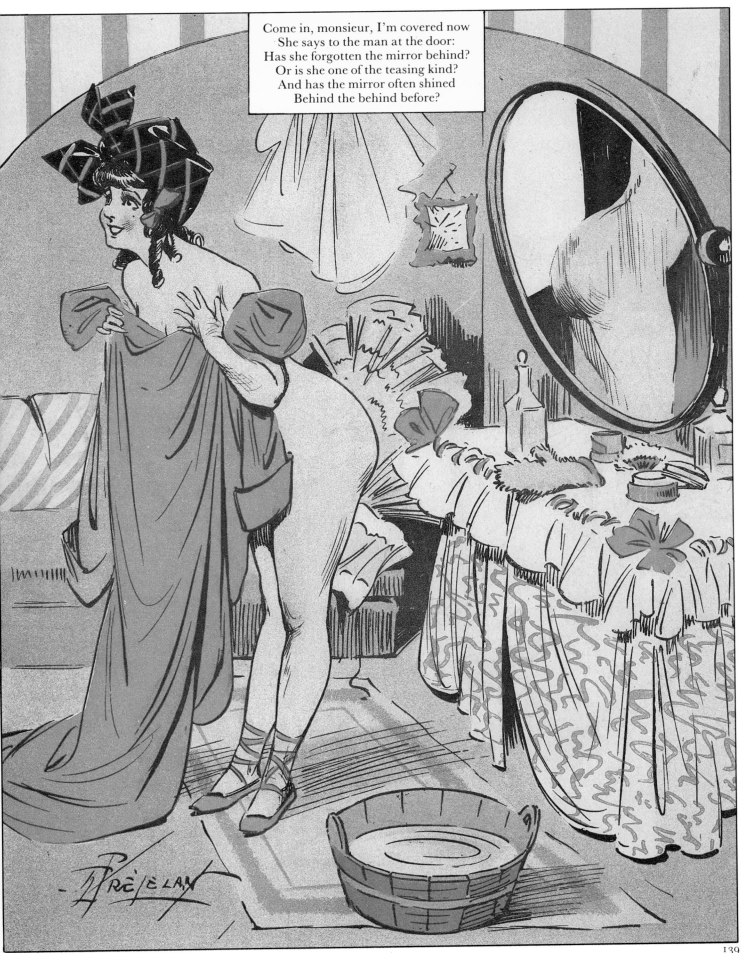

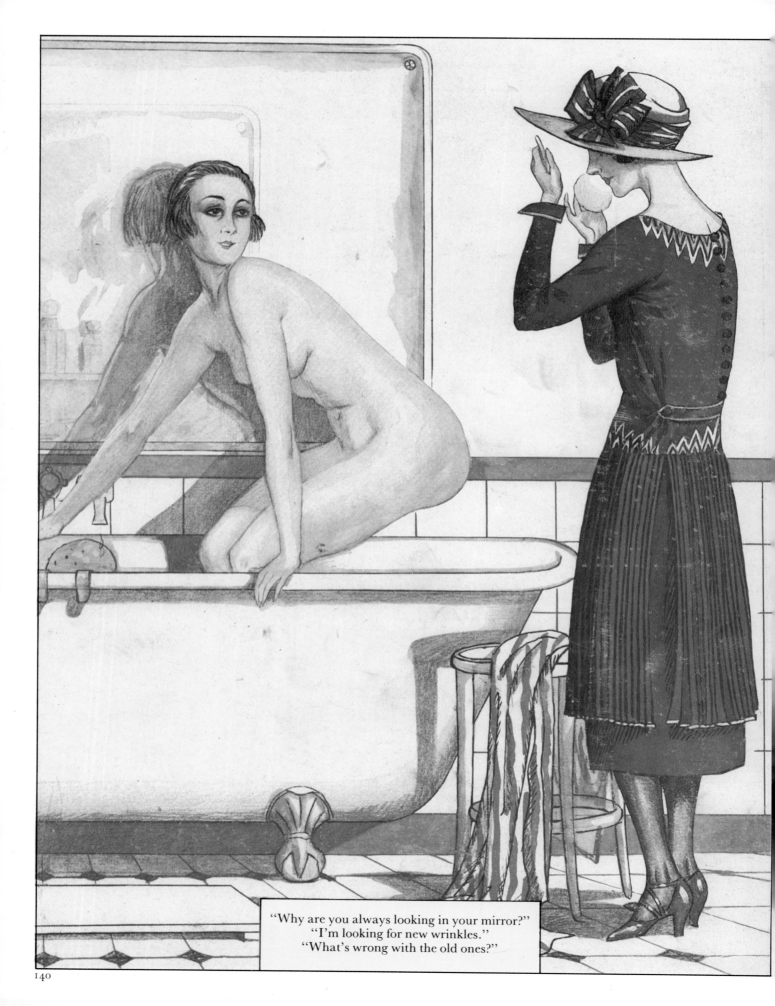

"Why are you always looking in your mirror?"
"I'm looking for new wrinkles."
"What's wrong with the old ones?"

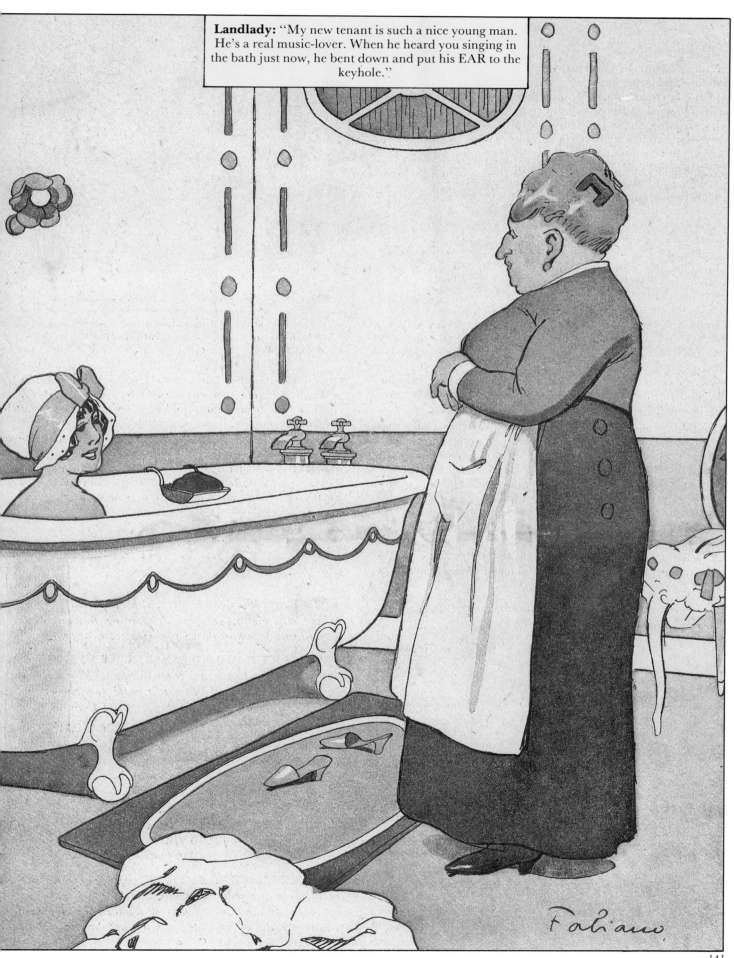

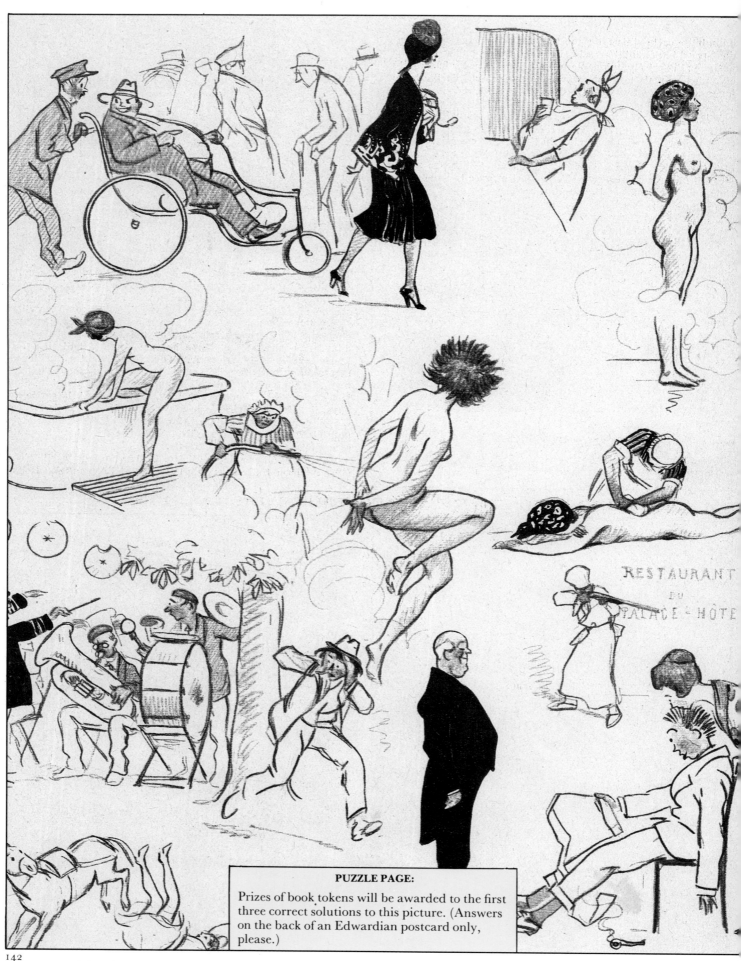

PUZZLE PAGE:

Prizes of book tokens will be awarded to the first three correct solutions to this picture. (Answers on the back of an Edwardian postcard only, please.)

Ooh-La-La! The Ladies Of Paris
In The Bedroom

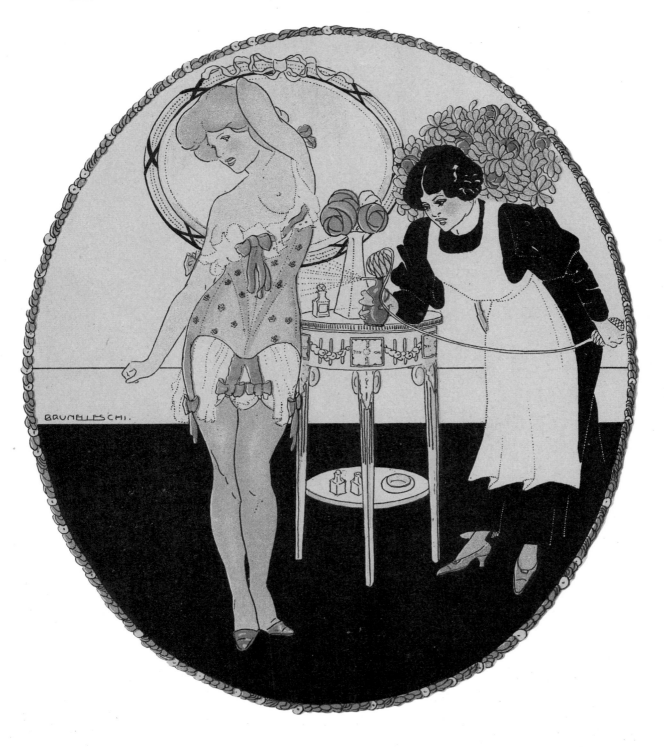

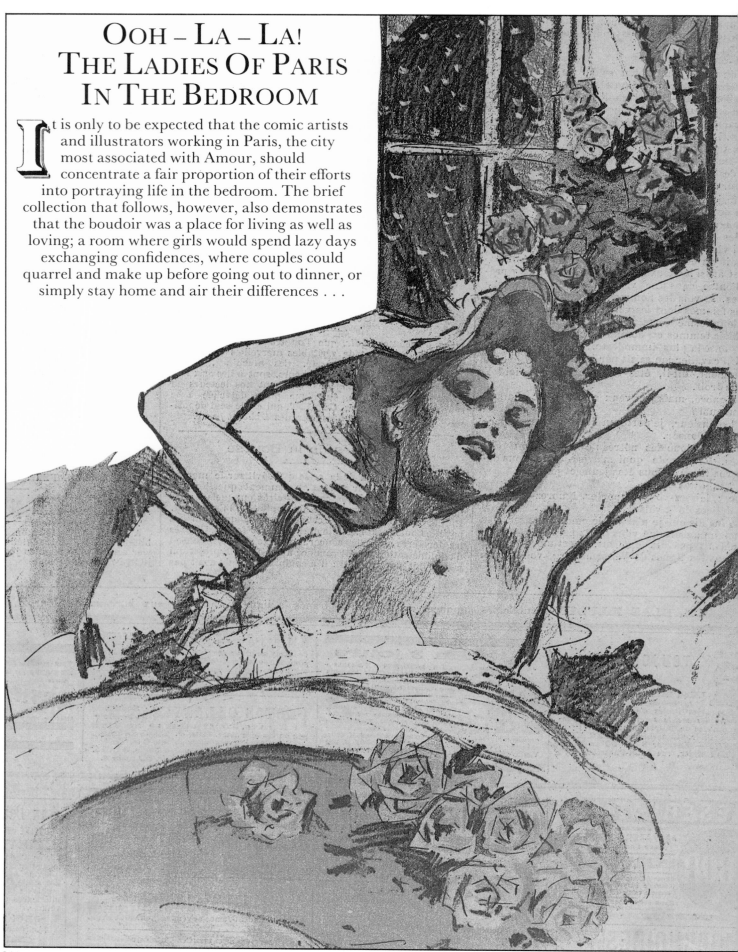

Ooh – La – La!
The Ladies Of Paris
In The Bedroom

It is only to be expected that the comic artists and illustrators working in Paris, the city most associated with Amour, should concentrate a fair proportion of their efforts into portraying life in the bedroom. The brief collection that follows, however, also demonstrates that the boudoir was a place for living as well as loving; a room where girls would spend lazy days exchanging confidences, where couples could quarrel and make up before going out to dinner, or simply stay home and air their differences . . .

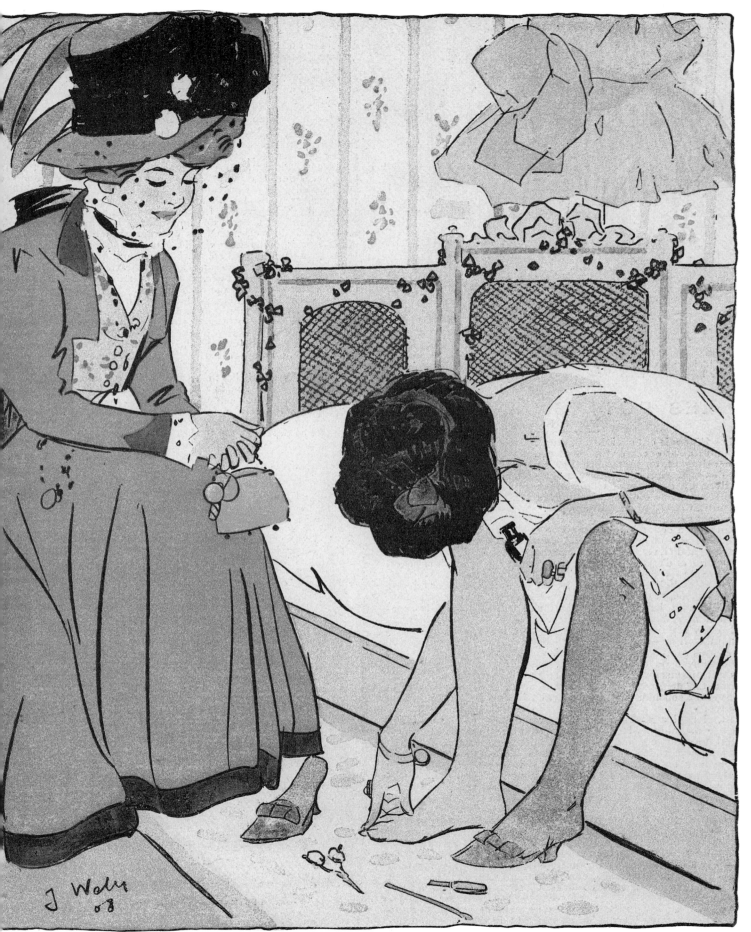

She: "I've got a big corn on the bottom of my foot."
Her: "That's the best place for it. Nobody can step on it but you."

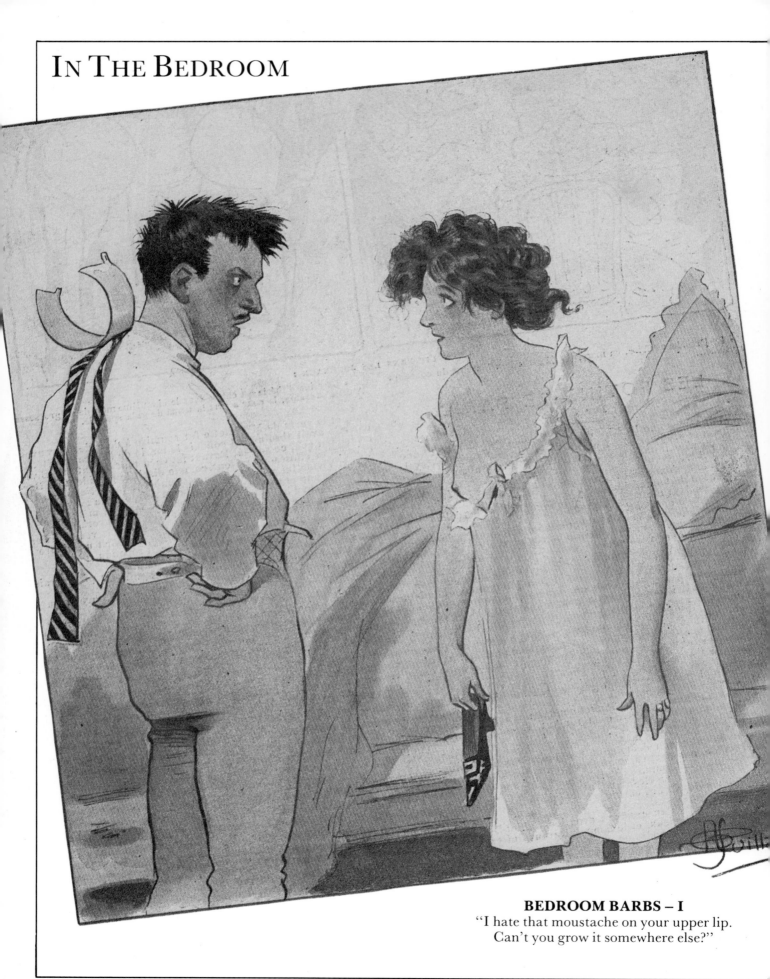

BEDROOM BARBS – I
"I hate that moustache on your upper lip.
Can't you grow it somewhere else?"

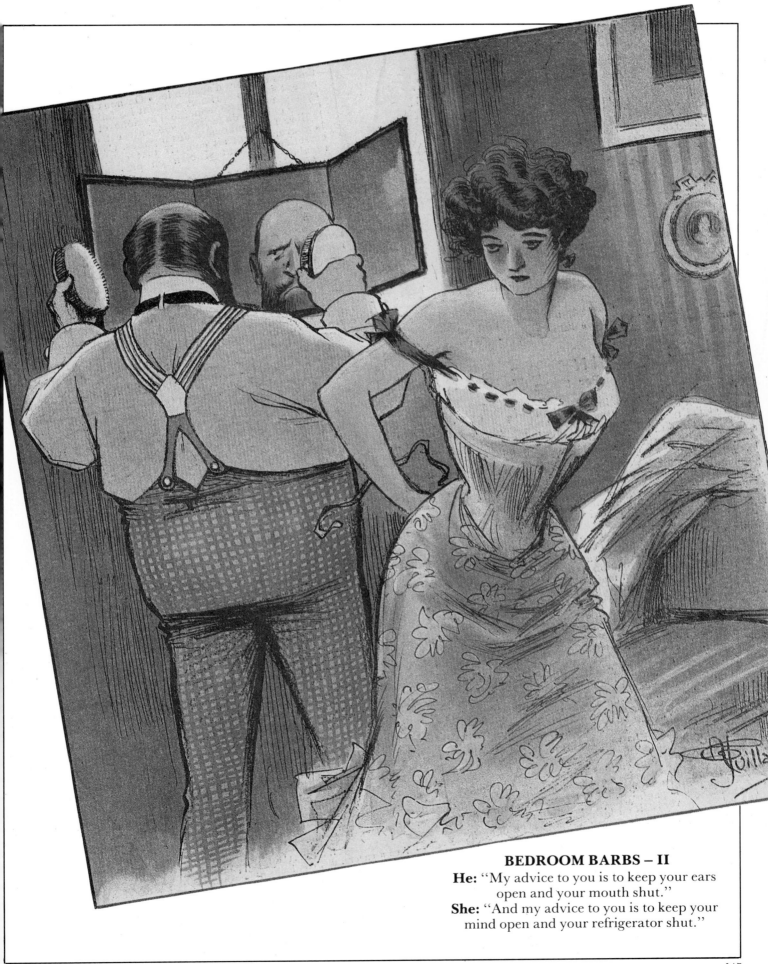

BEDROOM BARBS – II

He: "My advice to you is to keep your ears open and your mouth shut."

She: "And my advice to you is to keep your mind open and your refrigerator shut."

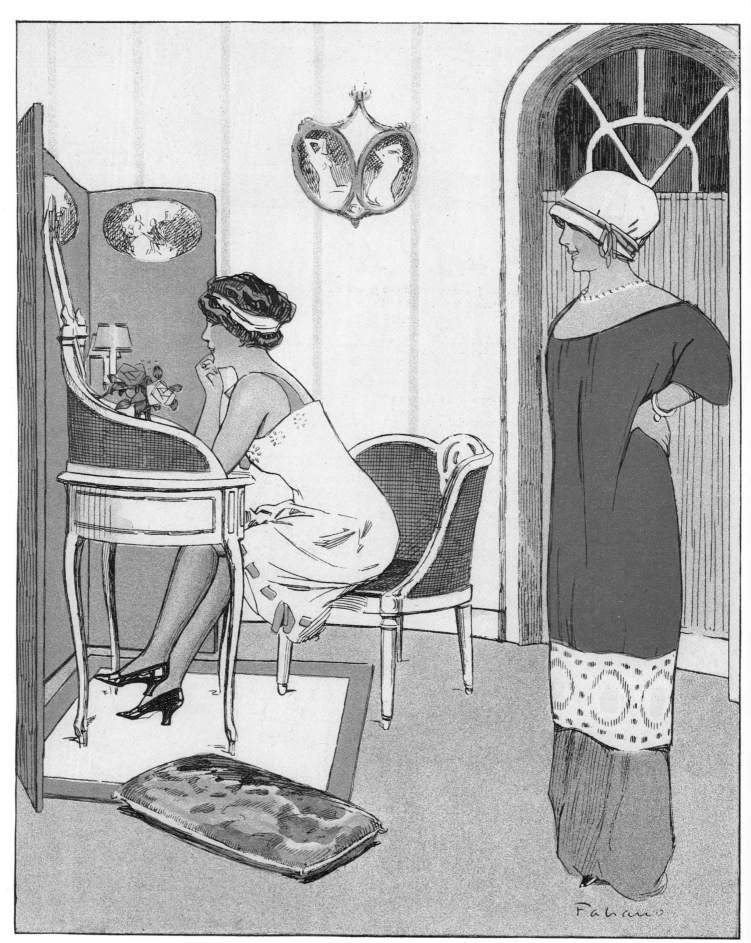

"What a beautiful dress! What did it cost you?"
"Two dozen kisses and a fit of hysterics."

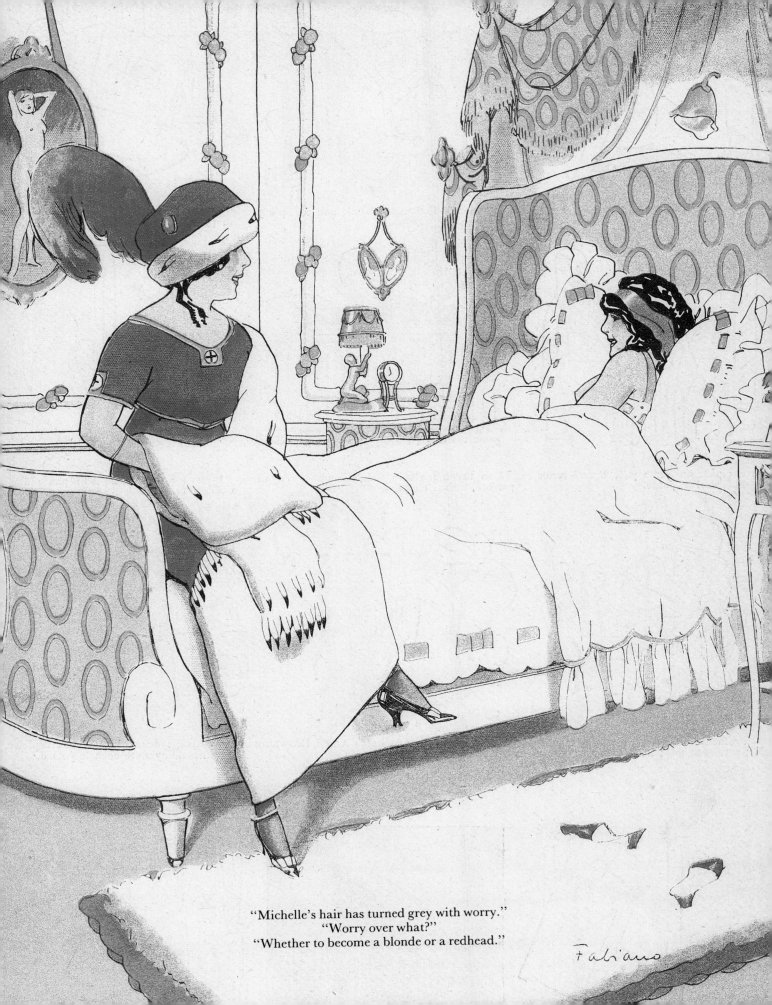

"Michelle's hair has turned grey with worry."
"Worry over what?"
"Whether to become a blonde or a redhead."

Fabiano

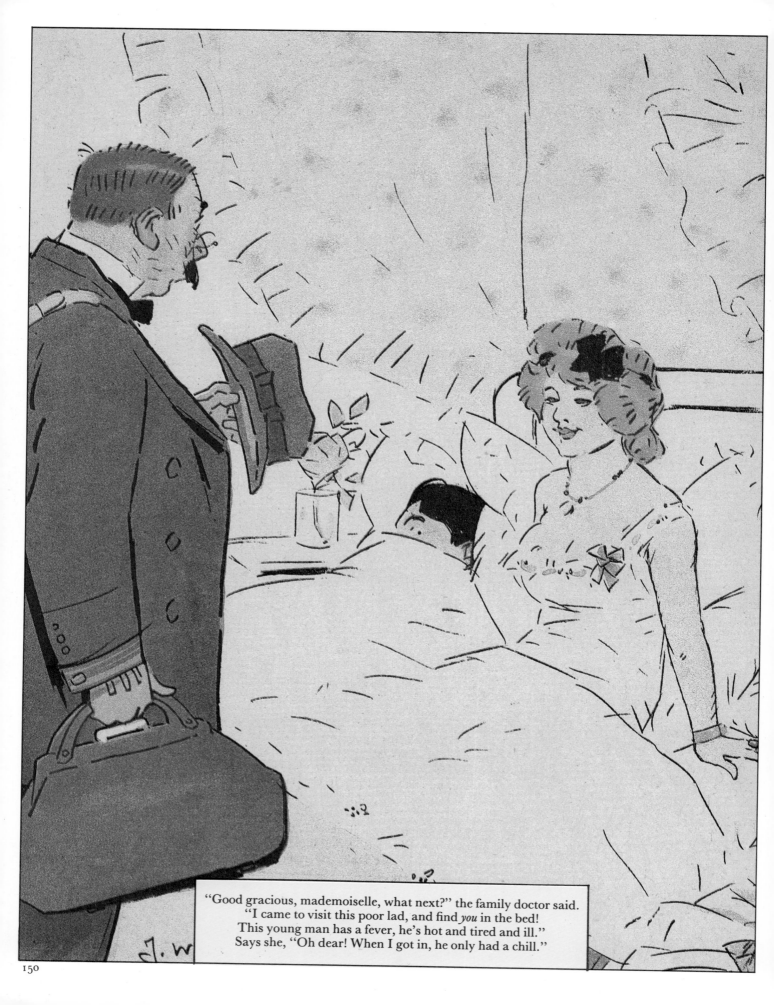

"Good gracious, mademoiselle, what next?" the family doctor said.
"I came to visit this poor lad, and find *you* in the bed!
This young man has a fever, he's hot and tired and ill."
Says she, "Oh dear! When I got in, he only had a chill."

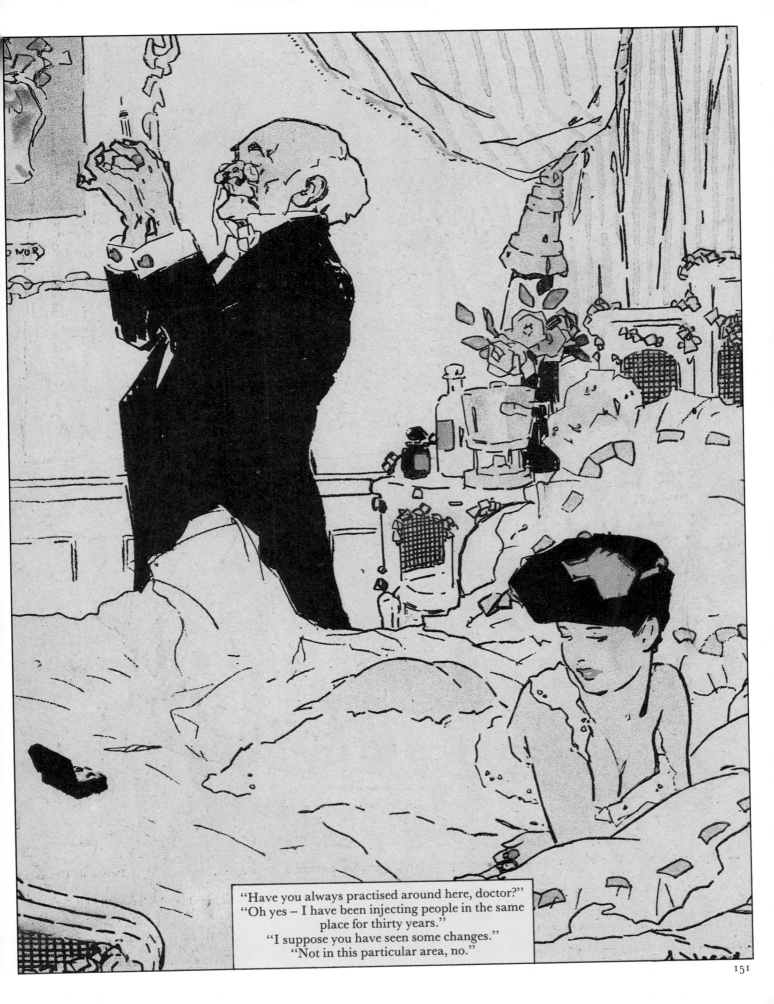

"Have you always practised around here, doctor?"
"Oh yes – I have been injecting people in the same
place for thirty years."
"I suppose you have seen some changes."
"Not in this particular area, no."

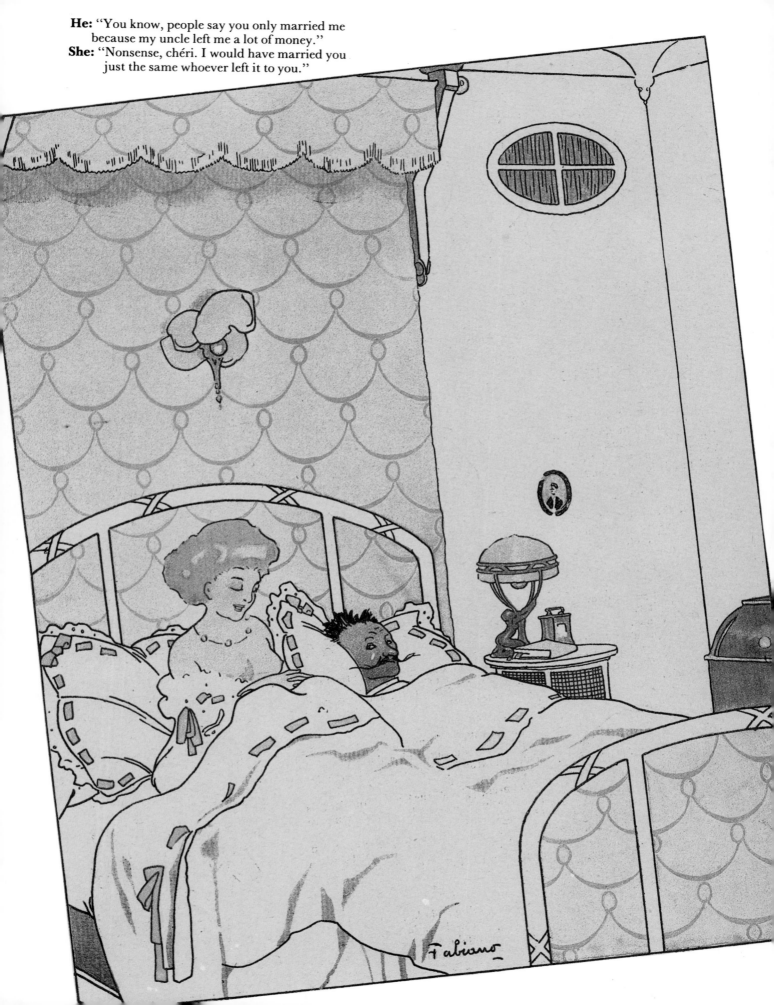

He: "You know, people say you only married me because my uncle left me a lot of money."
She: "Nonsense, chéri. I would have married you just the same whoever left it to you."

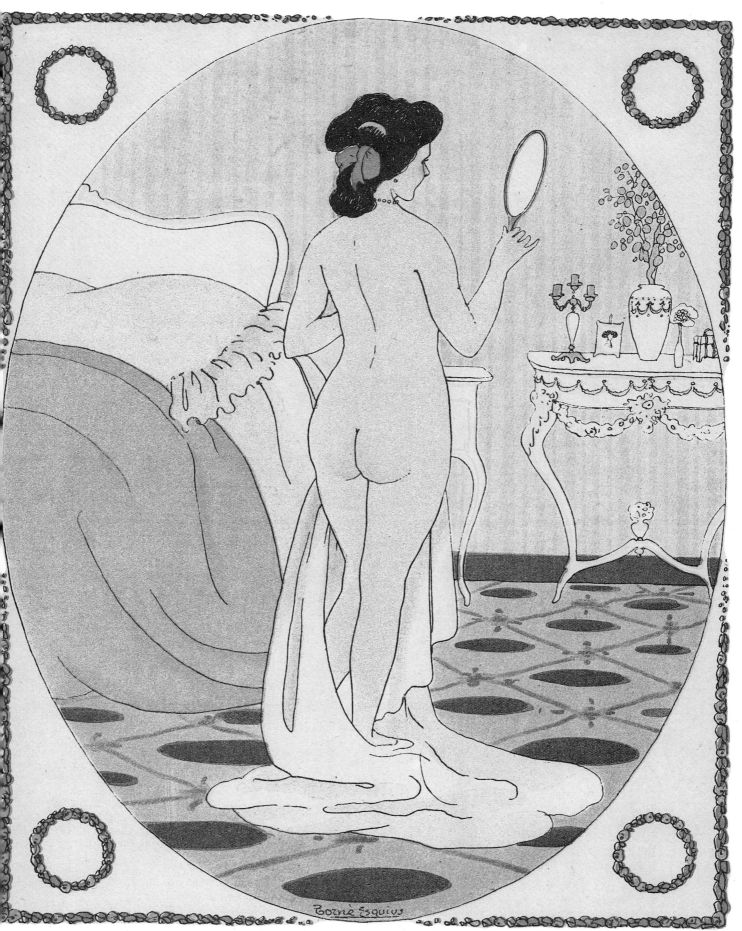

The mirror in her dainty hand delights this delicate creature.
But she needs a slightly larger one to see her prettiest feature.

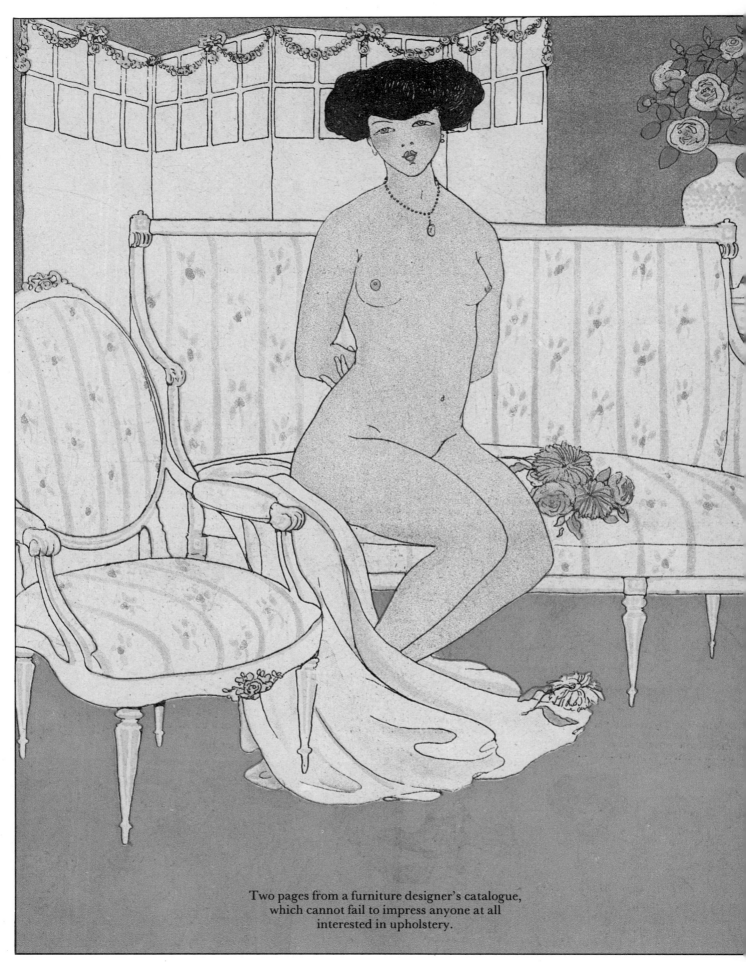

Two pages from a furniture designer's catalogue,
which cannot fail to impress anyone at all
interested in upholstery.

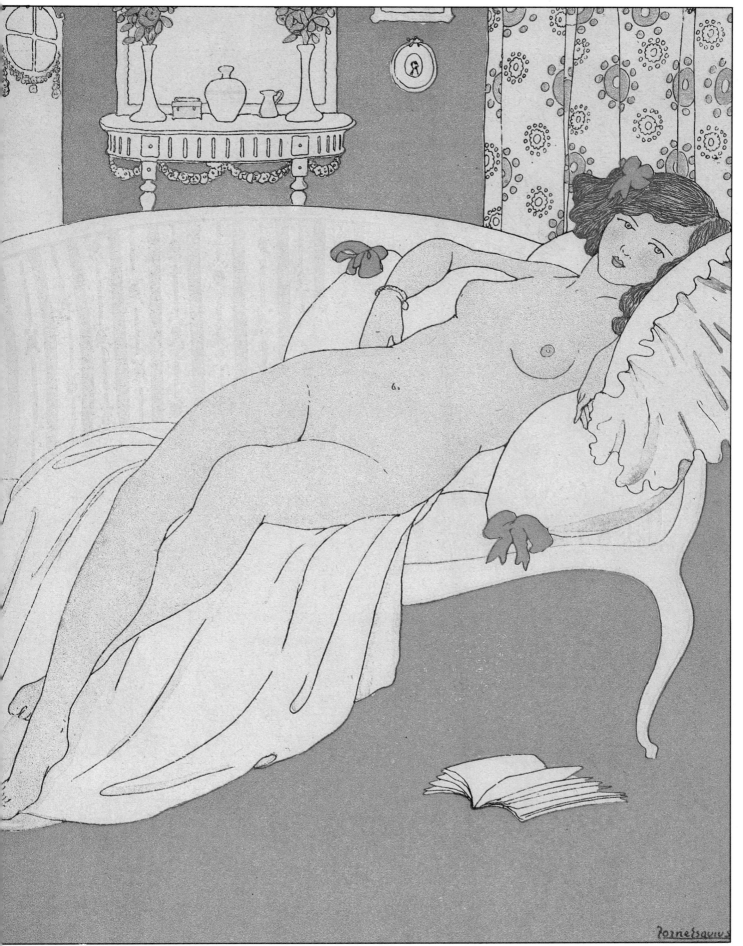

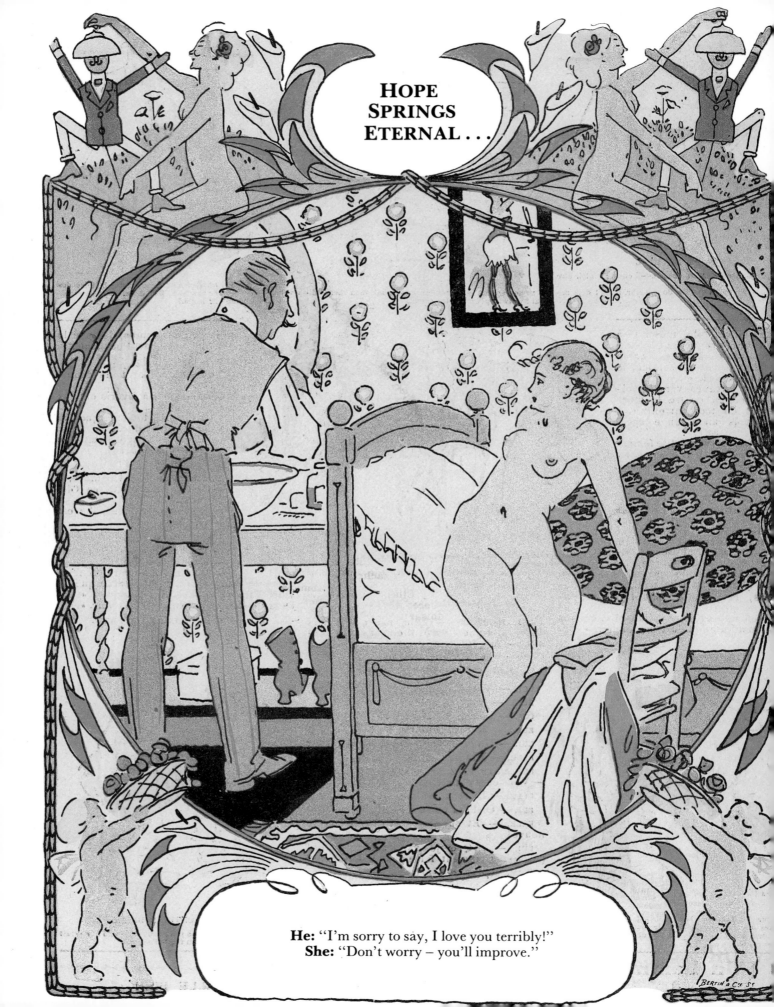

HOPE
SPRINGS
ETERNAL . . .

He: "I'm sorry to say, I love you terribly!"
She: "Don't worry – you'll improve."

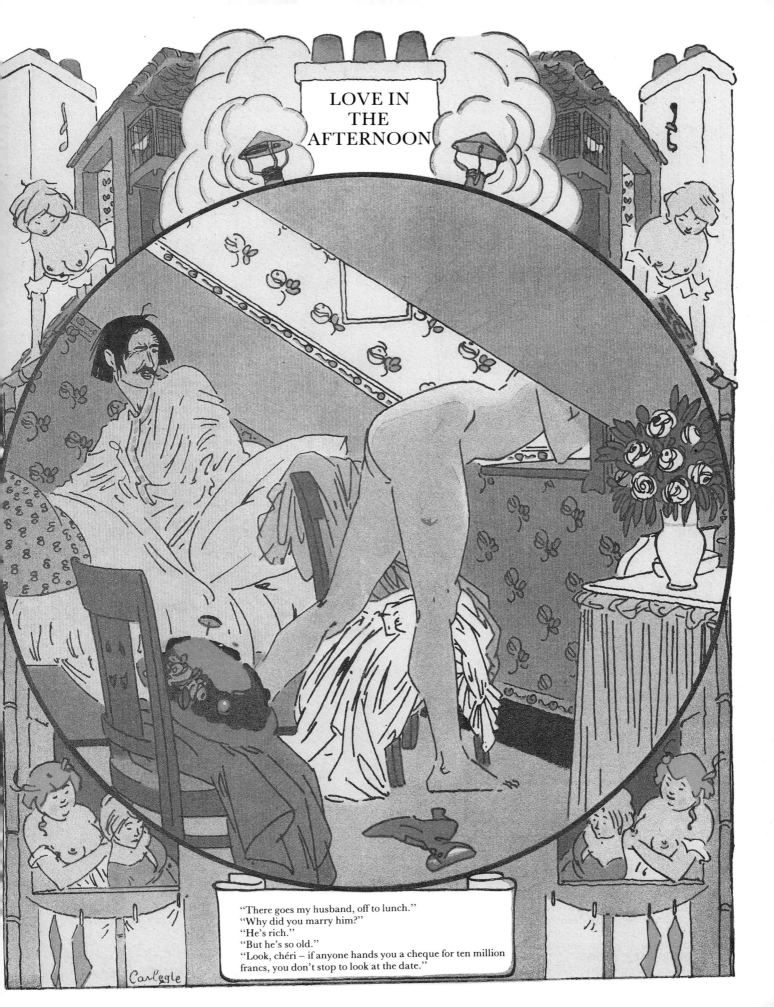

LOVE IN
THE
AFTERNOON

"There goes my husband, off to lunch."
"Why did you marry him?"
"He's rich."
"But he's so old."
"Look, chéri – if anyone hands you a cheque for ten million francs, you don't stop to look at the date."

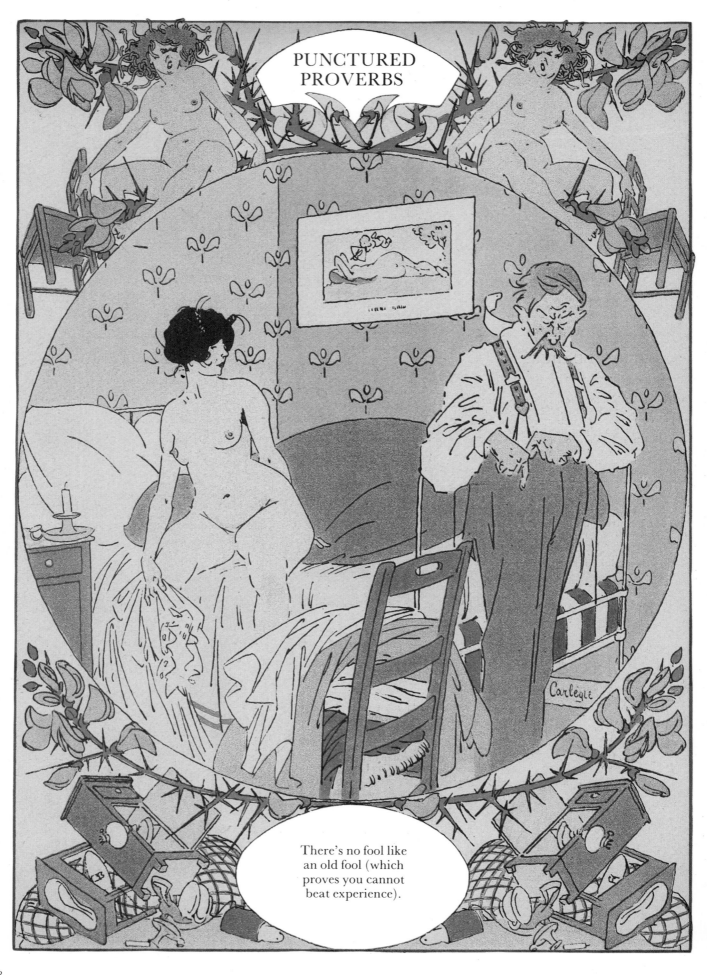

PUNCTURED PROVERBS

There's no fool like an old fool (which proves you cannot beat experience).

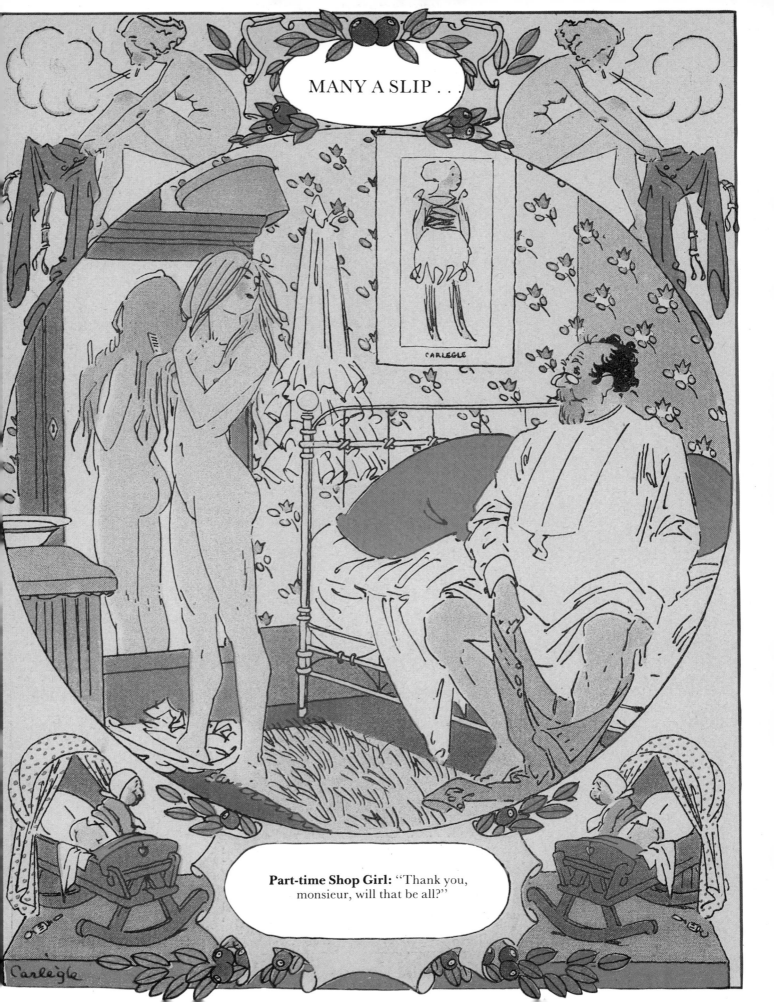

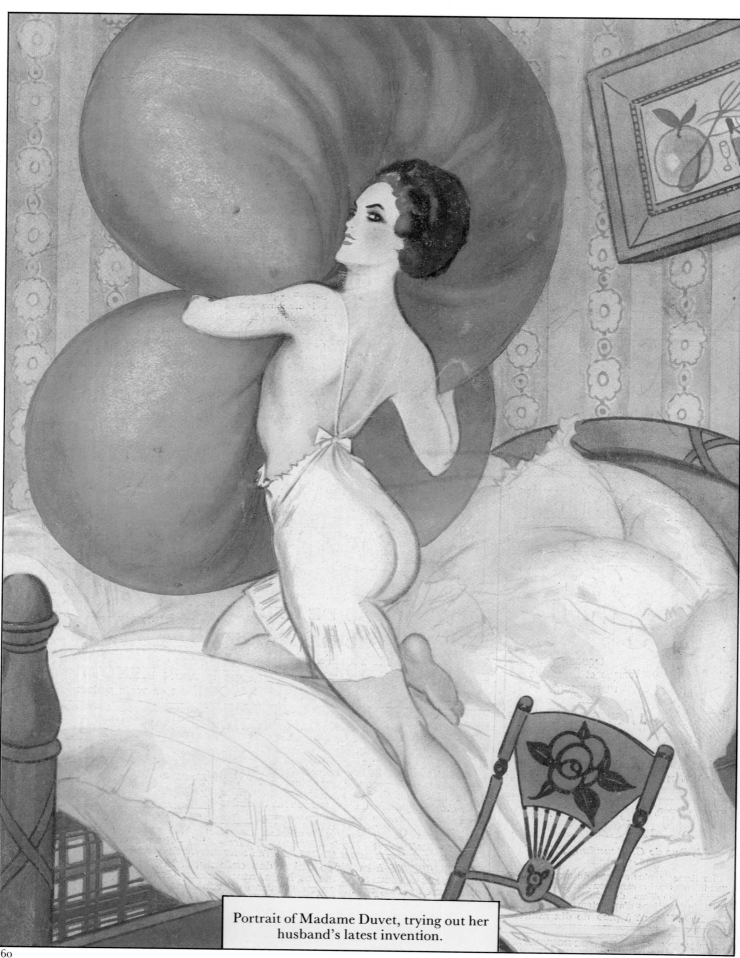

Portrait of Madame Duvet, trying out her
husband's latest invention.

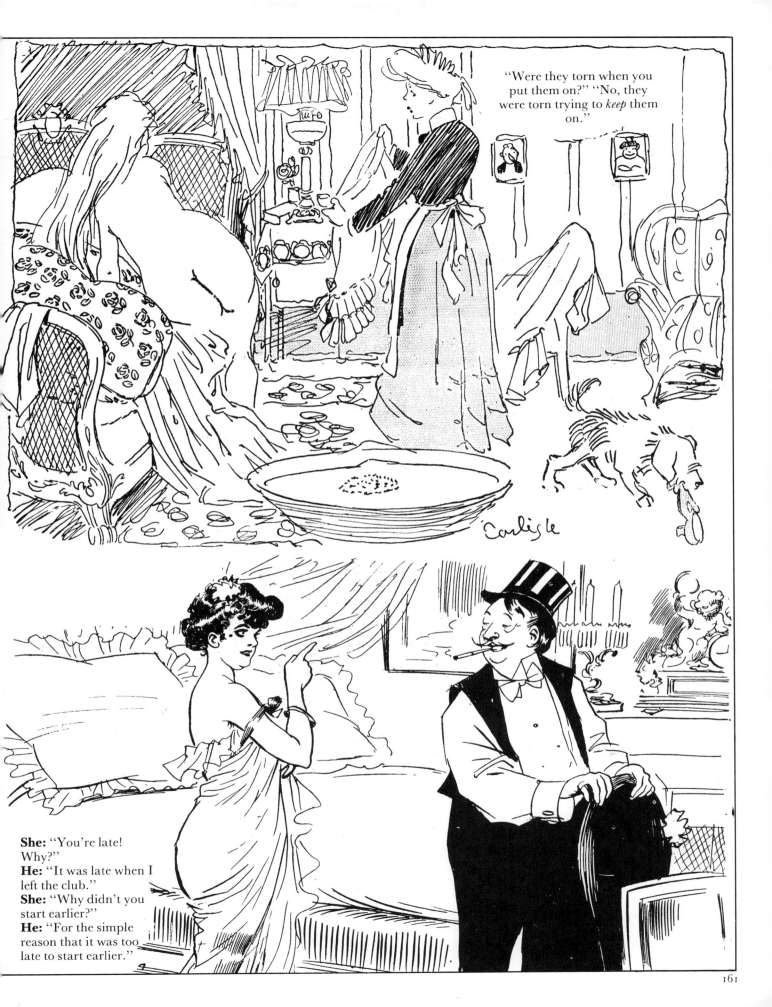

"Were they torn when you put them on?" "No, they were torn trying to *keep* them on."

She: "You're late! Why?"
He: "It was late when I left the club."
She: "Why didn't you start earlier?"
He: "For the simple reason that it was too late to start earlier."

In The Bedroom

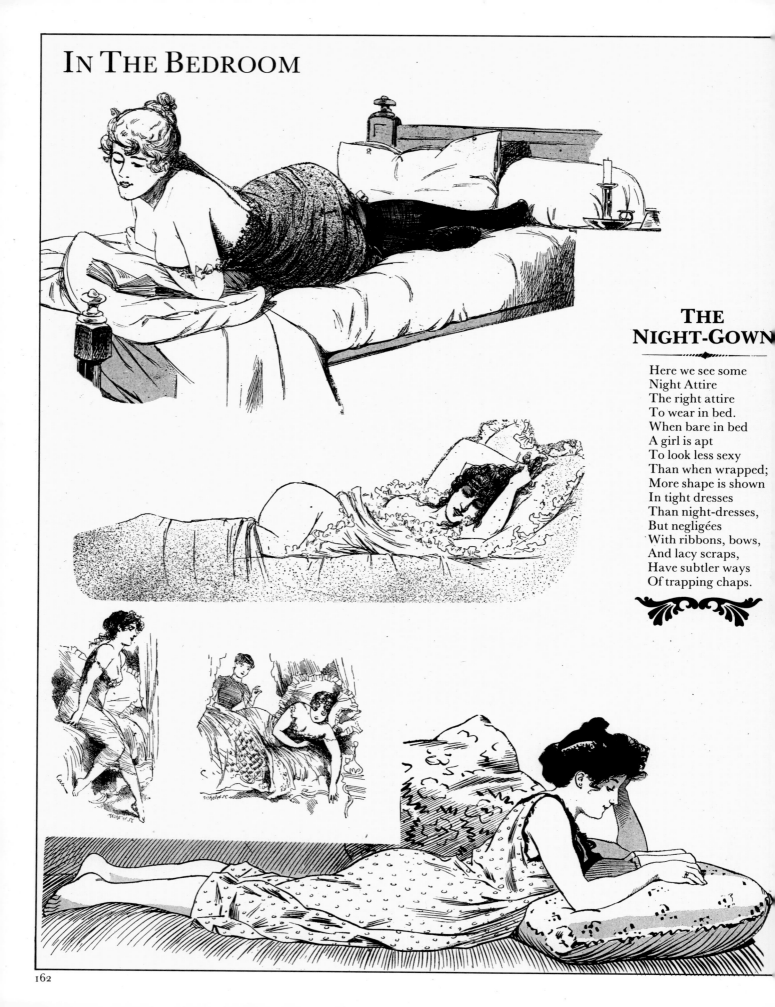

THE NIGHT-GOWN

Here we see some
Night Attire
The right attire
To wear in bed.
When bare in bed
A girl is apt
To look less sexy
Than when wrapped;
More shape is shown
In tight dresses
Than night-dresses,
But negligées
With ribbons, bows,
And lacy scraps,
Have subtler ways
Of trapping chaps.

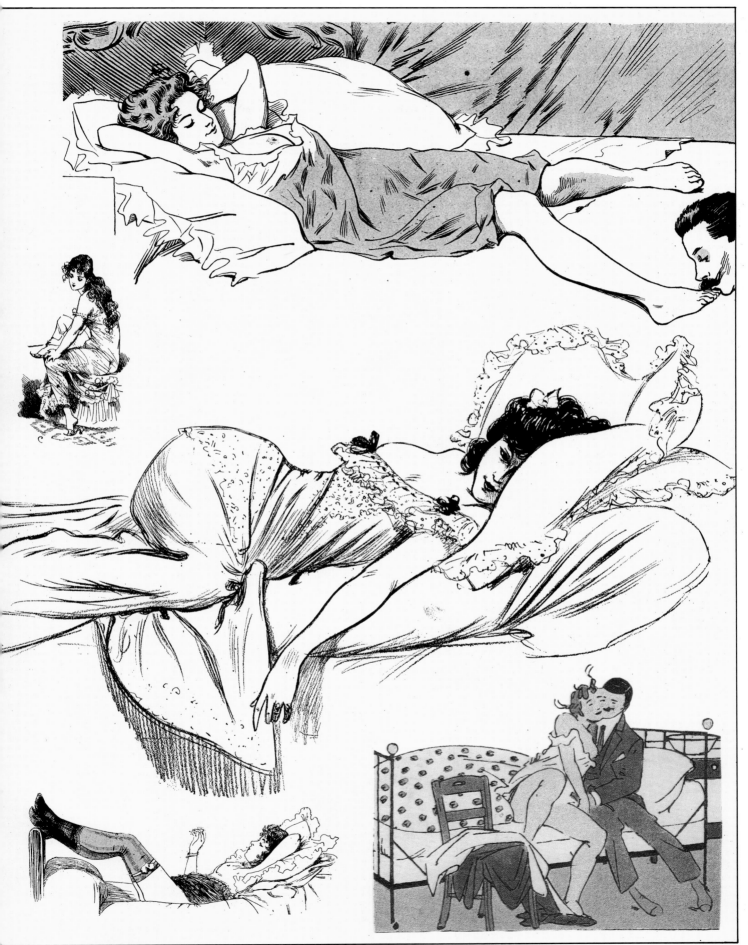

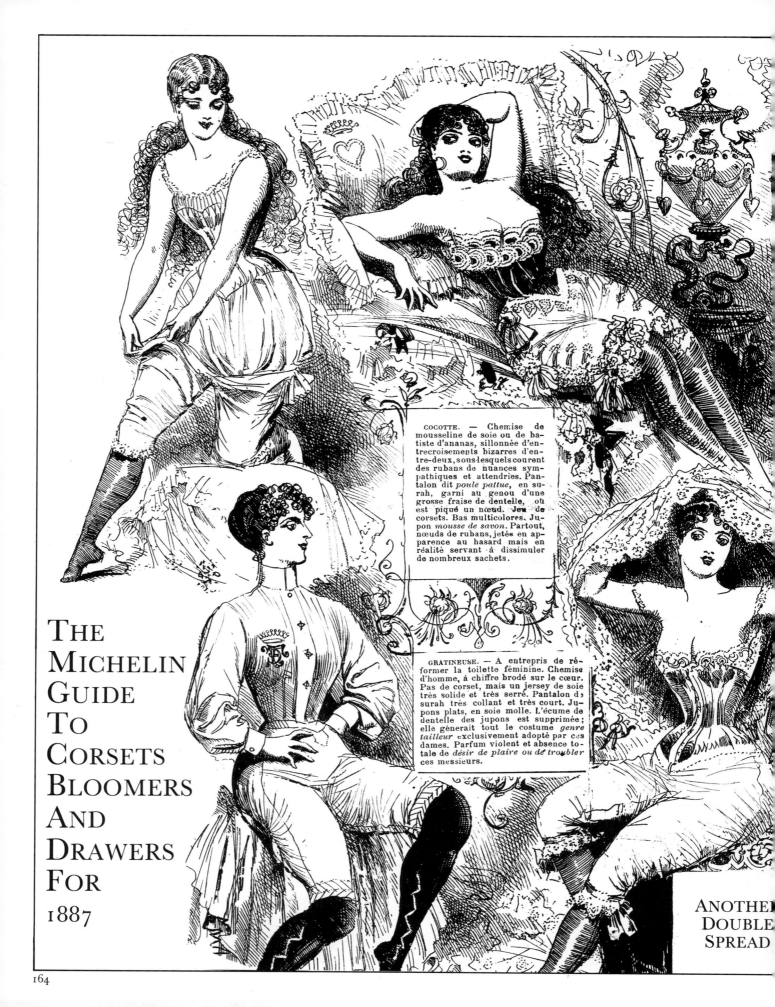

COCOTTE. — Chemise de mousseline de soie ou de batiste d'ananas, sillonnée d'entrecroisements bizarres d'entre-deux, sous lesquels courent des rubans de nuances sympathiques et attendries. Pantalon dit *poule pattue*, en surah, garni au genou d'une grosse fraise de dentelle, où est piqué un nœud. Jeu de corsets. Bas multicolores. Jupon *mousse de savon*. Partout, nœuds de rubans, jetés en apparence au hasard mais en réalité servant à dissimuler de nombreux sachets.

GRATINEUSE. — A entrepris de réformer la toilette féminine. Chemise d'homme, à chiffre brodé sur le cœur. Pas de corset, mais un jersey de soie très solide et très serré. Pantalon de surah très collant et très court. Jupons plats, en soie molle. L'écume de dentelle des jupons est supprimée ; elle gênerait tout le costume *genre tailleur* exclusivement adopté par ces dames. Parfum violent et absence totale de *désir de plaire ou de troubler* ces messieurs.

THE MICHELIN GUIDE TO CORSETS BLOOMERS AND DRAWERS FOR 1887

ANOTHER DOUBLE SPREAD

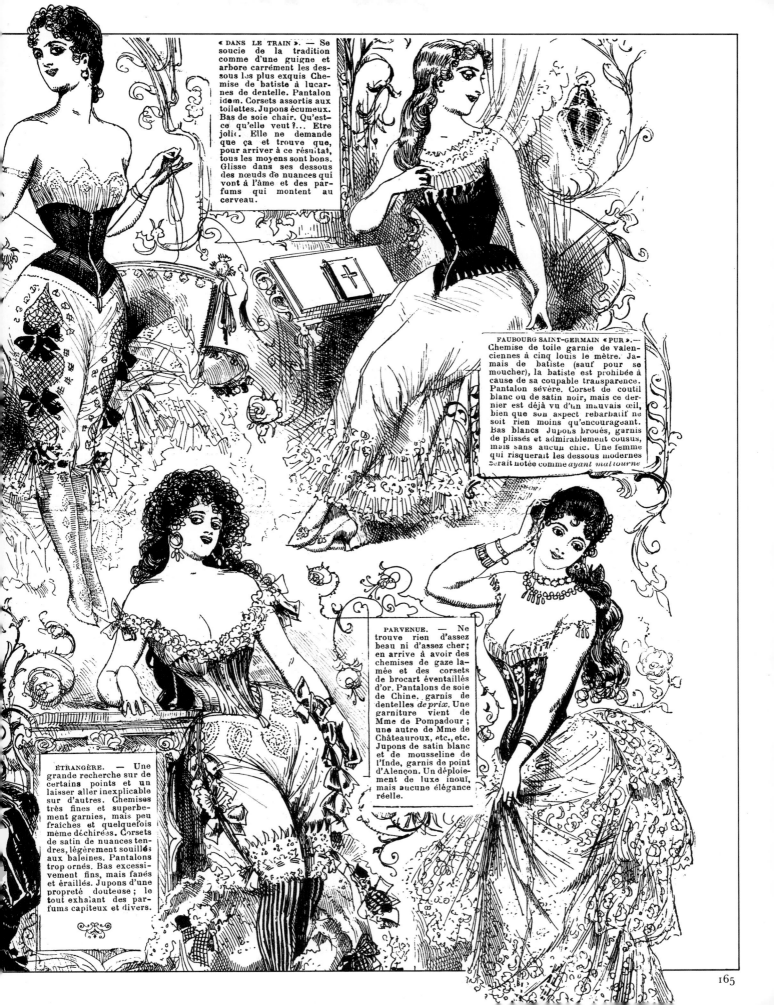

« DANS LE TRAIN ». — Se soucie de la tradition comme d'une guigne et arbore carrément les dessous les plus exquis Chemise de batiste à lucarnes de dentelle. Pantalon idem. Corsets assortis aux toilettes. Jupons écumeux. Bas de soie chair. Qu'est-ce qu'elle veut ?... Etre jolie. Elle ne demande que ça et trouve que, pour arriver à ce résultat, tous les moyens sont bons. Glisse dans ses dessous des nœuds de nuances qui vont à l'âme et des parfums qui montent au cerveau.

FAUBOURG SAINT-GERMAIN « PUR ». — Chemise de toile garnie de valenciennes à cinq louis le mètre. Jamais de batiste (sauf pour se moucher), la batiste est prohibée à cause de sa coupable transparence. Pantalon sévère. Corset de coutil blanc ou de satin noir, mais ce dernier est déjà vu d'un mauvais œil, bien que son aspect rebarbatif ne soit rien moins qu'encourageant. Bas blancs Jupons broués, garnis de plissés et admirablement cousus, mais sans aucun chic. Une femme qui risquerait les dessous modernes serait notée comme *ayant mal tourné*

ÉTRANGÈRE. — Une grande recherche sur de certains points et un laisser aller inexplicable sur d'autres. Chemises très fines et superbement garnies, mais peu fraîches et quelquefois même déchirées. Corsets de satin de nuances tendres, légèrement souillés aux baleines. Pantalons trop ornés. Bas excessivement fins, mais fanés et éraillés. Jupons d'une propreté douteuse ; le tout exhalant des parfums capiteux et divers.

PARVENUE. — Ne trouve rien d'assez beau ni d'assez cher ; en arrive à avoir des chemises de gaze lamée et des corsets de brocart éventaillés d'or. Pantalons de soie de Chine, garnis de dentelles *de prix*. Une garniture vient de Mme de Pompadour ; une autre de Mme de Châteauroux, etc., etc. Jupons de satin blanc et de mousseline de l'Inde, garnis de point d'Alençon. Un déploiement de luxe inouï, mais aucune élégance réelle.

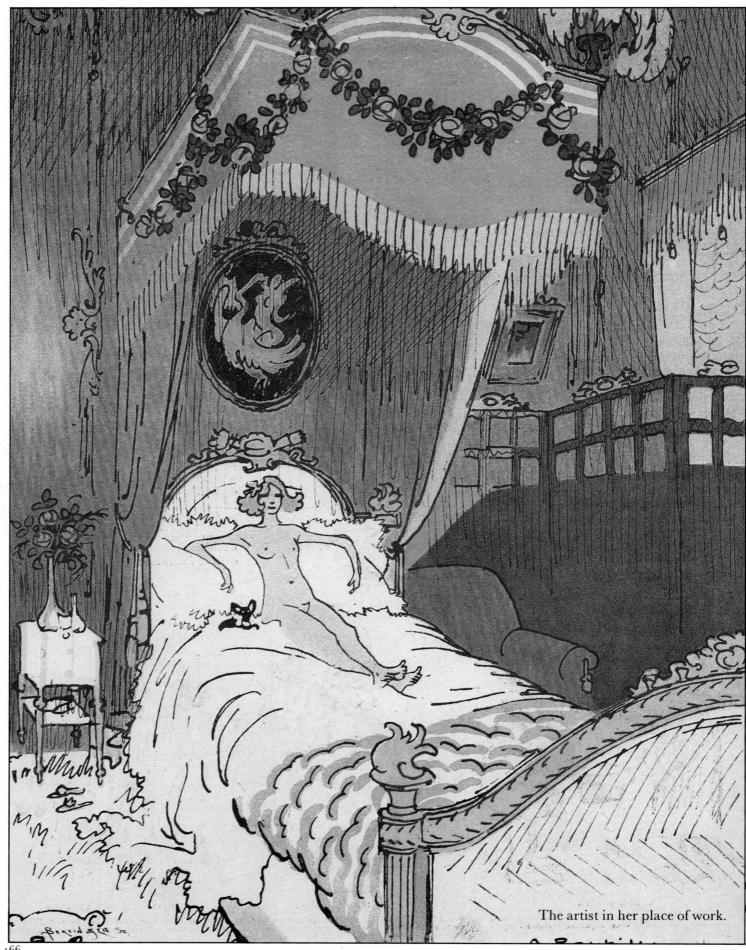

The artist in her place of work.

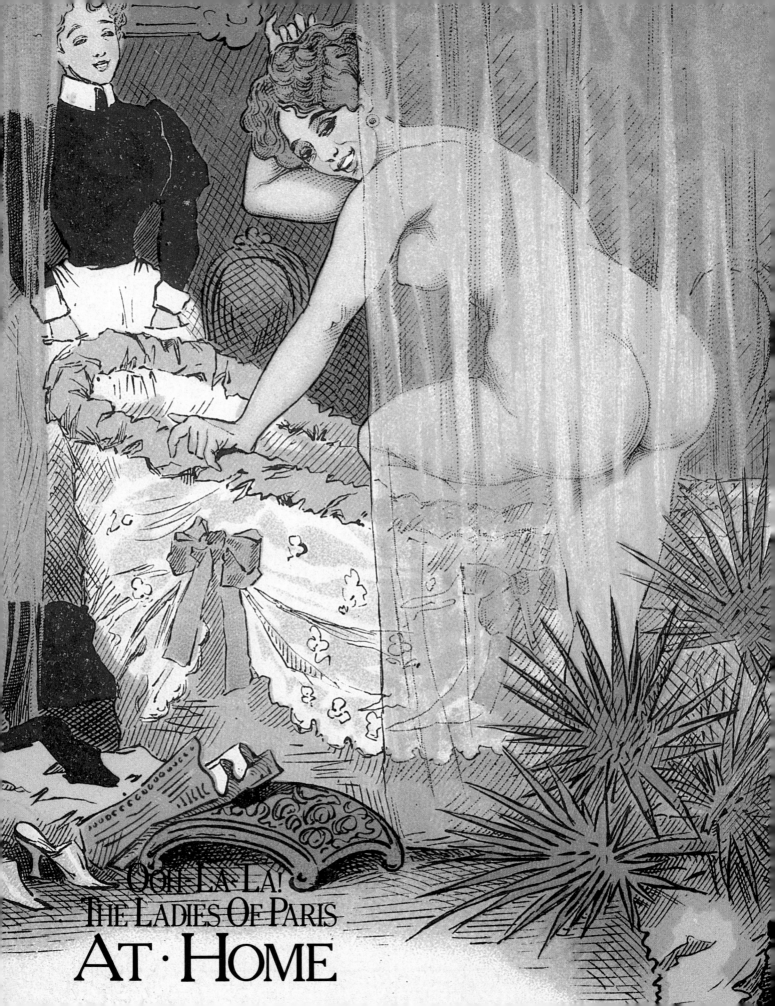

OOH LA LA!
THE LADIES OF PARIS
AT · HOME

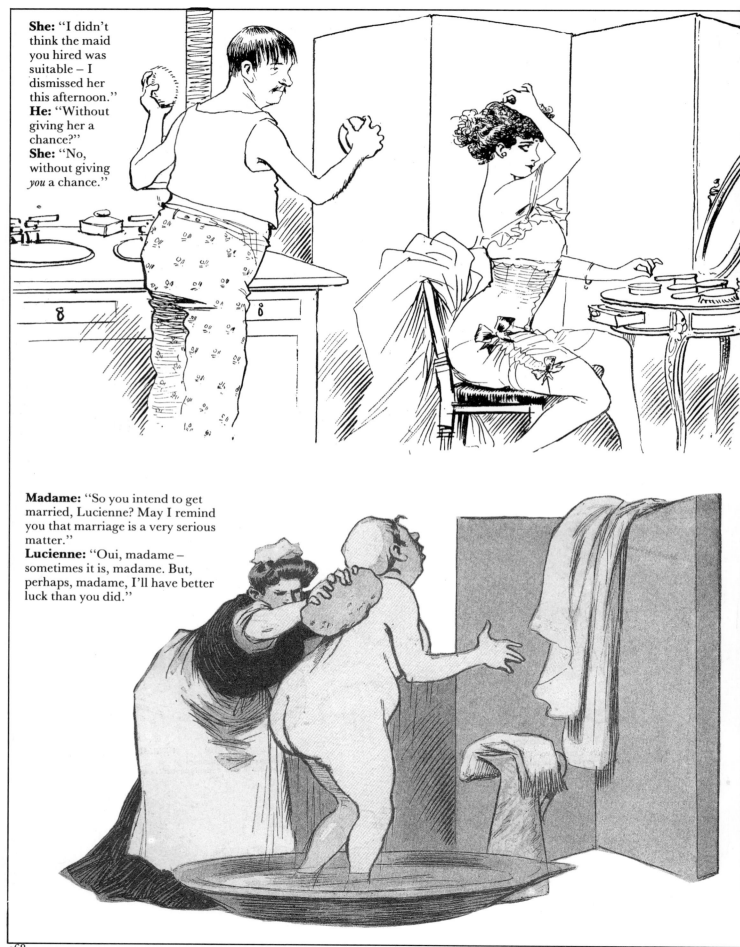

She: "I didn't think the maid you hired was suitable – I dismissed her this afternoon."
He: "Without giving her a chance?"
She: "No, without giving *you* a chance."

Madame: "So you intend to get married, Lucienne? May I remind you that marriage is a very serious matter."
Lucienne: "Oui, madame – sometimes it is, madame. But, perhaps, madame, I'll have better luck than you did."

OOH – LA – LA!
THE LADIES OF PARIS
AT HOME

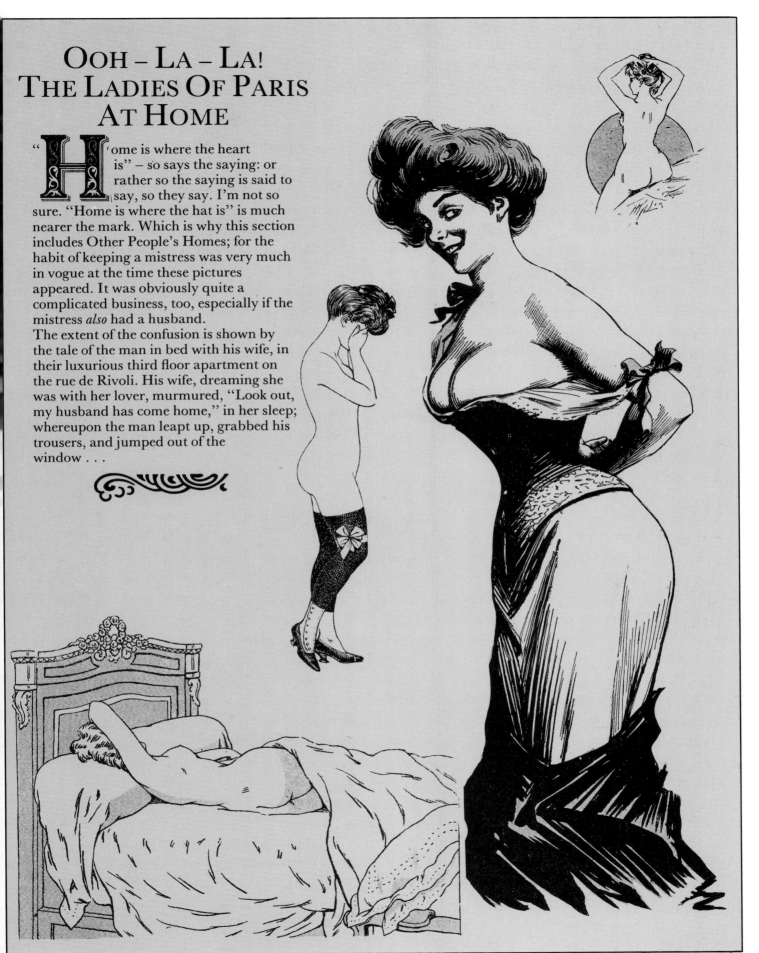

"Home is where the heart is" – so says the saying: or rather so the saying is said to say, so they say. I'm not so sure. "Home is where the hat is" is much nearer the mark. Which is why this section includes Other People's Homes; for the habit of keeping a mistress was very much in vogue at the time these pictures appeared. It was obviously quite a complicated business, too, especially if the mistress *also* had a husband.

The extent of the confusion is shown by the tale of the man in bed with his wife, in their luxurious third floor apartment on the rue de Rivoli. His wife, dreaming she was with her lover, murmured, "Look out, my husband has come home," in her sleep; whereupon the man leapt up, grabbed his trousers, and jumped out of the window . . .

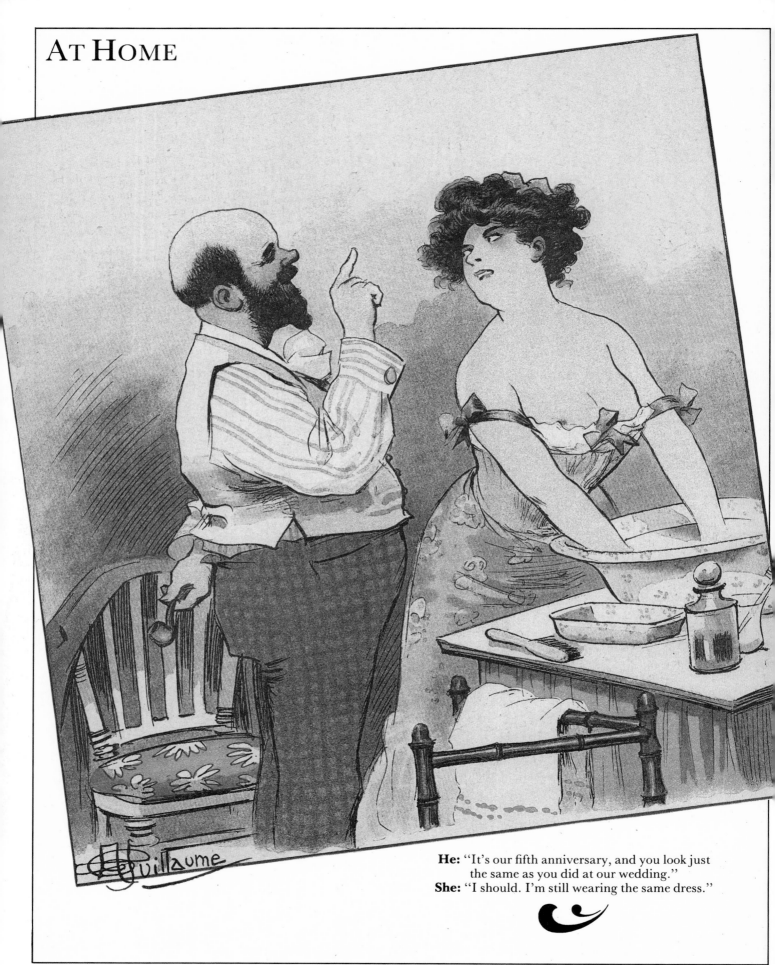

He: "It's our fifth anniversary, and you look just the same as you did at our wedding."
She: "I should. I'm still wearing the same dress."

Doctor: "I have some good news for you, Madame
Duval."
Girl: "It's *Mademoiselle* Duval."
Doctor: "Oh. Then I have some *bad* news."

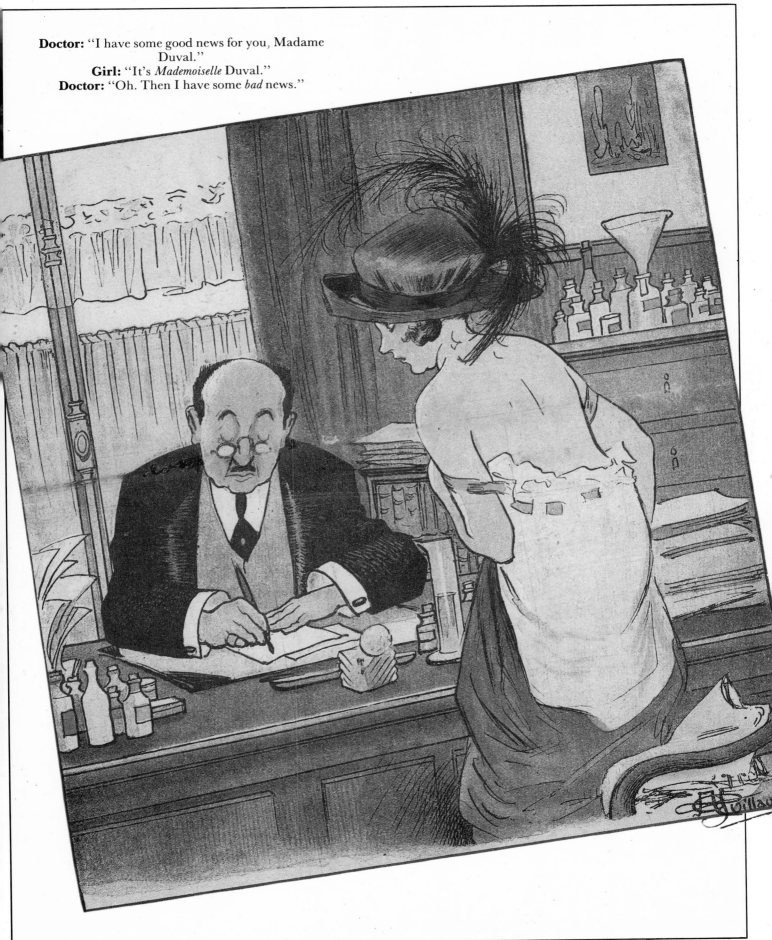

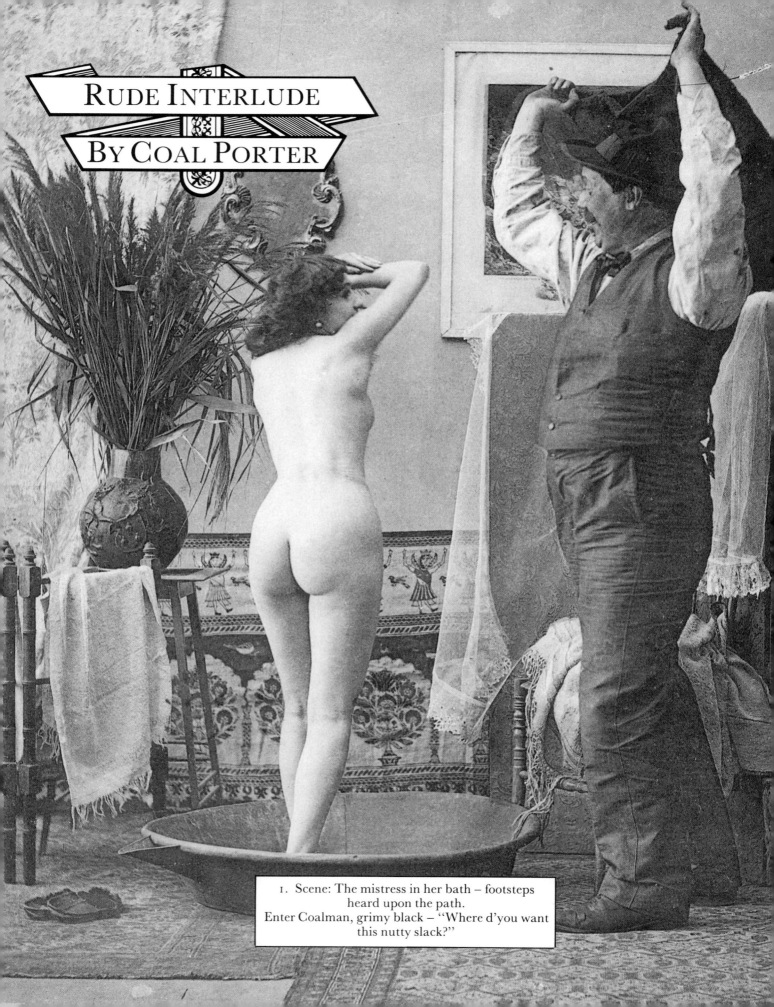

RUDE INTERLUDE

BY COAL PORTER

1. Scene: The mistress in her bath – footsteps
heard upon the path.
Enter Coalman, grimy black – "Where d'you want
this nutty slack?"

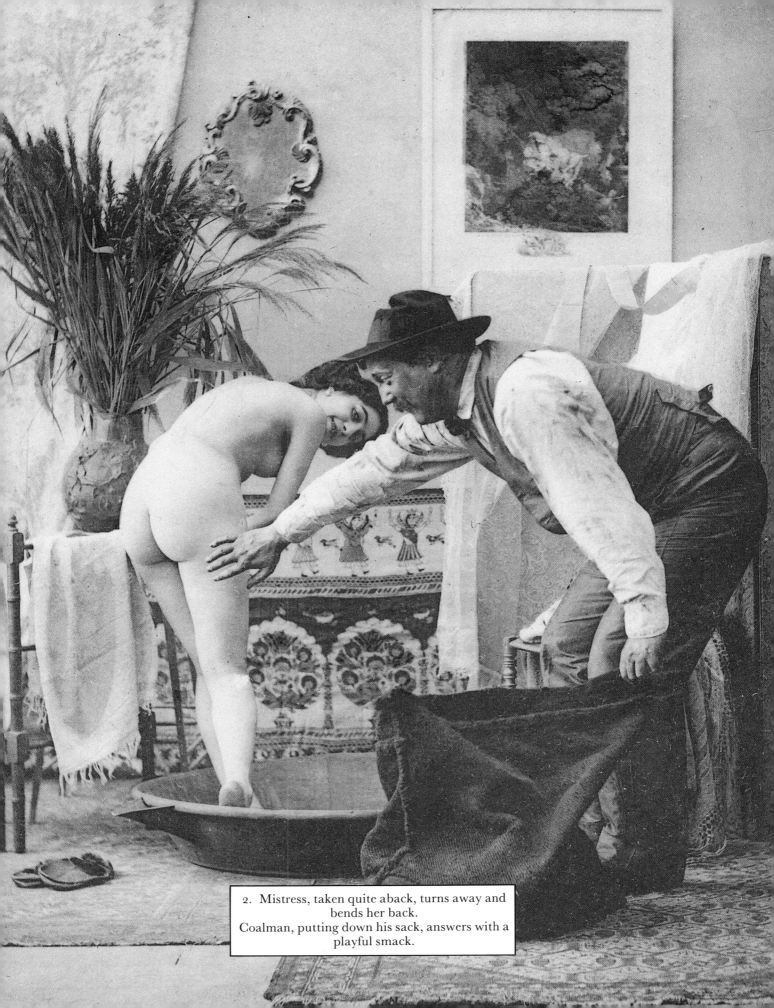

2. Mistress, taken quite aback, turns away and bends her back.
Coalman, putting down his sack, answers with a playful smack.

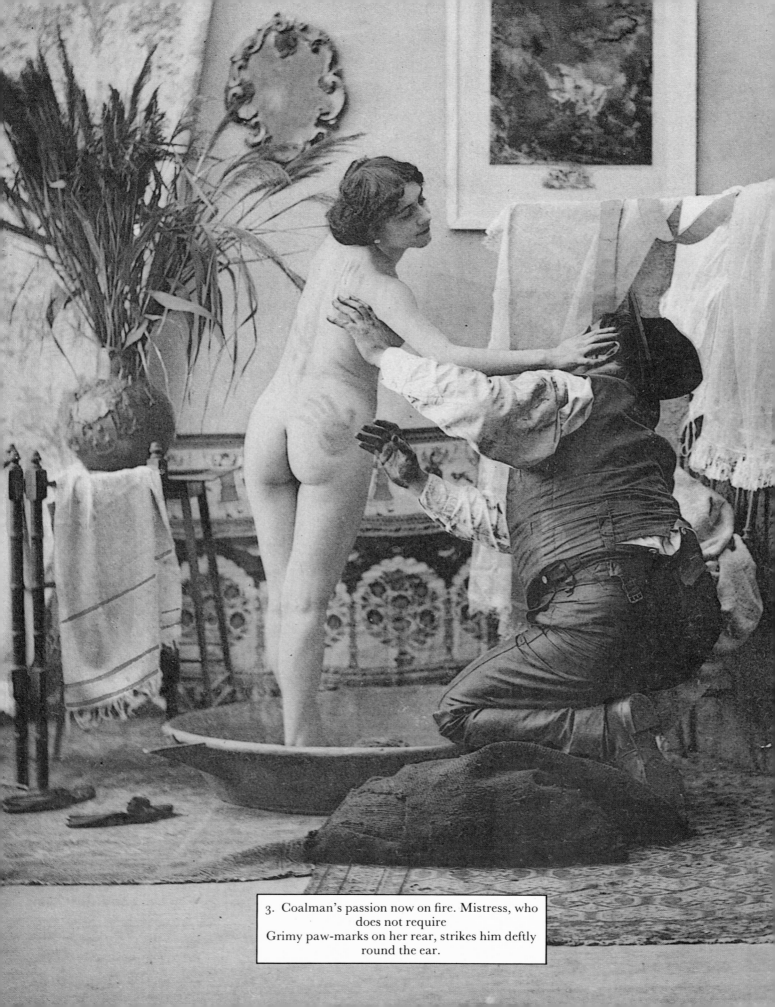

3. Coalman's passion now on fire. Mistress, who does not require
Grimy paw-marks on her rear, strikes him deftly round the ear.

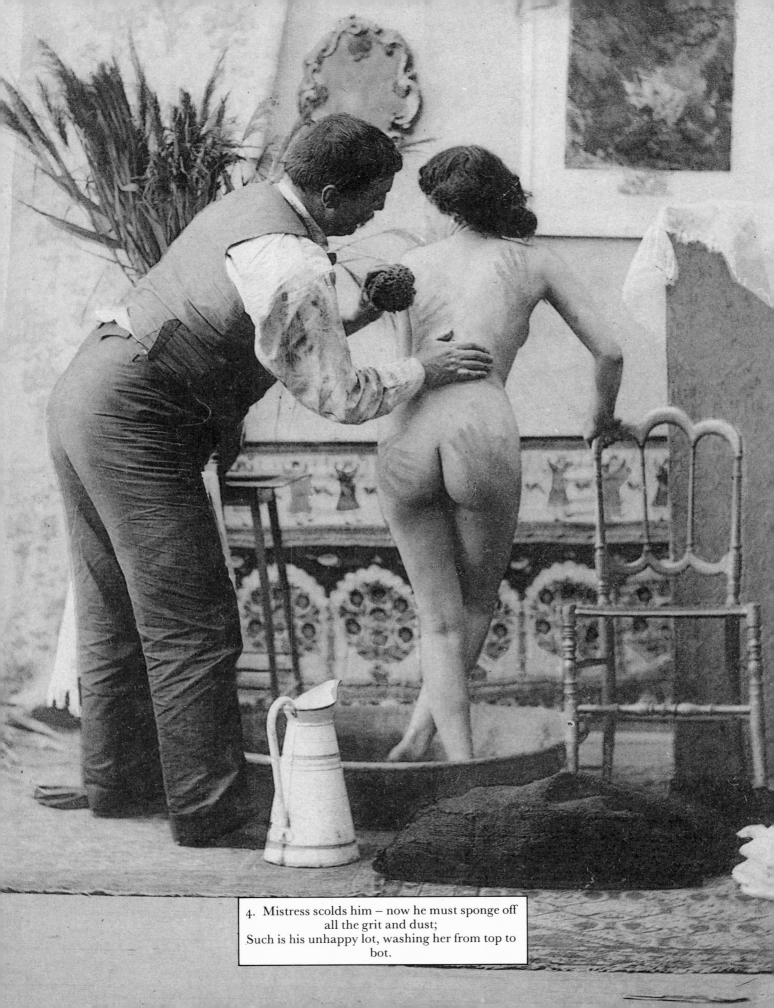

4. Mistress scolds him – now he must sponge off
all the grit and dust;
Such is his unhappy lot, washing her from top to
bot.

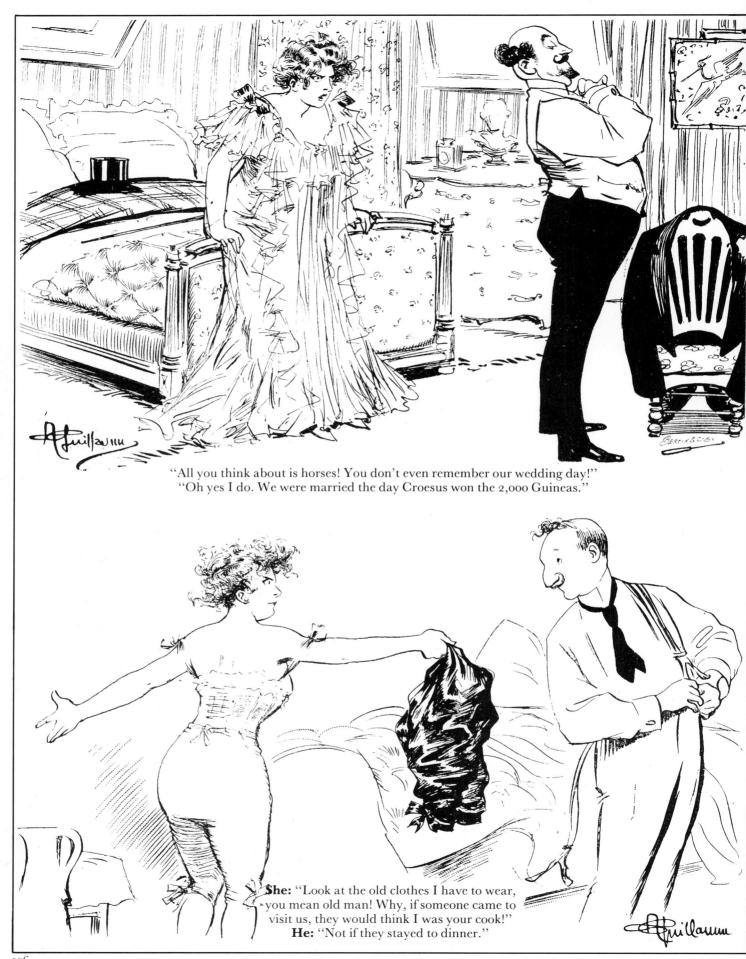

"All you think about is horses! You don't even remember our wedding day!"
"Oh yes I do. We were married the day Croesus won the 2,000 Guineas."

She: "Look at the old clothes I have to wear, you mean old man! Why, if someone came to visit us, they would think I was your cook!"
He: "Not if they stayed to dinner."

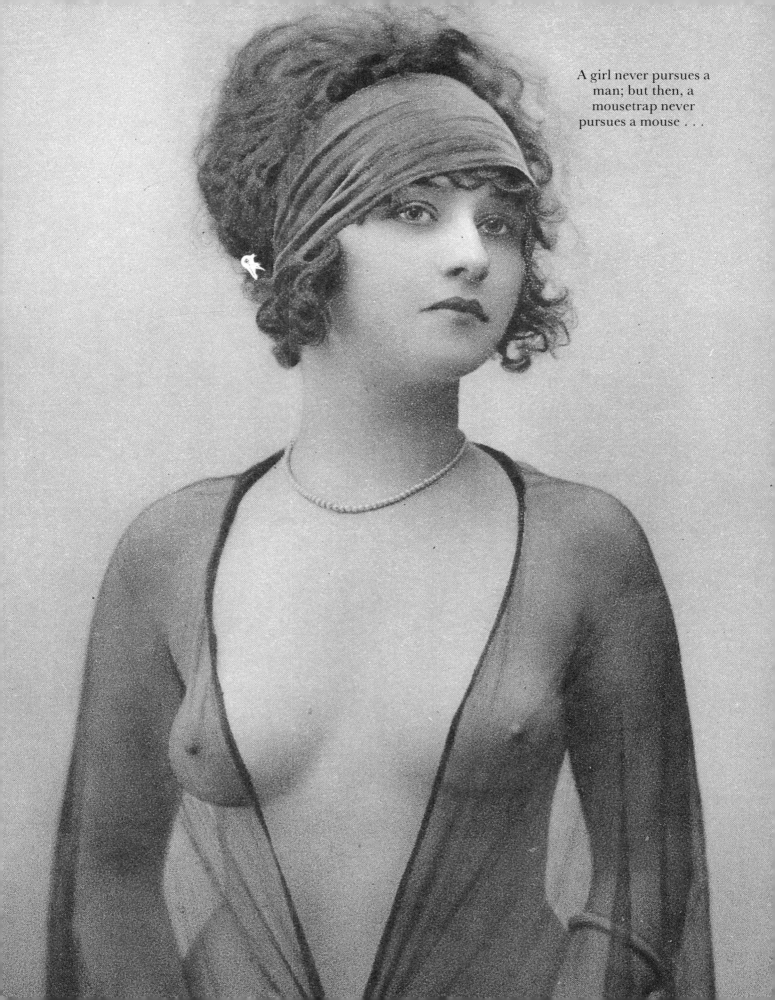

A girl never pursues a
man; but then, a
mousetrap never
pursues a mouse . . .

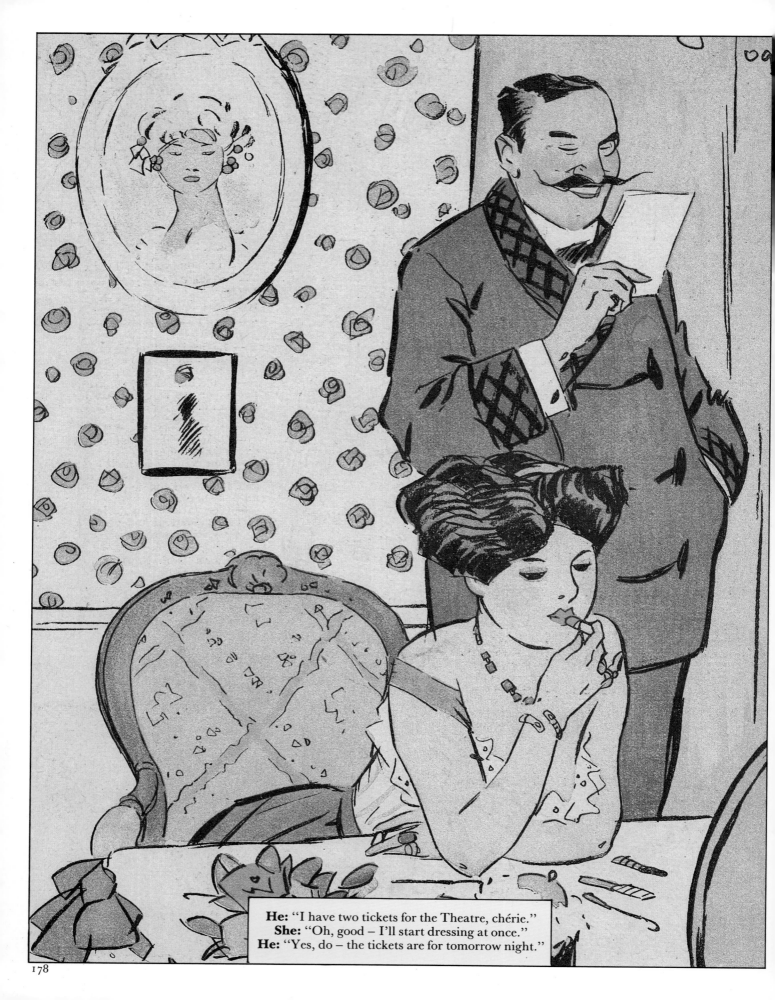

He: "I have two tickets for the Theatre, chérie."
She: "Oh, good – I'll start dressing at once."
He: "Yes, do – the tickets are for tomorrow night."

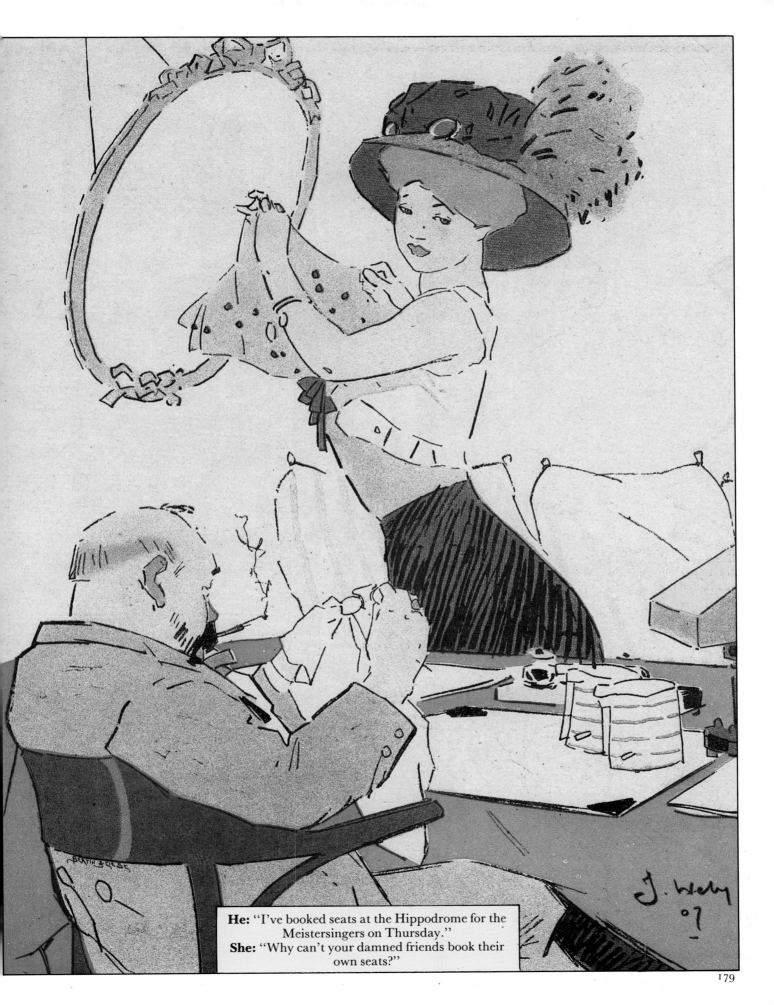

He: "I've booked seats at the Hippodrome for the Meistersingers on Thursday."
She: "Why can't your damned friends book their own seats?"

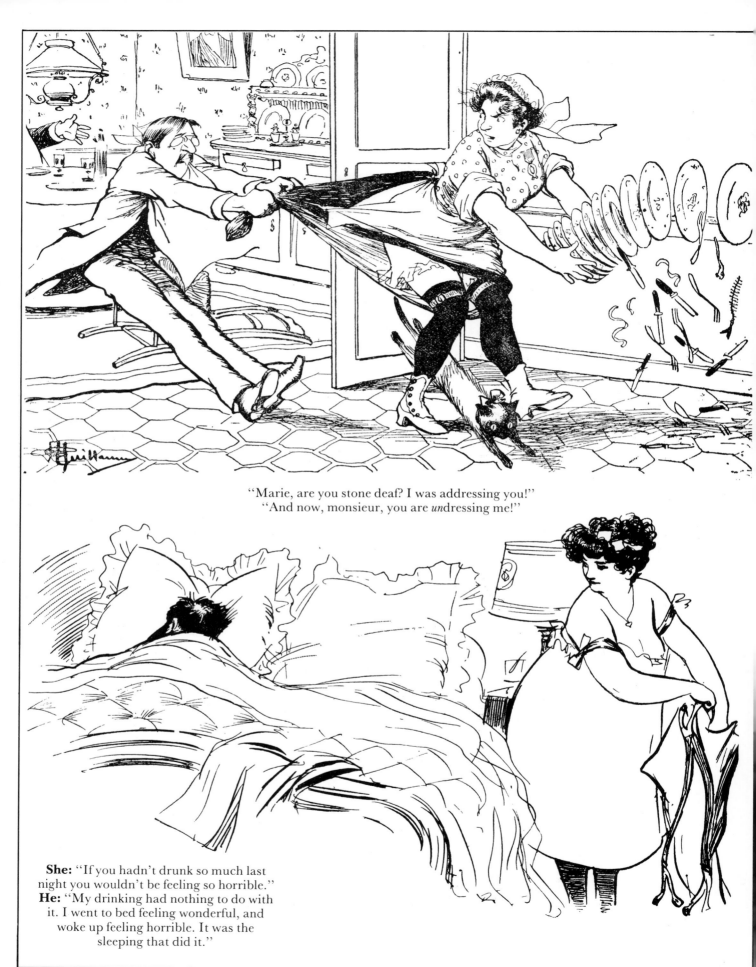

"Marie, are you stone deaf? I was addressing you!"
"And now, monsieur, you are *un*dressing me!"

She: "If you hadn't drunk so much last night you wouldn't be feeling so horrible."
He: "My drinking had nothing to do with it. I went to bed feeling wonderful, and woke up feeling horrible. It was the sleeping that did it."

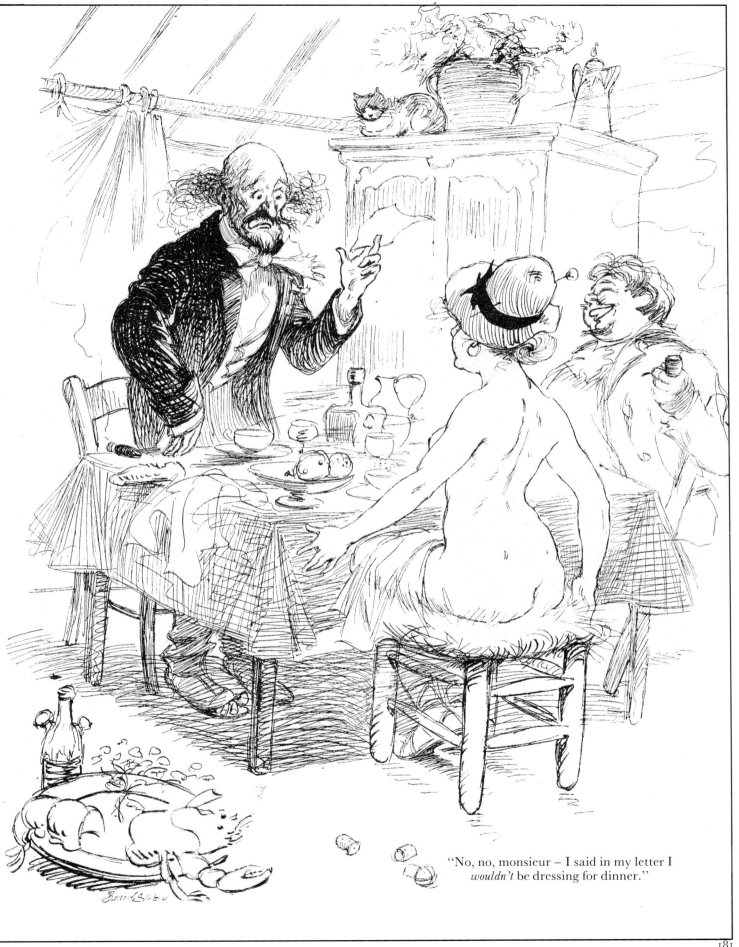

"No, no, monsieur – I said in my letter I *wouldn't* be dressing for dinner."

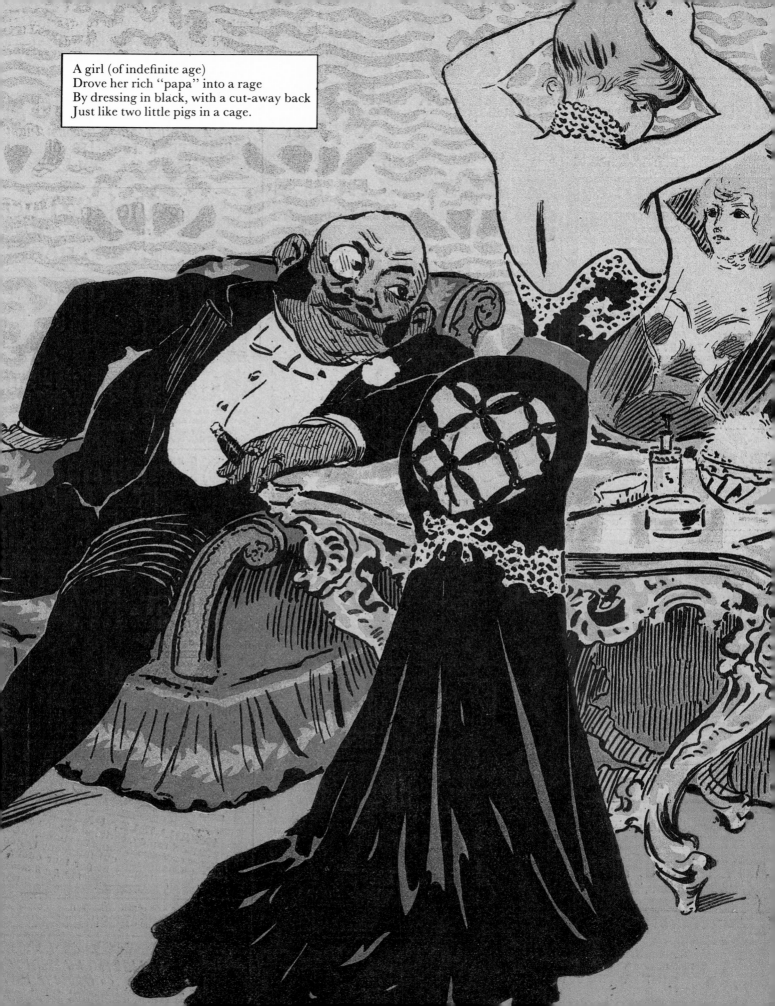

A girl (of indefinite age)
Drove her rich "papa" into a rage
By dressing in black, with a cut-away back
Just like two little pigs in a cage.

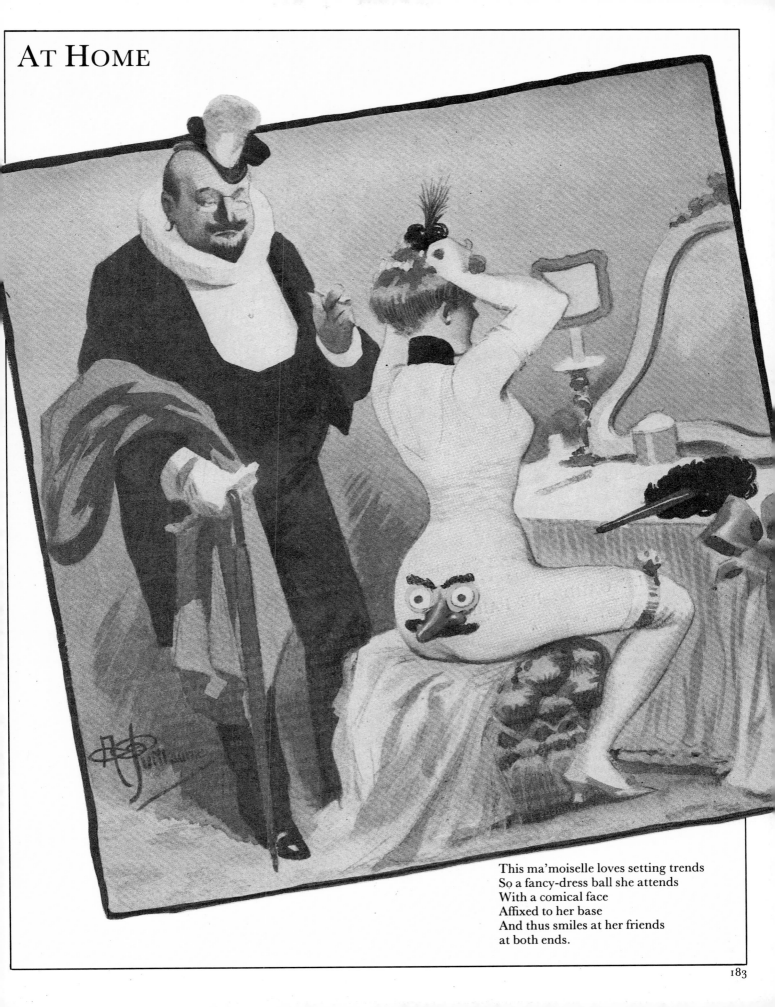

This ma'moiselle loves setting trends
So a fancy-dress ball she attends
With a comical face
Affixed to her base
And thus smiles at her friends
at both ends.

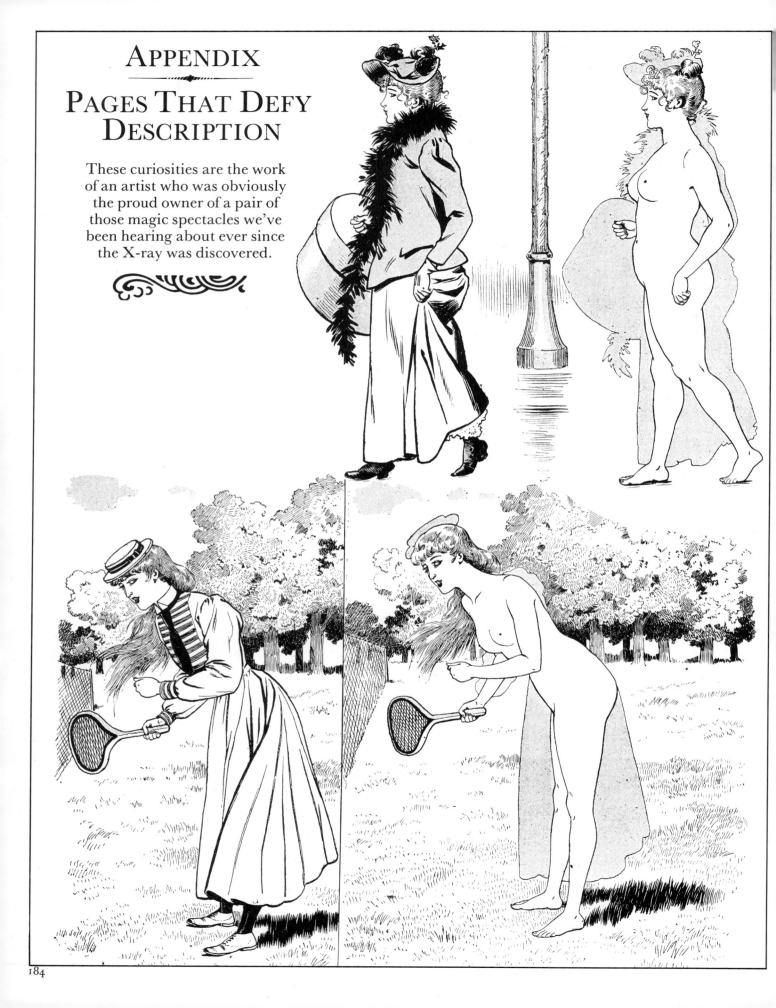

APPENDIX

PAGES THAT DEFY DESCRIPTION

These curiosities are the work of an artist who was obviously the proud owner of a pair of those magic spectacles we've been hearing about ever since the X-ray was discovered.

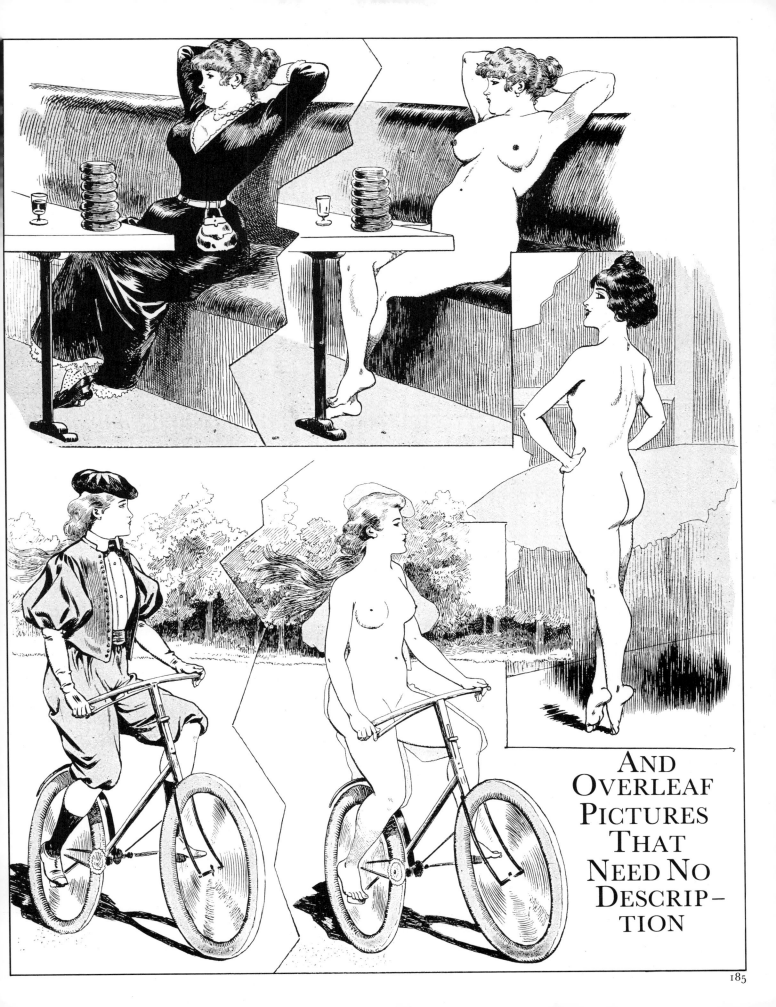

AND
OVERLEAF
PICTURES
THAT
NEED NO
DESCRIP-
TION

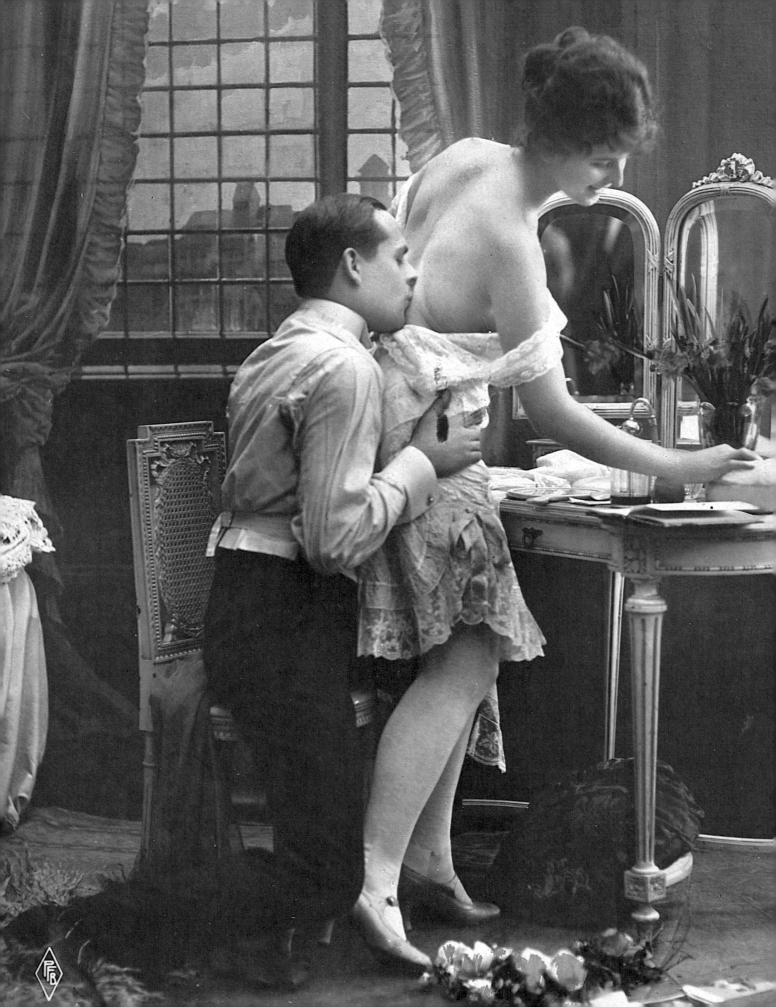

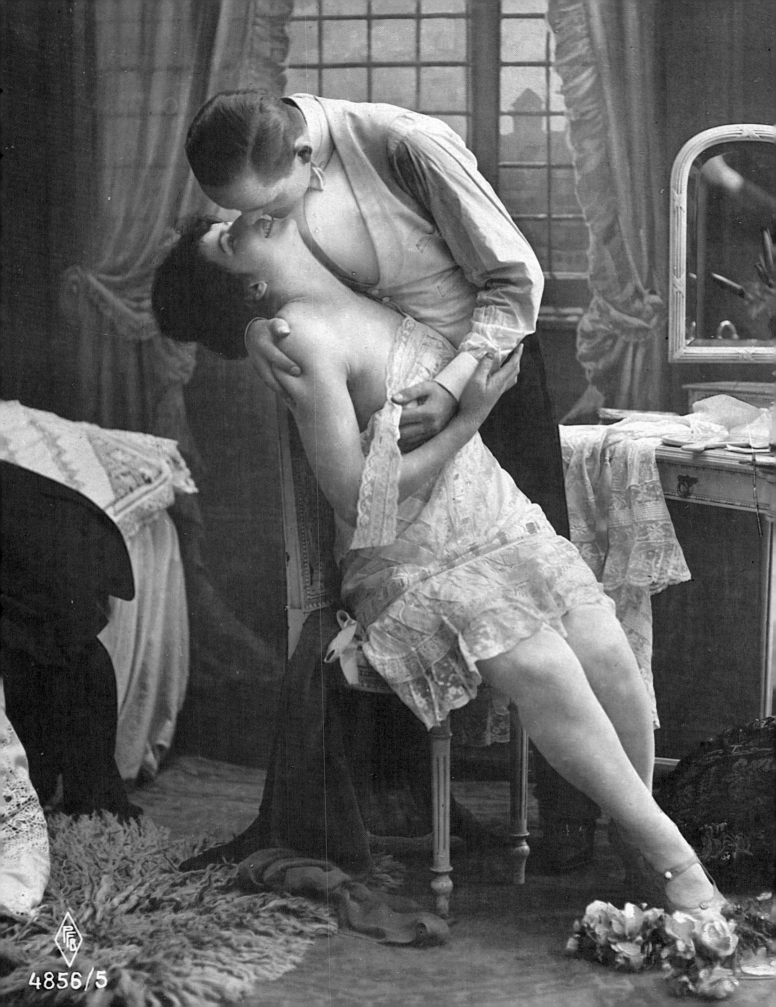

4856/5

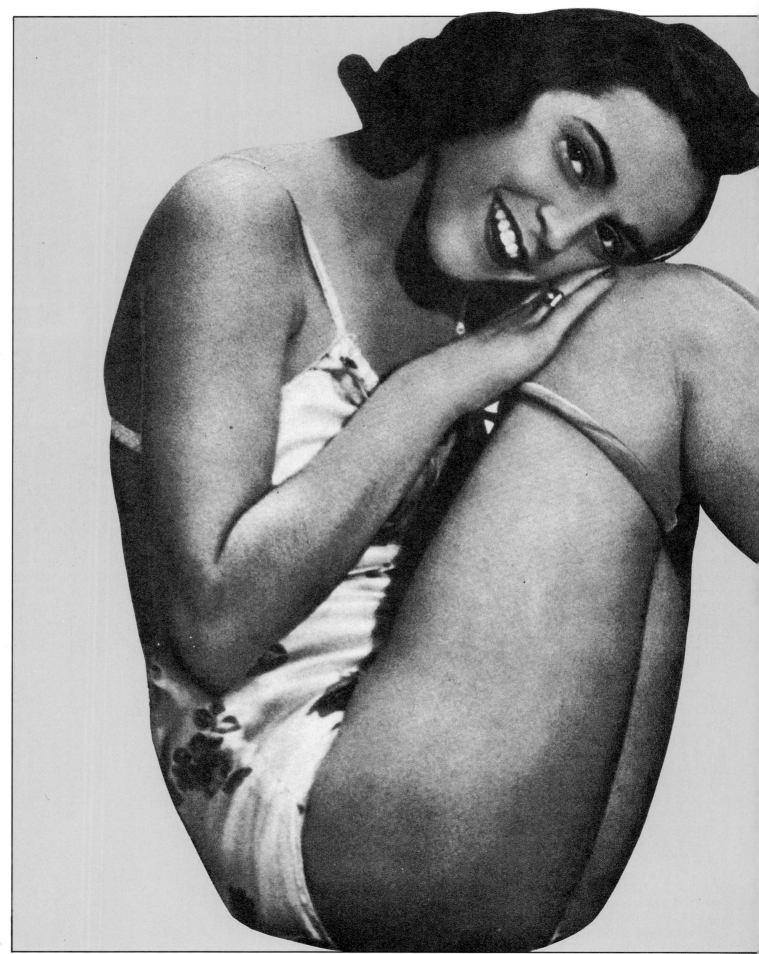

Ooh-La-La! The Ladies Of Paris
A·WORD·OF·FAREWELL

And so, as the guide-books say, we say au revoir to Paris, city of dreams; and this cheeky chorus-girl, spreading herself across two pages, sums up the spirit of fun that is, I sincerely hope, depicted so delightfully in ———————— the preceding pages. ————————

In my approach to the book, I have been rather like a fan-dancer's fan. I have drawn attention to the subject without attempting to completely cover it. You will find few epigrams – but, after all, an epigram is merely a joke in evening-dress. What you *will* find, I hope, is Paris. For the amazing fact is that all this visual art (for art it is, without question) was being produced at a phenomenal rate in one city during the span of a few fabulous years.

Those years are gone; the art lives on.

Until next time,

As ever,

Ronnie Barker

29. PARIS — R...

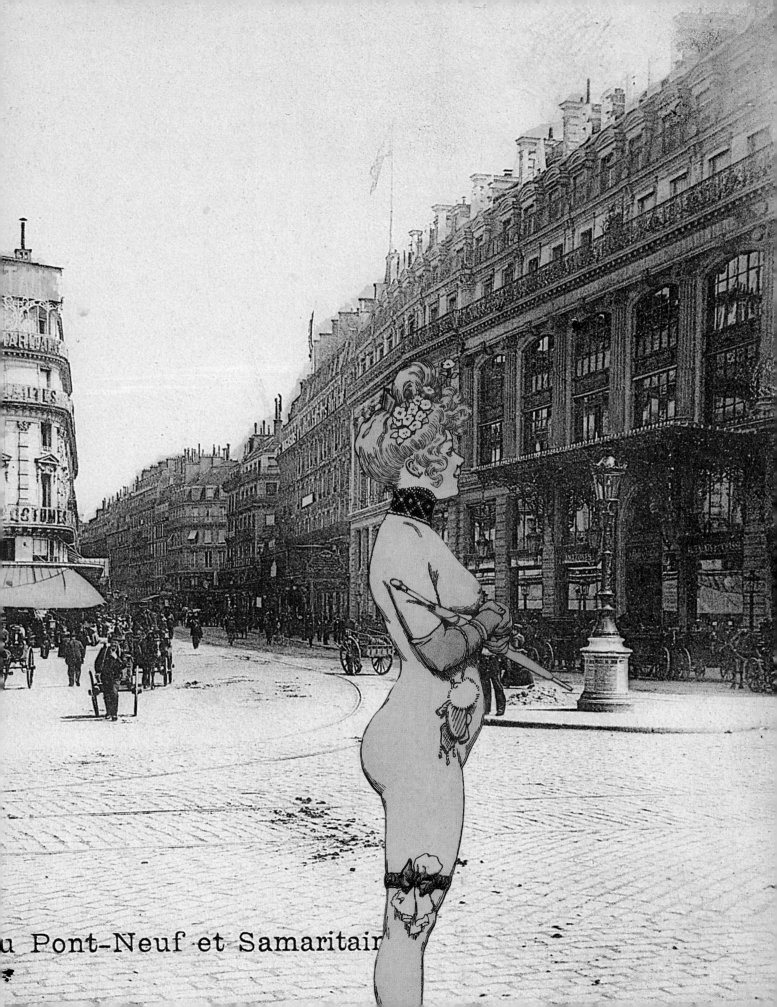

u Pont-Neuf et Samaritair

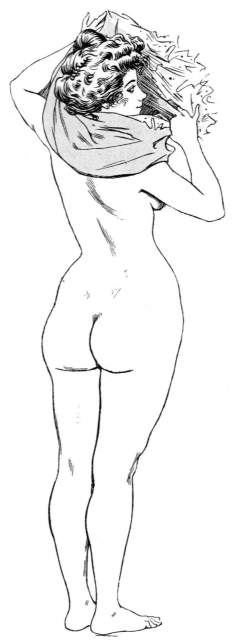

THE END

"You have seen everything there is,
mon ami – now I'm going to get
dressed again."